LEONARDO

A Study in Chronology and Style

LEONARDO

A STUDY IN CHRONOLOGY AND STYLE

CARLO PEDRETTI

UNIVERSITY OF CALIFORNIA PRESS

Berkeley and Los Angeles 1973

To Carmela and Charles Speroni

UNIVERSITY OF CALIFORNIA PRESS

Berkeley and Los Angeles, California

ISBN: 0-520-02420-6

Library of Congress Catalog Card Number: 72-97746

Printed in Great Britain

Contents

Preface

A comprehensive book on Leonardo's achievements as an artist can only be brief and somewhat dogmatic, and I am therefore offering no apologies for the boldness with which I have treated the subject. As a lighthearted journey through the delightful complexity of Leonardo's life and thought, this book is quite different from the standard biographies and scholarly evaluations of his art, and in fact it has no ambition to compete with such classic works as Lord Clark's famous account of Leonardo's art and Mr Popham's perceptive study of Leonardo's drawings.

After thirty years of research, I am not writing a concluding statement but simply my views, personal as ever, on a number of problems which will certainly fascinate students for generations to come. This book is confined to paintings and drawings, with occasional references to sculpture and architecture. I have not incorporated a discussion of Leonardo's literary remains and scientific and technological studies, in order not to affect the character of the book. On the other hand, these subjects are treated at length in my forthcoming Commentary on Richter's classic edition of Leonardo's Literary Works. For the last three years of Leonardo's activity, as mentioned in my Epilogue, the reader may be referred to my book on the Romorantin Palace and to a complementary article in the *Gazette des Beaux-Arts* (November 1970).

The Leonardo drawings at Windsor Castle are reproduced by gracious permission of H.M. the Queen. I am grateful to Mr Benedict Nicolson, editor of the *Burlington Magazine*, for permission to incorporate excerpts from my article on the Burlington House cartoon, with which I intend to show that I have not changed my mind about my dating of that cartoon. Everything else in the book is new, including documentary material which is mentioned here for the first time.

<div align="right">C.P.</div>

Major events in Leonardo's life

1452	*Born in Vinci*
c. 1469 to 1476	*With Verrocchio in Florence*
1476 to 1482	*In Florence receiving independent commissions*
1483 to 1499	*In Milan at the Sforza court*
1500 to 1506	*Second Florentine period*
[1499-1500	*Visits to Mantua and Venice]*
[1502-1503	*In Romagna with Cesare Borgia. Probably first visit to Rome]*
[1504	*At Piombino with Jacopo IV Appiani. Visit to Rome]*
1506 to 1513	*Second Milanese period*
[1507-1508	*Twice in Florence]*
1513 to 1516	*Rome, Florence and North Italy*
1516 to 1519	*France. Dies in Amboise*

Chapter One

THE RIVER

The earliest Leonardo drawing which has come down to us is a landscape of the Arno valley. It is dated 5 August 1473, when Leonardo was twenty-one years old. It is impossible to identify the exact location of the scenery depicted: natural sceneries do change in time, especially in proximity to rivers. Nor can we say how accurate the drawing is in representing the scenery. But we can be reasonably certain that it includes at least one pictorial trick. The trees, in fact, appear to be impressionistically rendered, according to a convention that Leonardo must have learnt in the Florentine studios of the Quattrocento. A print of Petrarch's *Triumphs* dating from about 1470, at the time of Leonardo's drawing, shows the same convention in representing the landscape which stretches behind the Classical chariot of the *Triumph of Love* and reaches high up into the background. The trees are rendered with curved, parallel lines drawn at great speed as if to convey the rotatory effect that the haze of a summer day in Tuscany may produce on branches and foliage. Thus Leonardo took advantage of a kind of short-hand device to convey the motion of light and the effect that atmosphere has on objects viewed at a distance. His contemporaries, in turn, may have learnt the trick from the Flemish. But it was he, Leonardo, who eventually carried out extensive research on the effect of light in the landscape, and it was he who even invented a name for this type of representation – aerial perspective.

The distance involved in any Florentine landscape of the fifteenth century is too great to show any possible effect of wind on the branches of trees; and in fact Tuscan painters were so little concerned with atmospheric activities that the horizon line was often brought very close to the top of the picture and only a strip was left of crystal clear sky. Again, Leonardo's first drawing shows what he had learnt in the Florentine studios. He has come up with what appears to be the result of a fresh

9

observation, and yet it is a scenery which can be suitably occupied by human figures at each side, as in Pollaiuolo's *Rape of Dejanira*, a work also dating from about the time of Leonardo's drawing. Regardless of whether human figures were introduced or not, we can sense that in the painter's intention the central theme, in both cases, is a river, which is perhaps the real protagonist, introduced as a fitting symbol in disguise, or at least as a device to convey animation, stressing the idea of action and even violence. We cannot go wrong identifying the river with the Arno.

If it were possible to conjure up an iconographer of rivers we would be told, while looking at these images, of an event which is recorded in the *Florentine Diary* of Luca Landucci under the date 12 January 1466. 'During the night', reports Landucci, 'the Arno began to be in flood, although there had not been a drop of rain; but the snow had melted suddenly, so that the river entered the town and flooded it as far as the Canto a Monteloro, and benches from the Church of Santa Croce floated across to that point ... Many mules and horses were drowned in their stables, and all the wine-casks went floating about, mostly towards the Arno. This flood had come suddenly.'

An earlier chronicler, the Florentine historian Giovanni Villani, records the disastrous flood of Florence of 1333, and reports on lengthy discussions which arose afterwards about the destructive power of water, presenting the argument almost in the form of a treatise. By the mysterious thread of tradition, the early discussions may have reached Leonardo, who set himself at the beginning of his career as a writer, about 1490, to investigating the same problem. As he intended to write a treatise on rivers, he began with a Proem, a suitable introduction to compare the destructive powers of water and fire. He pleaded a case for water with the same passion with which he was to proclaim the superiority of painting over the other arts. This early text is known in two drafts on two different sheets of the Codex Atlanticus. I reproduce the one that seems to me the later version:

'Amid the causes of the destruction of human property, it seems to me that rivers on account of their excessive and violent inundations hold the foremost place. And if against the fury of impetuous rivers any one should wish to uphold fire, such a one would seem to me to be lacking of judgment, for fire remains spent and dead when fuel fails it, but against the irreparable inundation caused by swollen and proud rivers no resource

of human foresight can avail; for in a succession of raging and seething waves, gnawing and tearing away the high banks, growing turbid with the earth from the ploughed fields, destroying the houses therein and uprooting the tall trees, it carries these as its prey down to the sea which is its lair, bearing along with it men, trees, animals, houses and lands, sweeping away every dike and every kind of barrier, bearing with it the light things, and devastating and destroying those of weight, creating big landslips out of small fissures, filling up with its flood the low valleys, and rushing headlong with insistent and inexorable mass of water.'

By the second half of the fifteenth century the rivers of Lombardy had already been tamed by a vast programme of canalization and were unlikely to display the powers to which Leonardo refers. It must be a river of his youth that he has in mind, the Arno, and in particular the flood of 1466. We do not know whether Leonardo was in Florence in 1466, but even in his home town, Vinci, some 40 miles from Florence, he could as a child have witnessed the violence of fantastic storms. It must have been one such storm which produced on his mind the powerful impression that was to lead him to the study of wind currents as compared to the motion of water and smoke. All this resulted in drawings which were not simply scientific illustrations, but also records in his old age of an image that had been haunting his mind since his childhood. Evidence of the frightening image of a storm is to be found in Machiavelli's *Istorie Fiorentine*, under the date 1456, when Leonardo was four years old.(And the same occurrence is recorded in Rucellai's *Zibaldone*.) It was a spectacular cataclysm which assailed the countryside of Tuscany, sparing the great cities. It was a devastation of a large strip of land stretching all the way from Ancona to Pisa, and as close as eight miles to Florence. The vividness of Machiavelli's narrative is equalled only by later descriptions of cataclysms by Leonardo himself. As one reads it, one can only think of Leonardo's drawings of deluges of some sixty years later: 3–5

'On 24 August, an hour before daybreak, a whirlwind of dense black vapour spreading for about two miles in all directions issued from the upper sea near Ancona, and traversing Italy passed into the lower sea near Pisa. This vapour driven by resistless forces, whether natural or supernatural I know not, and rent and driven in struggles with itself, split off into clouds which, now rising to heaven now descending to earth, dashed one against another, or whirling round with inconceivable

velocity swept before them a wind of measureless violence, and sent
3 forth as they strove together frequent lightnings and dazzling flames.
From these clouds thus broken and embroiled, from this furious wind,
and these quick-succeeding sheets of flame, came a sound louder than the
roar of thunder or earthquake, and so terrible that whosoever heard it
thought the end of the world had come, and that land and sea, and all
that was left of earth and sky, were returning mingled together to ancient
Chaos. Wherever this dreadful whirlwind passed it wrought the most
astonishing and unheard-of effects, but more notably than elsewhere near
the walled village of San Casciano, situated about eight miles from
Florence, on the hill separating the Val di Pesa from the Val di Grieve.
Between this town and the village of Sant'Andrea, standing on the same
hill, the hurricane swept, not touching Sant'Andrea, and merely grazing
the outskirts of San Casciano so as to strike some of the battlements of the
walls, and the chimneys of a few houses. But outside, in the space between
the two places named, many buildings were levelled with the ground;
the roofs of the churches of San Martino at Bagnuolo, and of Santa
Maria della Pace, were borne bodily to a distance of more than a mile; and
a carrier and his mules were found dead, some way from the road, in the
4 neighbouring valley. The strongest oaks and the sturdier trees which
would not stoop before the fury of the blast, were not merely uprooted
but carried far away from the places where they grew. When the tempest
had passed and morning broke, men remained stunned and stupefied.
They saw their fields devastated and destroyed, their houses and churches
laid in ruins, and heard the lamentations of those who looked on shattered
homesteads under which their kinsmen or their cattle lay dead. Which
sights and sounds filled all who saw or heard of them with the profoundest
pity and fear. But doubtless it was God's will rather to threaten than to
chastise Tuscany; for had a hurricane like this, instead of coming among
oaks, and alders, and thinly scattered dwellings, burst upon the close-
packed houses and crowded population of a great city, it would assuredly
have wrought the most terrible ruin and destruction that the mind of man
can conceive.'

As the imagination is set in motion by Machiavelli's description one
comes to visualize what would have happened had the storm hit Florence.
5 One of the drawings in the Windsor series of deluges, which dates from
about 1515, shows the close-packed houses of a great city attacked by the

destructive fury of a storm. The town is revealed for a moment as the waters swirl around through the framing hills, and the coiling clouds have not yet dashed down to join them.

Machiavelli describes an event he did not witness (he was born in 1469), but the memory of which must have been kept alive in Tuscany for many years. In 1456 the four-year-old Leonardo was no longer an infant in the cradle precociously experiencing erotic symbols (Freud), but a child with a fascination for nature and ready to undergo the first fears brought about by the fury of the unbridled forces of nature. The storm of 1456 reached its climax half-way between Ancona and Pisa, just south of Florence. From Vinci it could have been viewed as a threatening storm approaching from south-east; eventually it must have passed by Vinci, over Empoli, even though with decreasing violence. Later in life Leonardo might have recalled it in some such notes as the one in which he describes the power of wind currents:

'I have seen movements of the air so violent as to carry away and strew in their course immense forest trees and whole roofs of great palaces; and I have seen this same fury with its whirling movement bore a hole in and hollow out a bank of shingle and carry away in the air gravel, sand and water for more than half a mile.'

One can almost sense that the memory of the early storm was emerging from the back of his mind as he came to describe a huge cloud he had once seen over Milan:

'I have seen more than once such a conglomeration of clouds. And lately, over Milan, towards lake Maggiore, I saw a cloud in the form of a huge mountain, which looked as if it were full of glowing rocks, because the sky was reddish at sunset and the rays of the sun tinged the clouds with their own hue. And this cloud was attracting to itself all the little clouds that were near, itself remaining stationary. And in fact it retained the light of the sun on its summit for an hour and a half after sunset, so immense was its size. And some two hours later, at night, it generated such a wind storm that it was truly spectacular and unheard of.'

Ironically, the best illustration to such a vivid description is a drawing *6* at Windsor which is not by Leonardo. It shows a huge cloud over a landscape of rolling hills and a chain of rocky mountains on the left. The drawing might be by Francesco Melzi and probably dates from the time when both Leonardo and Melzi were in France, after 1517. Kenneth

Clark calls it 'unlike any of his school' but points out that the interest in curious clouds and rock formations shows his influence. The spires and round trees are Flemish and Florentine, and the whole conception suggests the romantic landscapes of Piero di Cosimo, for example the background of the Simonetta portrait at Chantilly.

The Simonetta portrait dates from about 1498 and shows what was happening to the depiction of landscape in Florentine art at the end of the century. There is no longer the abstract clarity of a strip of sky at the top of an immense vista that man dominates from a lofty position, as in the bird's-eye-view perspective of the cartographers. Now the point of view is lowered to earth level, and man looks up into the sky where clouds are engaged in great atmospheric activities. It is essentially a Venetian approach, as found in the Bellini, in Giorgione and above all in Mantegna, and there must be some truth in the assumption that it resulted from the Aristotelian teaching of the School of Padua. It was soon to affect the whole of Italian art. Eventually even Raphael was to abandon the peaceful, Umbrian landscape of his early period. His *Vision of Ezekiel*, of about 1516, does indeed point to the type of tempestous sky most suitable to a Baroque composition.

The landscape of Piero di Cosimo is certainly charged with symbols which are projections of the painter's melancholic mood. (The dark cloud as a premonition of death fittingly enhances the delicacy of the profile.) One can hardly help thinking of what Vasari writes of Piero di Cosimo: 'He could not bear the crying of children, the coughing of men, the sound of bells, and the chanting of friars; and when the rain was pouring in torrents from the sky, it pleased him to see it streaming straight down from the roofs and splashing on the ground. He had the greatest terror of lightning; and, when he heard very loud thunder, he wrapped himself in his mantle, and, having closed the windows and the door of the room, he crouched in a corner until the storm should pass.'

When we consider the friendship between Leonardo and Piero di Cosimo, we can perhaps understand better the turbulence which was gradually entering Florentine painting at the turn of the century. High Renaissance was by then emerging from Leonardo's principles of stereometry introduced into Bramante's architecture, and Leonardo's sense of form was to find a majestic expression in the female nude, Classically built up in space along a spiral line, like the *figura serpentinata*

105

of the coming generation of Mannerists. Leda was shaping in Leonardo's
mind around 1505, at the time of his extensive studies of the flight of birds. 7
He had come to identify every action in Nature as occurring along spiral
lines: the birds ascending in the sky, or Leda rising from her kneeling 101, 102
position. He made Leda a symbol of the generative forces of Nature, a
concept which he emphasized by surrounding her with a burst of vegeta-
tion, which at times took the shape of a surge of water. 8

In a sheet of studies of perspective dating from the early 1490s there
appears a curious serpent-like object which is inscribed: 'Body born of 9
the perspective of Leonardo da Vinci, disciple of experience. Let this
body be made without relation to any body, but out of simple lines only.'
A revealing *pentimento* shows that Leonardo was about to write 'of any
solid body', that is, geometrical body – and in fact the drawing recalls the
mazzocchi of the earlier perspectivists. But his intention was to depart
from the fifteenth-century tradition of *mazzocchio* perspective to investi-
gate the dynamic qualities of a continuous line in space. The same prin-
ciple of perspective was to be fully exploited in his later drawings of
water currents, as well as in his anatomical representations of 1505–10, in
which muscles are reduced to wires to indicate their lines of force. The
dynamic quality inherent in a spiral or coiling form is reflected even in
his drawings of machines for the excavation of canals, which date from
the first years of the sixteenth century. It was in 1504 that Leonardo under-
took the great project of the canalization of the Arno River. It was to be a
canal springing somewhere north of Florence, carried to Prato, Pistoia,
Serravalle, and down to the sea; but the realization of the project would
be difficult even today. Leonardo's idea is preserved in a series of admir-
able maps at Windsor, some of which are drawn with the precision of a 10
cartographer, others with the speed and violence of the flashing vision of I
an artist, to whose mind rivers may well take the shape of pulsating 11
arteries, and water the nature of blood. There is one drawing which shows II
how water itself can be used in place of machines to change the course of
a river: again a trick that Florentine technicians of the fifteenth century,
from Brunelleschi to Filarete, must have been well aware of. In fact, in
Alberti's treatise on architecture of about 1450 we read: 'These whirls
and eddies in a river seem to have somewhat of the nature and force of a
screw, which no strength or solidity can long resist.' This brings to mind
the familiar image of a Windsor drawing which shows an old man sitting 12

in meditation by the bank of a river, accompanied by four drawings of swirling water. A note at the bottom reminds the painter that the motion of water is exactly like that of human hair, which in fact follows two directions – one set by the weight of the hair, and one set by the line of its curls. The disquieting image of *St John the Baptist* in the Louvre, which dates from the time of this drawing, shows hair treated as flowing water, as if swirling around an obstacle.

167

I have mentioned Leonardo's studies on water in a somewhat chronological order, but it would be a mistake to conclude that the drawings of water currents and whirlpools at Windsor represent a branch of scientific investigation pursued by Leonardo only late in his life. There is in fact evidence of such studies throughout his activity, and one can see how they reflect his development as an artist. The early drawings of about 1490 are somewhat timid and hesitant, and are clearly illustrations to the text of notes, as in a fifteenth-century treatise on architecture. As he approaches the end of the century, in 1498, his drawings of water become much freer, thus conveying the effect of a greater speed and exuberance. The notes become an adjunct to the drawings. But it is only later, around 1508–10, that the principles of the High Renaissance are reflected in his drawings of water, which are now given the shape of vigorous diagrams showing the direction of the lines of force – just as muscles and tendons in his anatomical studies from the same time are rendered as wires which illustrate the action of the human machine. But Leonardo the scientist never supersedes Leonardo the artist. And so we can see that after an interval of some forty years he turns to the depiction of landscapes with mountains and rivers reminiscent of the Arno landscape of 1473.

13

14

15

I Map of the Arno river, c. 1503–4

II Breakwater system in the Arno River, c. 1503–4

III A storm over a viaduct, c. 1513

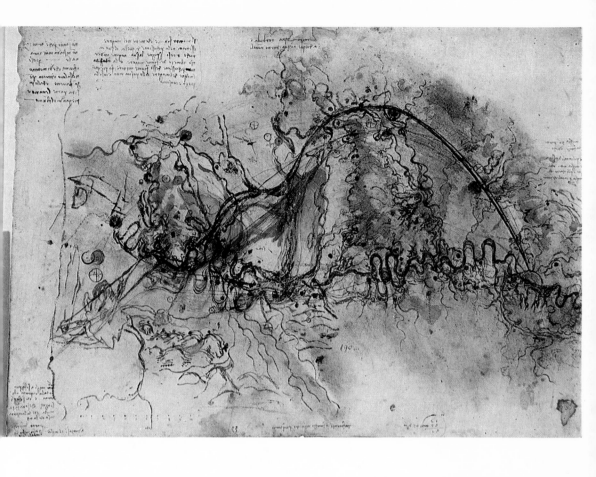

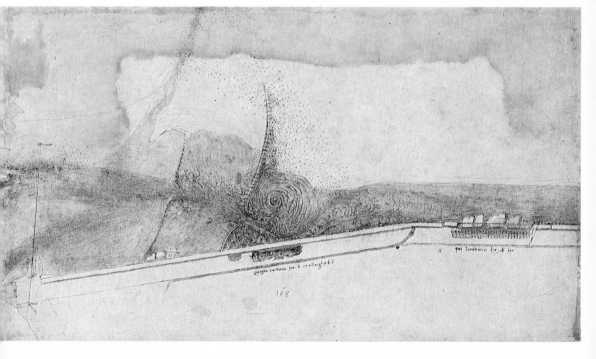

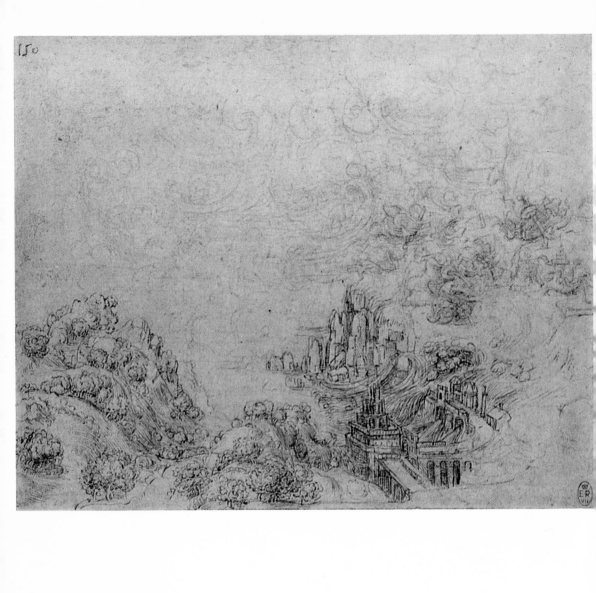

There is a series of small drawings at Windsor which have the pre- 16–18 cision and delicacy of Japanese prints and which used to be dated about the time of Leonardo's activity on the Arno canal, *c.* 1503–04. They can now be dated ten years later, *c.* 1513. They are all representations of the land- scape of the Adda River in Lombardy, and, more precisely, the land- scape between Vaprio and Trezzo. It was in Vaprio, in fact, that Leonardo was a guest of the Melzi family shortly before his departure for Rome. It was in Vaprio that he carried out the compilation of a great part of his anatomical studies, especially those on the movement of blood (the blue series at Windsor is dated 1513 on a folio which contains references to architectural structures at Trezzo and Vaprio). And finally, it was the Villa Melzi at Vaprio that Leonardo planned to enlarge into a sumptuous residence, which would have anticipated the great Roman villas of the succeeding years, e.g. Raphael's Villa Madama. A later painting by Bellotto 19 shows that in the eighteenth century the landscape of the Adda River around the Villa Melzi had not changed much. The ferryboat is exactly as depicted by Leonardo in one of his drawings. Leonardo must have done the drawing looking at the river from the terrace of the Villa Melzi. If it 18 were not for a bridge in steel and concrete which has replaced the ferry, the landscape would not be much different even today.

It must have been in Vaprio that Leonardo first envisaged the representation of a series of deluges. The apparently peaceful images of the Adda landscapes have in fact a much greater turbulence than his early Arno landscape. The process of rock erosion caused by the impetuous and swirling water sets the image in motion, with a pictorial trick similar to the early convention of rendering trees as rotating bushes. Now the landscape is rendered with scientific precision, yet the visionary power of the artist's mind has charged it with a tension which has almost the appeal of a symbol. The river has taken over the greater part of the scenery. There is no longer space for prominent human figures to be placed on each side of it, as in a Pollaiuolo painting. Man is an inconspicuous element of the landscape, even less noticeable than in a painting by Brueghel. We can sense that soon there will be no space left for him. But first the river comes to provide a setting for the enigmatic allegory of the so-called 20 wolf in the boat. All the interpretations of this famous drawing fail to point out what might be a revealing detail: the landscape is that of a river shown in its turbulent course, with a rocky shore on the left, rolling hills

in the back and upper right, and a rugged bank on the right – all elements which recall the Adda landscapes, as well as a large topographical sketch of the Adda River in the Codex Atlanticus. As the style of the drawing points to a late period, about 1513–14, a connection may be suggested with Francis I's munificent financing of the project of canalization of the Adda River in January 1516, a project to which Leonardo had contributed a great deal. (And there is some evidence that in December 1515 he was in Milan with the king.) One may fancy that the boat and the wolf (or rather a dog, a traditional symbol of fidelity) stand simply as symbols of river navigation made safe by an evergreen fortune, the *fortuna verde* mentioned by Machiavelli in his *Legazione al Duca Valentino* (letter 10), that is, the tree in place of the mast, which may also symbolize the benefit brought about by irrigation. Just below the globe, on the shore, are scattered round-shaped objects, which may be taken to represent coins. Thus the faithful Lombard subject (the dog) is overcoming the impetuous river as he is guided by the splendid king of France (the eagle on the globe), who tames nature with an act of imperial majesty. (The king was indeed to become a candidate for the Imperial crown in 1519, but the title was snatched by his rival Charles V, who adopted in his coins the Roman symbol of the crowned eagle on a globe, exactly as in Leonardo's allegory.) This is of course a theory, but a date about 1516 would explain the enigma of the Turin self-portrait, which is stylistically related to this allegory and which would therefore represent Leonardo at the age of sixty-four.

There is a sheet in the Codex Atlanticus which is almost entirely occupied by notes written by Francesco Melzi, the faithful pupil and assistant in Leonardo's late years, and probably written under Leonardo's dictation. They are all about the movement of wind, the course of rivers and the turbulence of smoke. At the bottom Leonardo added a set of notes to explain the effect of mountains falling on towns and of water in a cataclysm. At the end of one note he writes: 'And the remainder of this will be described at length in the book on painting.' One such long description, which is headed 'Descrizione del diluvio', has been preserved in a sheet at Windsor. Like the folio in the Codex Atlanticus, the Windsor sheet can be dated about 1515. It is a page of great literary power, which is reproduced in every anthology of Leonardo's writings. At the end of it Leonardo records the action of sea waves at Piombino in Tuscany. There is in fact evidence that around 1514 and 1515 Leonardo was in north

Italy and again in Florence. I believe that the Windsor series of deluges was inspired by an actual happening which brought back to Leonardo's mind the recollection of a terrifying experience of his childhood, the hurricane of 1456 described by Machiavelli. Another storm, equally terrifying, occurred in 1514, on 3 July, as recorded in Landucci's *Diary*: 'At midday, there was such a tempest of wind at Dicomano that it exceeded everything ever heard of . . . it uprooted many walnut-trees, olive trees, and oaks, and took off nearly the whole roof of the church of Vico . . . At Poggio Marino it did great damage.' In north Italy, where Leonardo remained until 25 September 1513, similar cataclysms occurred at about the same time, and he refers to one of them in a note in the Codex Atlanticus: '. . . for in our own times a similar thing has been seen, that is, a mountain falling seven miles across a valley and closing it up and turning it into a lake.' This must be the landslide which occurred in the Alps near Bellinzona, in 1513, when Leonardo was either at Milan or Vaprio, and which is described by Leandro Alberti in 1550: 'In the past years an earthquake caused a large part of a mountain to collapse, in such a way that the Bregno valley came to be obstructed; and as the river came to be dammed up, it produced a large and dark lake with great damage to the inhabitants of the valley, many of whom were drowned and their houses submerged. And so it stayed for quite some time, until the fallen earth made gradually soft by the infiltrations of the water and being no longer sufficiently strong to retain the immense pressure of it, suddenly burst open to the fury of the swollen waters. And since the former river bed, which was joined to the Ticino, was no longer adequate to contain it, the water flooded all the neighbouring regions, overthrowing in part even that strong wall which Lodovico Sforza had built near Bellinzona.' This description fits remarkably well one of the deluge drawings at Windsor, *III* in which the water is shown dashing down into a valley through a breach in the huge wall of a viaduct. Leonardo's visions of cataclysms, at times stylized beyond any logic of scientific representation (what are in fact the large ceremonial banners twirling among the clouds in the drawing of the viaduct?), are unlike anything ever produced in the whole period of the Renaissance. The only resemblance can be found in Giulio Romano's *Fall of the Titans* at Mantua of some twenty years later, which also reveals how easily Leonardo's ideas could be distorted into the grotesque and bizarrerie of Mannerism. We can no longer trace links with the Florentine

tradition of the Quattrocento. Paolo Uccello's *Deluge* looks coldly didactic in comparison to Leonardo's, like an illustration to Alberti's precepts on the composition of the *istoria*, with a stress on the monumentality of the human figure. Uccello also follows Alberti's suggestion of showing the direction of the wind by indicating that it originates from the blowing mouth of a wind god. It is characteristic of Leonardo that any such convention handed over by Quattrocento theories should fascinate him to

21 the point of fancying his own rendering of it. His wind gods now merge into the calligraphy of the clouds, and remind us of the familiar game of hunting for images in the ever-changing forms of the clouds.

Clouds and storms like human beings – human beings like clouds, and storms, and water. We are now prepared to see that Leonardo's latest drawings of human figures emerge out of the tempestuous atmosphere of his deluge drawings. The Classically fashioned profile of a bearded man

22 at Windsor, reminiscent of a bust of Lucius Vero, has hair which looks like
23 stormy clouds. And there is another drawing at Windsor which shows the head of an old man in profile, a dramatic symbol of decay – but contrasted with the head is the vitality of the majestic flow of beard, resembling the water of a river in spate. We may reasonably consider it as an ideal self-portrait of Leonardo, which has the same intensity as the self-portrait of the old Titian. On the other hand, this head and its companion in another drawing at Windsor have the unmistakable features of Jewish doctors for the composition of a *Christ disputing in the Temple*.

Early in life Leonardo began inquiring into the fascinating process of the working of Nature. His writings contain evidence of his insight into the magic world of Classical fables, and one of his earliest literary pieces is inspired by the finding of the fossil of some prehistoric animal, a huge sea monster which rides again in his imagination, majestic and terrifying as the gigantic waves over which it jumps in triumph. Throughout his vision one can sense an echo of the reading of Ovid, and Lucretius, and Virgil, and the Classical overtone flares up again in his later years, with his

24 recreation of the image of Neptune, a drawing done in 1504 as a parting present to his friend Segni, who was also a friend and a patron of Raphael. This remarkable drawing, almost shaped after the oval of an antique cameo, is a forerunner of the deluge series, not only because a sheet of the series includes, as we have seen, wind gods, but also because the coiling forms of the sea-horses and dolphins are shaped after the same swirling

curves of sea-waves. A later drawing which can be dated, on the basis of style alone, from the time of the deluge series, is the image of a fantastic 25 monster, again something brought back from the artist's subconscious, a symbol of primeval life which has materialized from the mist left behind by the devastating fury of the deluge.

There is a theory that some of the drawings of monsters and masqueraders dating from Leonardo's latest period were inspired by Dante's *Divine Comedy*. And so the famous and beautiful drawing of a lady point- 26 ing into distance has been identified as representing Matelda, who suddenly appears to Dante at the end of *Purgatorio*, Canto xxviii, and becomes his guide until the appearance of Beatrice. She stands with her feet together, like one who dances, and points out to him the river of Lethe and the rustling grove. Kenneth Clark states that the drawing cannot be interpreted except as an illustration, and that its unique appeal to our feelings suggests that it illustrates some great moment of poetry. The whole passage in Dante, with its description of the movements of air and water, could have had a particular appeal to Leonardo. This time the mist left behind by the deluge reveals the poetic image of a religious symbol, a majestic figure which has the mysterious smile of Mona Lisa.

Leonardo never believed for a moment that the universal deluge of the Bible ever took place. If he could prove its impossibility with an elegant piece of scientific deduction, he would not discard with equal contempt its appeal as a symbol. One of his drawings, which can be 27 related to the deluge series, shows that he may have considered – at least once – the theme of the Biblical judgment, in particular the destruction of Sodom and Gomorrah, but again it has been shown that Leonardo's source was more probably Dante's *Divine Comedy*. A detail of the sheet shows a striking resemblance to Signorelli's *Resurrection* at Orvieto. Yet the eleven drawings of deluges at Windsor are clearly representations of natural forces, and offer no ground to the iconographer. 'Though the drawings have a scientific background', writes Kenneth Clark, 'they are fundamentally excuses for the release of Leonardo's sense of form, and for the expression of an overwhelming feeling of horror and tragedy.'

And so if it can be accepted that profound personal feeling is hidden in these drawings an obvious explanation may follow. As Leonardo approaches the end of his life and witnesses again some local cataclysm, a memory of his childhood comes back to his mind with the intensity of a

symbol. His deluge is now the graphic equivalent to his meditation about 'our judgment' which, as he writes late in life, 'does not reckon in their exact and proper order things which have come to pass at different periods of time; for many things which happened many years ago will seem nearly related to the present, and many things that are recent will seem ancient, reaching back to the far-off period of our youth.'

Chapter Two

THE FICTION

'How to bring a crucifix into a room.' Thus wrote Leonardo about 1508 to indicate the principle of the *camera obscura* in a small sketch of the cross-section of a room which is shown with a curious mistake of perspective, as in a Trecento painting or illumination. An earlier drawing which illustrates a text on how to control the light in the artist's studio shows that the painting in the making (a rectangle inscribed with a cross) is a Crucifixion. This 'short-hand' system of representing a typical Quattrocento subject is a most effective means of indicating a painting in the artist's studio. But there is no evidence that Leonardo ever entertained the idea of painting one such subject which was to have so much appeal to Michelangelo and his followers. The idea that nails should be thrust through a human body must have been abhorrent to Leonardo (the only arrow shown in his drawing of a St Sebastian at Hamburg hits the tree above the head of the saint), but he did not need to be a controversial philosopher to reject a religion which had chosen to be symbolized by an act of human ferocity. (Vasari wrote in 1550 that Leonardo 'did not adhere to any kind of religion, believing that it was perhaps better to be a philosopher than a Christian.') He simply neglected this aspect of the Christian fable to search for more congenial aspects of it. He knew that a painter, like a poet, can produce 'a fiction that signifies great things'. All the subtleties of his art and the mystery of his smiling figures are the outcome of his idea of *finzione*, and even in his religious paintings he is representing actors of the human comedy or tragedy.

None of the paintings ascribed to the earliest period of Leonardo's career can be dated on the basis of documentary evidence, the *Adoration of the Magi* being no exception, since it is not necessarily to be identified with the painting commissioned in 1480. The style of the preliminary drawings (and of the handwriting on some of them) shows that in 1479–80

Leonardo was working on it, and it is therefore to be assumed that the identification is correct. As Leonardo was twenty-eight at the time (exactly the age of Masaccio when he died), he must have been a recognized artist already, with an impressive record of accomplishments which were to rank him together with Perugino as one of the most promising artists of the new generation:

> *Due giovin par d'etade e par d'amori*
> *Leonardo da Vinci e 'l Perusino*
> *Pier della Pieve ch'è un divin pittore.*
> (Two young men of equal age and likings
> Leonardo da Vinci and Pier della Pieve,
> The Perugino who is a divine painter.)

Thus wrote Raphael's father, Giovanni Santi, in a chapter of his *Rhyming Chronicle* in which he describes a journey of Federico da Montefeltro to Milan in 1468. Leonardo must have entered Verrocchio's studio about that time, for much later in life he recorded the system used in soldering the copper ball that Verrocchio was to place on top of the lantern of Florence Cathedral – a commission dating from 1469. In 1478 a painting of unspecified subject was commissioned from Leonardo for the chapel of S. Bernardo in the Palazzo Vecchio. On the basis of a series of drawings it has been suggested that this was to be an *Adoration of the Shepherds*. For some reason Leonardo failed to produce it and eventually a Madonna enthroned with Saints and Angels by Filippino Lippi took its place.

Leonardo's studies for the *Adoration of the Shepherds* can be grouped by reference to a fragmentary sheet in the Uffizi inscribed with the date 1478. Two fragments at Venice must have come from a sheet of similar contents, with drawings of machinery. The Virgin, down on both knees, is shown in a three-quarter view to the left, her bust turned to a frontal view with an unprecedented sinuous quality which enhances the form of her body underneath the drapery. She is gazing down at her child who reclines with a somewhat classical composure, his belly turned to the ground as if he were about to crawl away from his playmate, the infant St John, who is shown as a ghost in silverpoint kneeling on the left. St Joseph sits on the left, his left arm resting on a staff, his bust and head turned around to look up at a younger shepherd at his back who appears to be spiralling into the scene. The complexity of movement suggested

28, 29

by the figures in the lower part is reflected by that of the wreath of angels twirling in the sky, immediately above, with the exhilarating effect of a flight of Icarus. It has been suggested that the idea of such angels had come to Leonardo from the Portinari altarpiece of Hugo van der Goes, but the Flemish angels have nothing to do with Leonardo's. His are spirited creatures flying out of an antique frieze, and their counterclockwise rotation (Leonardo was left-handed) is evocative of the contrivance of a stage set. Another angel is shown foreshortened on the other sheet, which includes studies of the children on the ground and the study of a kneeling youth almost in full profile to right. His pose is that of the angel of an Annunciation, only the right knee resting on the ground, suggesting a swastika motif as in a sketch by Villard de Honnecourt. It is apparent that early in his career Leonardo had learnt the principles of design which aim at presenting the human body, especially of women, with an almost erotic emphasis in rendering its qualities of volume and movement. It is pointless to speculate on the 1476 accusation of sodomy (the last record of Leonardo's association with Verrocchio) in order to contradict his fondness for the female body as revealed by his drawings.

A large sheet at Windsor, which contains a variety of drawings of male and female heads in profile and which can be dated with reasonable accuracy in 1478 (the words *Jn dej* to test the pen show the identical characteristics of the script of the dated sheet at the Uffizi) includes a full-page sketch of a kneeling Madonna. She is down on her left knee *30* only, and her suckling child is placed on her right knee. As the lower part of the drapery is indicated only with two sweeping lines, the sensuous form is fully exposed as in a nude figure and is curiously contrasted by the dreamy quality of the profiles below, which have the delicacy of a *relievo stiacciato*. It is easy to understand how influential one such conception could have been on later artists, especially on Raphael, since a painting of the identical subject by Andrea da Salerno at Naples shows that a painting or cartoon by Leonardo must have developed from this sketch, which is also copied in the Sogliani sketch-book at the Uffizi. And I am inclined to believe that the lost painting or cartoon was one of the two Madonnas that Leonardo had begun in the last three months of 1478, as he records on the Uffizi sheet. The record is usually interpreted as a reference to the *Benois Madonna* and to a missing painting of similar subject, the *Madonna of the Cat*, for which there is a whole series of studies. But the studies for a *31, 32*

Virgin and Child with a cat might be simply a preliminary phase in the conception of the *Benois Madonna*. Leonardo might have come to realize that the theme as treated with so much verve would have resulted in a sketch of daily life completely devoid of religious connotations. The cat is delightfully treated in a variety of domestic attitudes and there is nothing in it to suggest the intention that it should represent anything but the child's pet. The composition ultimately results in a complexity of inter-locked forms which anticipates the principles of design of the later studies for the *Virgin and St Anne*. But in these early drawings Leonardo seems to be aiming at a sculptural effect inspired by the bas-reliefs of Desiderio da Settignano, while the later studies seek the effect of a sculpture in the round, as in a statue by Jacopo della Quercia.

IV With the *Benois Madonna* Leonardo found a formula which he was to apply again in the Virgin of the Louvre *St Anne*, and which was to be most influential on later artists – even as late as Barocci and Domenichino. The body is placed in three-quarter view to the right, the right leg extending forward and the left lightly retracted to sustain the large child. As in the Louvre *St Anne*, the drapery is billowing out by her hip in a play of bunchy folds. The composition no longer suggests the delicate surface of bas-relief, the format of which, however, still provides a suitable frame for it. Now the bodies form a single volume, a cube, two sides of which meet at a central vertical axis near the foreground and are felt as receding laterally to suggest the corresponding sides on the back. Filippo Lippi had already hinted at this effect with his *Tarquinia Madonna* of 1437. The effect is enhanced by the strong light directed to the group from top left and by the subsidiary soft light brought in from the window in the back. The figures are conceived architecturally, so that the whole composition can
33 be translated into a ground plan. Preliminary drawings and drawings from the same time show that this sense of volume was becoming Leon-ardo's chief aim, which might reflect his activity as a sculptor after a train-
34 ing with Verrocchio. Children are studied in a number of attitudes which expose the suppleness of their bodies with details of their limbs carried to a careful definition of skin surface. Even the silverpoint may lose its
35 metallic quality when Leonardo comes to representing the bust of a lady in eighteen different poses, crowding a sheet with unprecedented freedom and with a lightness of touch which is equalled only by Watteau. Only the self-assured expression of the portrait on the upper left, showing the

lady almost full face, reminds us of the Tuscan origin of the drawing, as if the artist had taken a bust of Desiderio da Settignano as a model.

The sense of volume should be enhanced rather than toned down by the enveloping element of the drapery. The familiar pose of the kneeling 36
Madonna appears again in a highly sophisticated drapery study which retains intact the sensuousness of the female body, as in the Windsor sketch of 1478. These images of kneeling figures may serve to bring in the subject of Leonardo's *Annunciations*, both the one at the Louvre, which probably comes from the predella of Verrocchio's *Madonna di Piazza* at Pistoia, and the one at the Uffizi. In the Louvre predella the Madonna is 37
kneeling on both knees as in a Nativity, while the angel is kneeling in a swastika pose. The two figures are brought close to the central vertical axis of the panel, the head of the Virgin being only slightly above the level of the angel's head, but exactly in line with the top of the angel's wings. The restful sense of balance in the whole composition is underlined by the architectural setting which is chanelled out into a terrace in the background landscape, thus providing a device to separate the two figures and confer an iconic quality on that of the Virgin, set as she is against the abstract element of a wall surface in shadow. I am inclined to believe that the painting is all by Leonardo and not too early in his career, perhaps between 1478 and 1480. But Leonardo is here conforming to a commission programme as set by Verrocchio and as carried out by Lorenzo di Credi. Since the Pistoia altarpiece can be taken as the summation of formulae tested and established by Lippi and Fra Angelico, Leonardo appears conscious of the need to pay a tribute to a tradition out of which he is emerging. He is looking back at Masaccio in order to dispose of a certain fashionable calligraphy in favour of forms which should be broadly defined by the suppleness of colour and by an almost humid quality of the atmosphere. One is tempted to recognize a purifying process through which painting can be brought up to the ideals of the High Renaissance. The juxtaposition of the Virgin's head and a female reclining head in a highly finished drawing at the Uffizi, effective as it might be in showing the identity of a type and even expression, amounts to a comparison between Masaccio and Gentile da Fabriano. Yet the painting and the drawing date from the same time and may be taken as the first indication of a characteristic which can be followed through Leonardo's career and which can be detected even in the style of his handwriting – that is, the

direct, even bold, expression of an idea alongside the elaborate labyrin-
thine definition of it, the rough sketch suggesting form, and the careful
drawing describing it. For this reason I do not believe that the Uffizi
V *Annunciation* is a much earlier painting, as early – as it has been suggested –
as 1472 when Leonardo was accepted as a member of the Florentine
Painters' Guild and was therefore allowed to receive independent com-
missions. The Uffizi painting comes from the convent of St Bartholomew
at Monteoliveto near Florence, but there is no evidence about its origin,
and the attribution to Leonardo, which has often been questioned in
favour of one to Domenico Ghirlandaio, is now generally accepted. I have
no doubt that the painting is all by Leonardo and that it should be dated,
like the Louvre predella, about 1478–80. As the mood is changed into
one of slow calligraphy, the general effect is one of sophistication which
reflects that of the contemporary mythological paintings by Botticelli.
Even the elements of landscape and architecture show the type of man's
control over nature (notice the artificial shape of the trees) that was to
affect the actual garden architecture at the time of Lorenzo the Magnifi-
cent. It is a reflection of the attitude towards a revival of the fastidiousness
of International style combined with that of decorative motifs of antiquity,
as felt already in Benozzo Gozzoli's decoration of the Medici chapel. In
the Uffizi *Annunciation* Leonardo presents the taste of the day with the
faithfulness of a chronicler who is sensitive to the charm of elegance and
even pomp. Only in the far distance, at the centre of the picture, is his
imagination given free rein as he shows a towering mountain emerging
out of the misty atmosphere of a harbour town with an almost Dantesque
magnitude. The whole composition is a virtuosity of Flemish accuracy,
including the detail of the interior of the Virgin's room shown through
the narrow strip of the door's opening. The sonorous colours and the
overwhelming orchestration of the forms defy the rigidity of the perspec-
tive construction, making allowance for the majestic figure of the Virgin
to be brought out of a correct relation to the lectern. This is a painting over
which the eye moves with a continuous flow, ignoring the mathematical
scheme of the perspective which texturizes the surface of the panel with a
painstaking network of lines. The horizontal scene has the formal com-
posure of Baldovinetti's *Annunciation* at S. Miniato, which retains the
coldness of the marble veneer of the chapel. Leonardo's has the playful
warmth of a summer day in Tuscany. The religious scene has disposed of

such traditional devices as the column intervening between the two figures so as to enhance the iconic quality of the Virgin; nor is there the excessive distance from one figure to the other as in the *Annunciations* by Giotto and Masolino, in which each figure is placed at either side of an arch. It is no longer a mystical event, but a garden meeting evocative of the atmosphere of Boccaccio's *Decameron*. The kneeling angel has found a comfortable position which he may retain for a long period. In the Louvre predella he is genuflecting for the brief time of an announcement.

With this in mind, it is easy now to understand the revolutionary figure of Leonardo's kneeling angel in Verrocchio's *Baptism of Christ*, a 38, VI work dating from about 1473–75. The angel, almost an ideal self-portrait, has just moved into the painting to join his companion who was already kneeling on both knees. One can almost sense that Leonardo's angel was standing a moment before just by the painting side, like an actor ready to enter a stage. He is in fact the actor who has moved in for the concluding scene to bring the towel for the baptized Christ, to whom he is ready to hand it over as he looks up at Him. Since he is shown from three-quarters behind, his right leg is placed on the ground in line with the direction of the stream of water, to become therefore the Albertian device of leading the spectator's attention to the subject of the painting. As a side figure it has the same function as the St Thomas in the Orsanmichele group, who is standing, by the entrance of the niche, turned to the figure of Christ, except for the right foot which is still related to the spectator. And in fact the two works have such a close conceptual affinity that I am tempted to detect the influence of Leonardo in the successful solution of placing two figures in the narrow space of a niche. The angel in Verrocchio's *Baptism* is usually taken as Leonardo's earliest work, and in fact there is a portion of the upper landscape which can also be attributed to Leonardo and which shows a direct relationship to the Arno landscape of 1473. The head is of the ideal type of Tuscan youth as introduced by Antonio Rossellino and Desiderio da Settignano, but with an added intensity of expression which has the subtlety of a Classical model. Leonardo must have made a number of preparatory drawings for this angel, especially drapery studies, and I believe that the finished study for the head is to be identified with one of the anonymous drawings in the Royal Collection at Turin. A portion of 39 the upper part of the head is missing and badly restored, and the whole drawing has been retouched, but still retains some of the original delicacy

of the silverpoint, wash shading and white highlights – a technique exactly like the one of the Uffizi head of a Madonna and the Louvre study for the head of the Munich Madonna, a Verrocchiesque drawing that Suida has attributed to Leonardo. What convinces me that the Turin drawing is a Leonardo study for the angel in Verrocchio's *Baptism* and not a copy is the treatment of the hair, which is not exactly as in the painting but channelled down into continuous, revolving waves (even the ribbon is made to partake of its movement), according to a system that was to become one of Leonardo's earmarks. There are also indications of left to right lines of shading, and the facial features are closer to those of an actual model, with a greater suppleness in the area of the chin, which is treated as a bas-relief. In fact I am tempted to identify this with the item listed by Leonardo himself in the inventory of the works that he was carrying to Milan in 1482: 'una testa ritratta d'Attalante che alzava il volto' – a head of Attalante (his companion Migliorotti, the musician who followed him to Milan), shown as he was turning his face up. This is of course a theory, but it is well possible to take the drawing as the earliest document of Leonardo's activity.

40 One of the earliest studies for the *Adoration of the Magi*, which shows a first idea of the whole composition including classical architecture in ruinous conditions, contains in the foreground the nude figure of a kneeling king, who is stretching his arms forward to bring his offering to the child and is extending his left leg away from the scene as if it were hanging outside the picture frame towards the spectator: again the device introduced in Verrocchio's *Baptism*, this time aiming directly to the centre of the composition. Leonardo must have come to realize that this would affect the balance of the composition, the elements of which have in fact the tendency to come loose. Once more he had to look back at Quattro-cento precedents, especially those of the sculptors. The background needed

41 to be carefully studied in its perspective organization. The perspective study at the Uffizi has the format and flavour of a Donatello bas-relief, but the task was too much even for Leonardo, who got lost in the maze of orthogonals and horizontals, making mistakes that he covered up with a number of gesticulating figures. Then, after he had tested a variety of

VII individual figures, the final solution was to be reached almost direct on the square panel in a way which is highly evocative of a blown-up panel of Ghiberti's *Gates of Paradise*.

 Much has been said about the principles of composition and design of the *Adoration of the Magi*, about the fascination of the elusive quality of its figures and about the magic appeal of an iconography which escapes definition. The figure of the sitting Virgin is isolated in the centre (her head is at the meeting of the diagonals of the panel) against a dark area framed by an arch of kneeling adorers. The arch is supported at each side by the buttressing elements of two standing figures, the Old Philosopher on the left and the young man on the right (Leonardo himself?), who is turning his head away from the scene to look out of the picture – the only device that can be taken as a reference to the spectator. The second row of adorers includes horsemen and old and young people, as well as angel-like youths who may be women. The crowd is disposed around a rocky projection of the terrain which serves as the seat for the Virgin and on top of which are two trees. This produces the sharp contour which separates the foreground scene from the background, the latter being much lighter in definition, as if it were meant to be treated as a flattened out relief. The whole scene has an emphatic theatrical quality, like the unfolding narrative of a *sacra rappresentazione*. The Virgin has just taken her seat in a natural setting which replaces her traditional throne. She has come from the hut of the Nativity, of which only a post and part of the roof are visible in the background on the right facing the ruins of the temple on the left, and which is still sheltering the ox and the ass. (In the perspective study for the background a figure leaning against the post is looking inside the hut as if to suggest the moment when the Virgin was still there.) The two trees in the centre of the composition are so prominent that they must be symbolic of the event. The palm is a traditional symbol of peace, but the other tree has baffled botanists and iconographers. It looks like a walnut, yet the trunk and the leaves would be inaccurately rendered. It might well be a carob tree, which is called *Locust* or *St John's Bread*, in reference to the belief that the 'locusts' upon which John the Baptist fed were actually carob pods. If so, the figure just below it, with the right hand pointing upwards, would be St John himself. The carob tree was also known as the tree from which Judas was to hang himself, and Leonardo might have been acquainted with such popular belief as recorded by Pulci in his *Morgante* (XXV, 77):

> *Era di sopra alla fonte un carubbio,*
> *L'arbor si dice, ove s'impiccò Giuda.*

But it is probably safer to confine one's interpretation of the picture to its general programme: thus the background would represent the pagan *VIII* world in a landscape of ruins and moral decay (one wonders whether the magnificent female figures enticing the horsemen are meant to represent prostitutes) as compared with the world of Christian faith represented in *42, 43* the foreground. In points of detail (such as the fight of the horsemen on the far right, originally thought of as a dragon fight) the iconography of the painting remains a mystery. Perhaps the key to the solution of the enigma is the Egyptian column standing so prominently over the ruins, as if to suggest that the background was to embody some prophetic aspect of the philosophy of Hermes Trismegistus, which Ficino had made fashionable with his *Pimander* of 1463, and which was to be illustrated in the pavement of Siena Cathedral in the 1480s. The painting can be appreciated as the record of the movements of Leonardo's mind, but one can hardly penetrate its meaning beyond its principles of design, several aspects of which were to recur throughout Leonardo's career. Here is Leonardo's first full expression of his idea of *finzione*, which shows that he had learnt all the rules of rhetoric. One can hardly do better than Raphael, who would stand in front of it speechless.

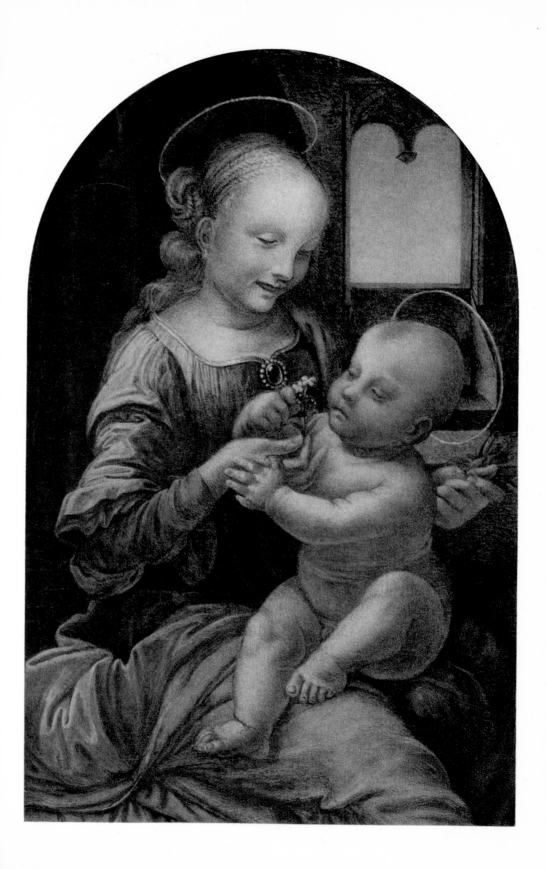

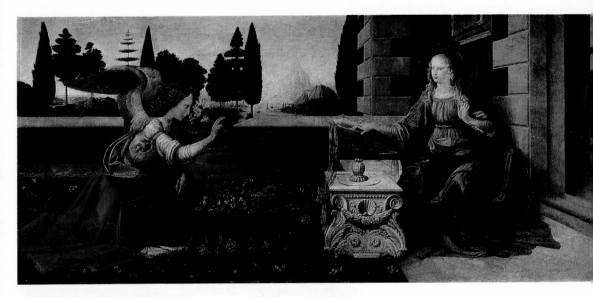

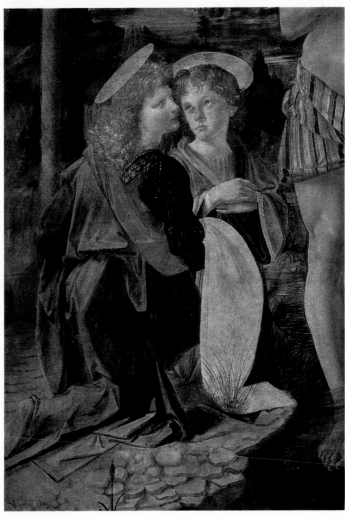

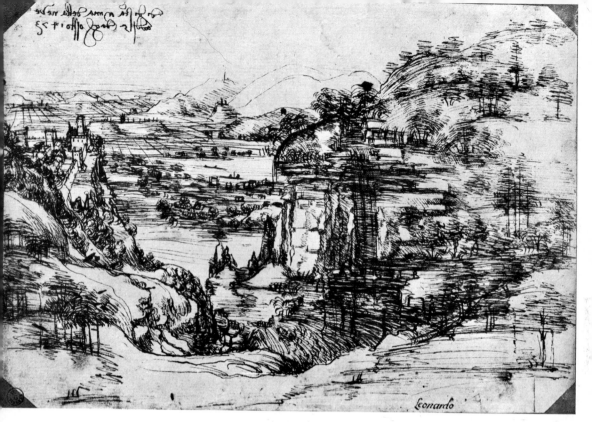

1 Landscape, 1473

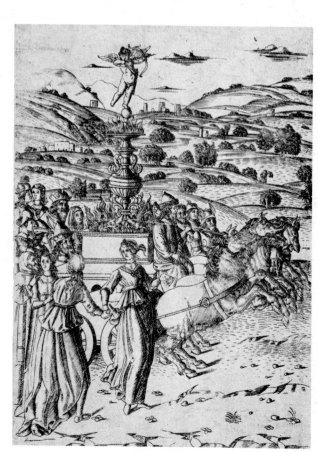

2 Triumph of Love. Anonymous Florentine, 15th century

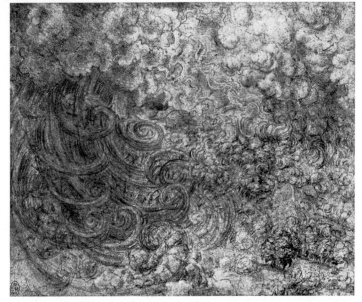

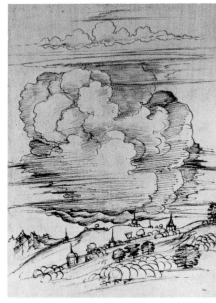

6 Francesco Melzi (?). Cloud
formation, c. 1517

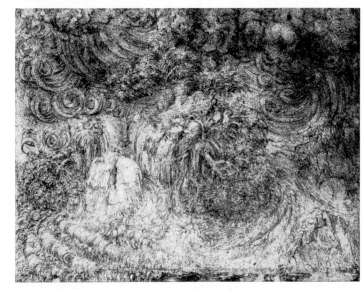

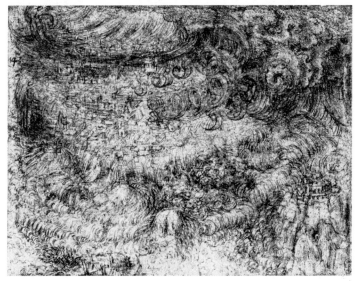

3–5 Deluge, c. 1515

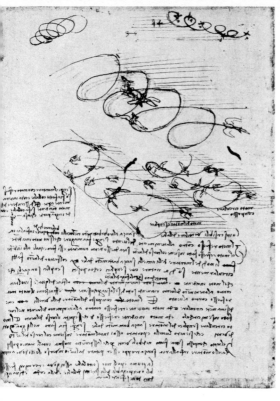

7 *Studies on the flight of birds, c. 1505*

8 *Star of Bethlehem and other flowers, c. 1506–8*

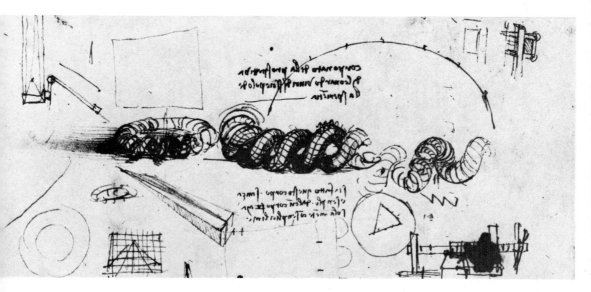

9 *'Body born of the perspective of Leonardo da Vinci, disciple of experience', c. 1490 (detail)*

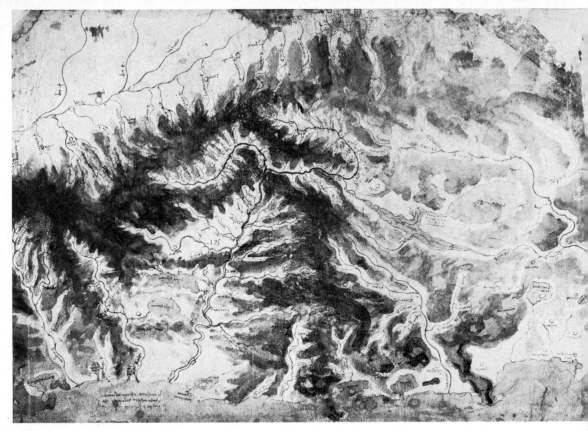

10 Map of Tuscany, c. 1502

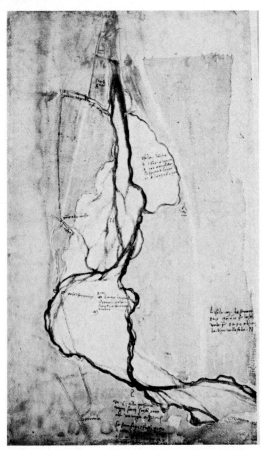

11 Map of the Arno river, west of Florence, c. 1503–4

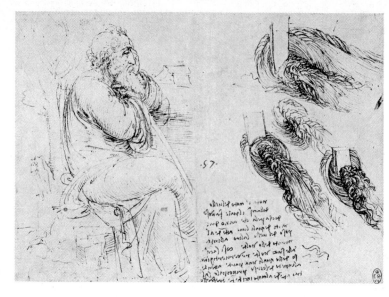

12 Old man and water vortexes, c. 1513

13–15 Studies of water currents: c. 1492 (detail); c. 1498 (detail); c. 1509

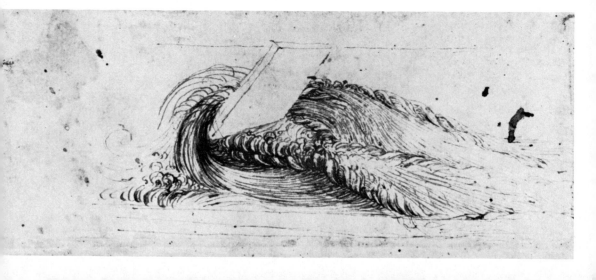

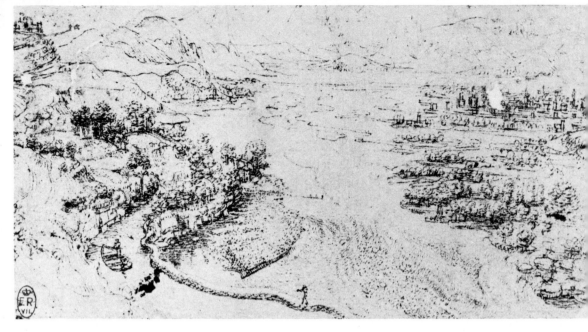

16 *Adda landscape*, c. 1513

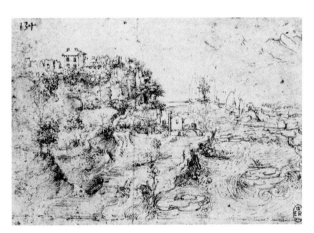

17 *Adda landscape*, c. 1513

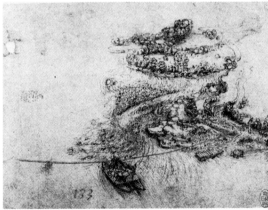

18 *Ferry boat at Vaprio d'Adda*, c. 1513

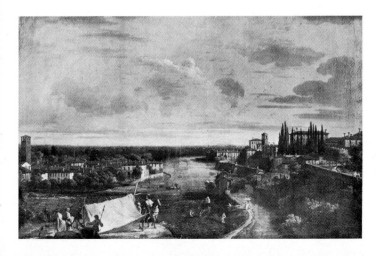

19 *Bernardo Bellotto, View of the Villa Melzi at Vaprio d'Adda*, c. 1780

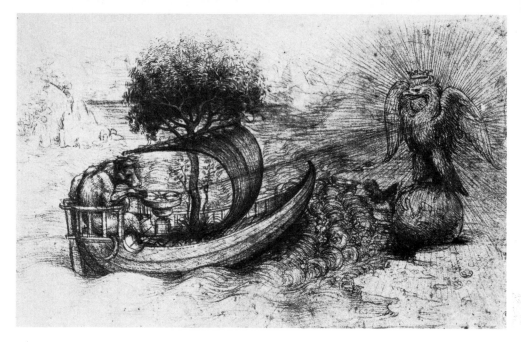

20 *Allegory of the wolf (or dog?) directing a boat to a crowned eagle on a globe, c. 1515*

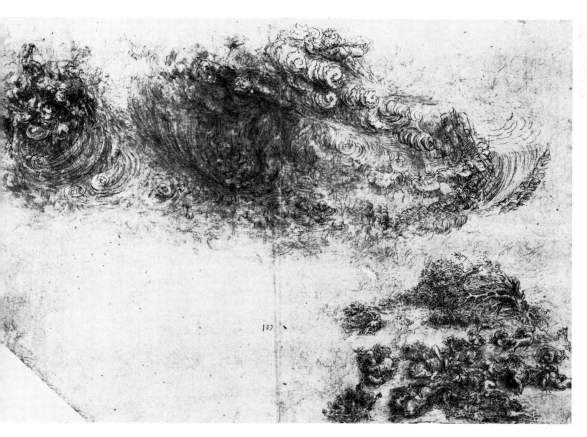

21 *Wind gods in stormy clouds, c. 1515 (or later)*

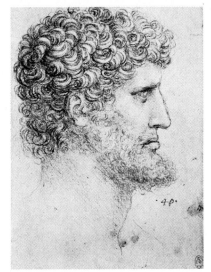

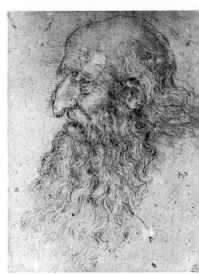

22 *Head of a man in profile to right*, c. 1513

23 *Head of an old man in profile to left*, after 1513

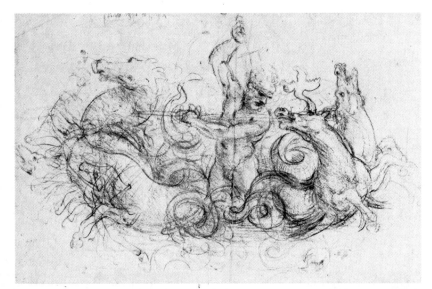

24 *Neptune*, c. 1504

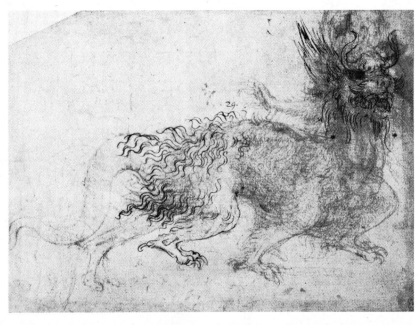

25 *A monster*, c. 1515

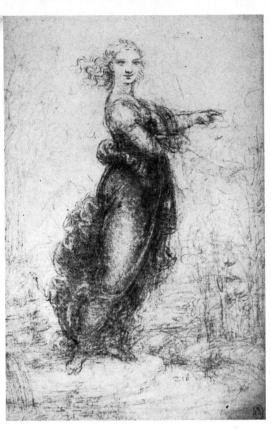

26 *The Pointing Lady, c. 1515*

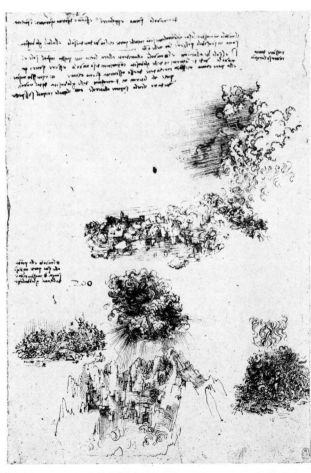

27 *Studies for a Last Judgment, c. 1515*

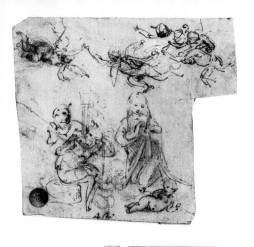

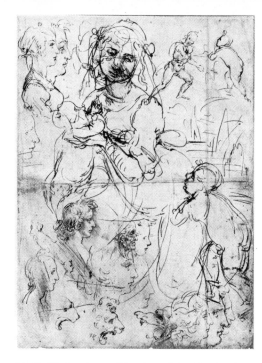

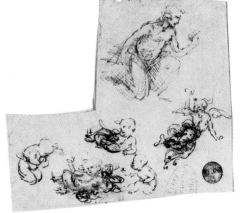

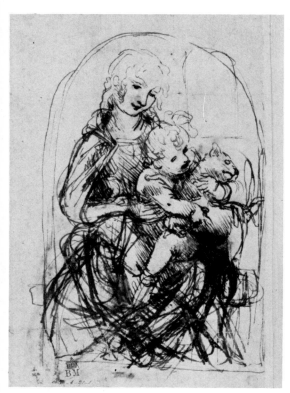

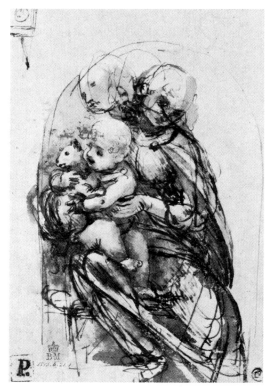

*28, 29 Studies for an Adoration of the Shepherds,
c. 1478*

*30 Study for a kneeling Madonna and other
sketches, c. 1478*

31, 32 Studies for the Madonna of the Cat, c. 1478

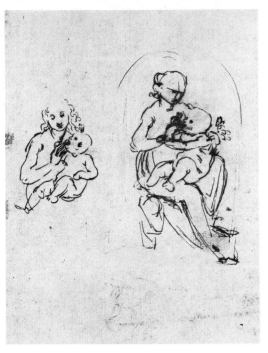

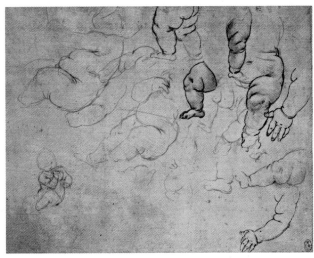

33 *Studies for a Madonna of the Flower,*
c. 1478 (detail)

34 *Studies for a child, c. 1478*

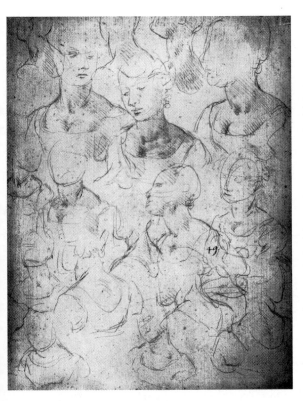

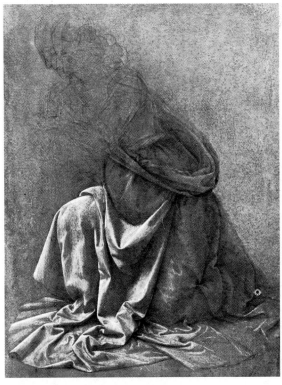

35 *Studies of a woman's head and bust, c. 1478*

36 *Drapery study, c. 1475*

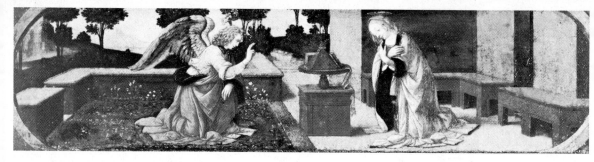

37 *Annunciation (predella), c. 1478*

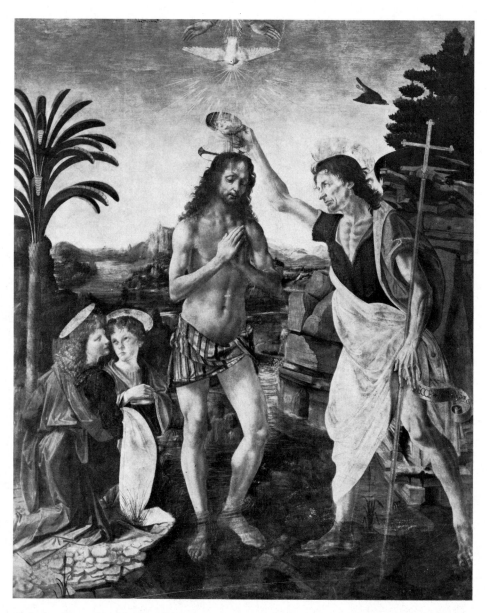

38 *Andrea Verrocchio. Baptism of Christ, c. 1473–8*

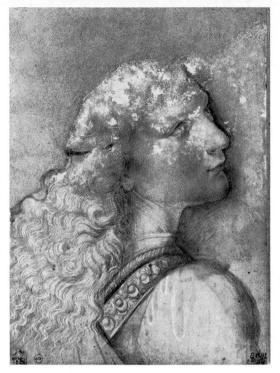

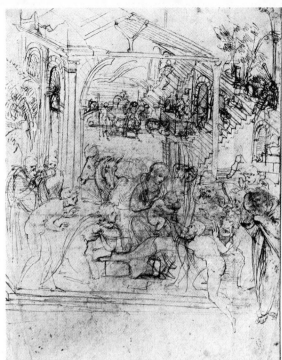

39 Study for the Angel in Verrocchio's
Baptism of Christ, c. 1473

40 Composition sketch for the
Adoration of the Magi, c. 1480

41 Perspective study for the Adoration
of the Magi, c. 1480

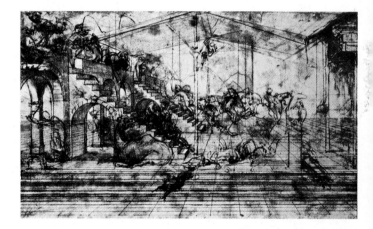

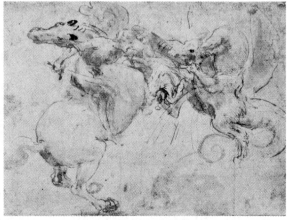

42 Fight of horsemen. Detail of the background of the
Adoration of the Magi, c. 1481 (see Pl. VII)

43 Dragon fight, c. 1480

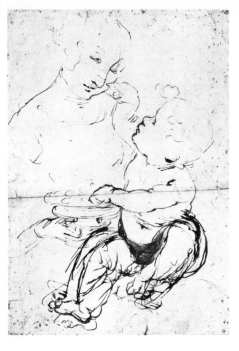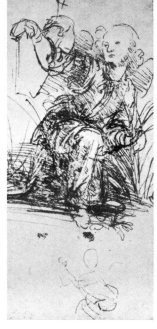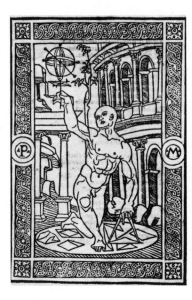

44 *Study for a Madonna with the Fruit Bowl, c. 1478*

45 *Study for a kneeling angel, c. 1480*

46 *Title-page of the Antiquarie prospettiche Romane, c. 1500*

47 *Andrea Verrocchio (and Leonardo?). Lady with the Primroses, c. 1475*

48 *Study of a woman's hands, c. 1475*

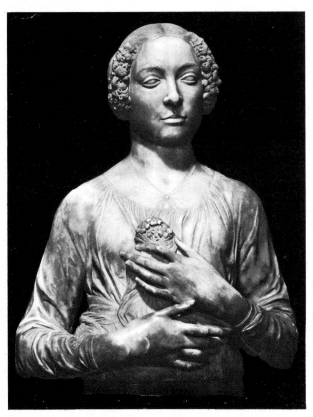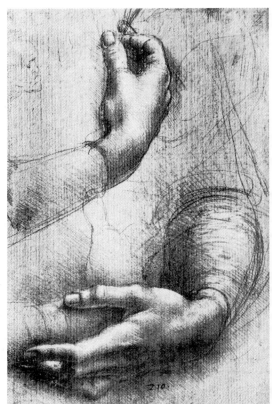

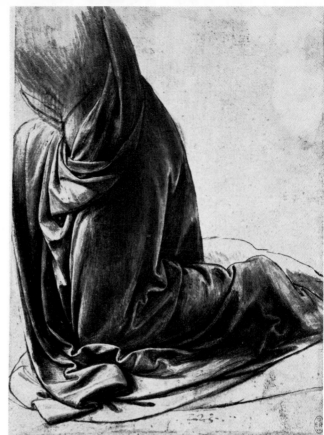

49 *Francesco di Simone. Page of sketchbook, with words written by Leonardo, c. 1475 (?)*

50 *Study of drapery, c. 1506–8*

51 *Studies for a Nativity, c. 1495–7*

52 *Sketch of draped figure and detail of costume, c. 1497*

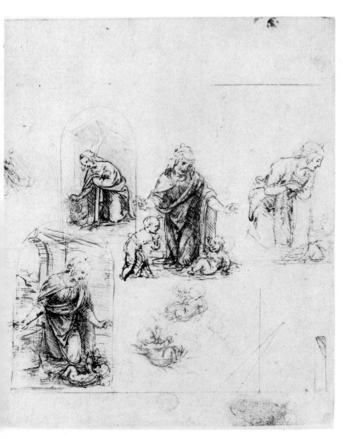

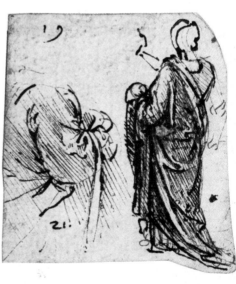

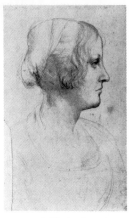

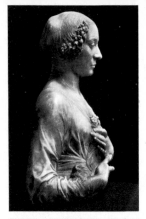

53 Bust of a girl,
profile to right,
c. 1485

54 Andrea
Verrocchio (and
Leonardo?). Lady
with the Primroses
(see Ill. 47)

55 Study of the
head and bust of a
girl, c. 1483–5

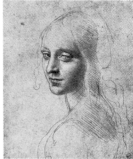

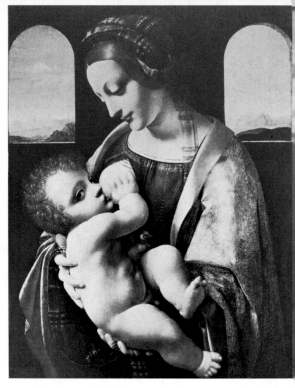

56 Madonna Litta, c. 1485–90

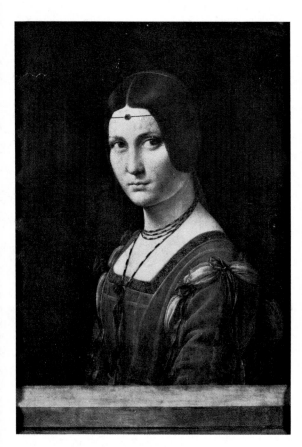

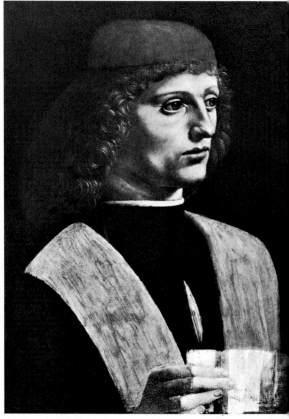

57 La Belle Ferronière, c. 1497

58 A Musician, c. 1485–90

The works dating from the ten years of Leonardo's first Florentine period, about 1470 to 1480, are all of religious subjects, except for the portrait of Ginevra Benci. They include the still Verrocchiesque *Madonna* at Munich, and the large drawing in the Louvre, which may be a study for a lost *Madonna with a Fruit Bowl*, or again an idea which preceded the conception of the *Benois Madonna*. There is also a *St Jerome* which must have originated at the same time as the *Adoration of the Magi*, to which it is clearly related in technique and style. The kneeling figure of the Saint is turned into an anatomical model, the right arm stretched out as in an illustration in the anatomical manuscripts at Windsor of twenty years later. The figure is conceived as a wax model that can be turned around and has three points of support (two feet and one knee) in addition to a bunch of drapery which counterbalances the weight of the extended arm. Leonardo has barely indicated the structure of the body, but has succeeded in conveying the sense of its presence in space as if to suggest the articulation of an architectural structure. The lion (hardly more than a silhouette) is placed in front of the Saint on the same path through the rocks as indicated by his legs. Its bulky, yet elegant, form occupies the whole foreground, the flatness of which is relieved by the sweeping curve of the lion's back and tail. An opening in the rocks, which admits the light directed to the Saint's face, reveals a church façade in the distance (S. Maria Novella?) and the contour of a Crucifix. In an early drawing in the British Museum, there is an angel in an almost identical pose, his right arm shown twice as if to indicate the act of lifting a curtain. With the discovery of the dynamic quality inherent in a kneeling figure Leonardo has come to postulate a basic principle of the High Renaissance as significantly symbolized by the kneeling figure in the title-page of the *Antiquarie prospettiche Romane*, a poem of about 1500 attributed to Bramante and dedicated to Leonardo. The figure is set against a background of classical ruins, his body somewhat twisted around so as to bring the muscular torso to a frontal view. As he rests on his left knee and right foot, his left hand is engaged with an open compass firmly set on the ground, thus suggesting a third point of support. His right hand is lifted in mid-air to hold a spherical device at which he gazes as he turns his bald head slightly up and around. The continuous flow inherent in the pose conveys the idea of simultaneous observation and recording, an appropriate representation for the act of studying classical ruins. The

IX
44

X

45

46

geometrical designs on the ground are enclosed in a circle which is shown in foreshortening and which serves as a platform for the figure – a visual device to suggest that the figure can be turned around like a piece of sculpture.

According to the earliest biographer of Leonardo, the Anonimo Magliabechiano, Leonardo was admitted by Lorenzo the Magnificent to study and work in the Medici garden, which was a collection of antique sculpture. It is not known whether Leonardo was still with Verrocchio when he came in contact with the keeper of the collection, Bertoldo di Giovanni, a pupil of Donatello and a restorer of antiques. There is much to indicate that Leonardo had received a training as a sculptor, but no sculpture has come down to us that can be attributed with certainty to him. There is even the evidence of his letter to Lodovico Sforza of about 1482 in which he claims to be an accomplished sculptor, proficient in marble carving and bronze casting. In Verrocchio's workshop Leonardo must have been well acquainted with Francesco di Simone, one of whose drawings includes a few words written by Leonardo. And I am inclined to believe that the Louvre bas-relief of *Scipio* is a work conceived by Leonardo but actually produced by Francesco di Simone. Leonardo's drawing of a similar subject, the so-called Hannibal in the British Museum, shows that he may have had a hand in Verrocchio's portraits of ancient captains that Lorenzo de' Medici was to send as a gift to King Matthias Corvinus of Hungary. The Medici patronage, again, may have been at the origin of the Bargello bust of the *Lady with the Primroses*, which has also received an attribution to Leonardo and which may be taken as a reflection of a type of female portrait that Leonardo was to introduce in the mid-1470s. This is the portrait of *Ginevra Benci*, the lower part of which, now missing, certainly included the hands in a position that must have been very similar to that of the hands of the lady with the primroses. A drawing at Windsor is generally accepted as a study for the missing hands of Ginevra. Even so, without a detail that would have anticipated the conception of the *Mona Lisa*, the portrait has an evocative power which escapes any analysis and sets it apart from the immediate model represented by the Virgin in the Uffizi *Annunciation*. As yet another kind of *finzione*, in which the body stands still, it glows with an inner life which has the translucency of smooth marble. The statuesque body is set against the dense foliage of a juniper tree, which is symbolic of the sitter's

name, as is the emblem on the back of the panel, and which frames a distant vista of waters and mountains almost suggestive of primeval life. Leonardo has performed the miracle of turning the Quattrocento portrait of a woman into an atmosphere of melodious colours and magic light which has no dimension in time and space.

When Leonardo moved to Milan about 1482, nearly all the Florentine artists had been called to Rome for the decoration of the Sistine Chapel. The anonymous biographer says that Leonardo was sent to Milan by Lorenzo de' Medici to bring the gift of a musical instrument to Lodovico Sforza. By 1483 he was certainly there, as he received the commission of an altarpiece for the Franciscan confraternity of the Immaculate Conception. He produced a painting which was still recorded in the church of S. *XII* Francesco Grande at Milan as late as 1785, and the descriptions of which fit the *Virgin of the Rocks* now in the National Gallery in London. Yet the *XIII* London painting is a later version by Leonardo himself and an assistant, which was preceded by the version now in the Louvre. The Louvre one is in fact closer to the style of the paintings of Leonardo's first Florentine period, but there is no other evidence about its origin, so that it has been suggested that Leonardo had brought it from Florence and that the painting for the 1483 contract was to grow slowly out of a series of legal controversies. On the other hand, some preliminary studies for the Christ Child on a sheet inserted in the Arundel MS. can be dated about 1483 by reference to the style of handwriting in the notes on the verso, the contents of which are related to sheets of the same date in other collections.

The panel of the *Virgin of the Rocks* was to be included in an elaborate frame together with two wings, each of which was to have a full figure of an angel playing a musical instrument. These are also at the National Gallery in London, but they are not by Leonardo even though they might have been done at the same time as the later version of the painting. It is difficult to say how much later the second version might be and why it came to replace the earlier one. According to an acceptable explanation, the earlier painting was sold towards the end of the fifteenth century because the painters were not getting the additional payment requested (all the money paid according to the contract went into the production of the elaborate frame), and, as the result of an agreement finally reached at the beginning of the sixteenth century Leonardo and his assistant took up the subject again and produced a replica of it.

XII The early version originated almost certainly between 1483 and 1486. In addition to the Tuscan flavour of its composition, it has a Lombard quality of atmosphere. It applies, simplified, the basic scheme of the *Adoration of the Magi*, with the group of the Virgin, the two children and the angel placed in the foreground as elements of a stage set, just as the mountains of the grotto are built up in a sequence of planes as if represented in a backdrop. The colours are those of the Uffizi *Annunciation*, but the light is that of the *Ginevra Benci*. The sheet of water shown in the far distance through an opening in the rocks may be thought of as reaching a lake in the foreground, the presence of which is only suggested by the effect of erosion that reveals the stratification of the cliff by which the group is placed. The Christ Child is sitting so close to the margin of the cliff that the angel is sustaining him with the protective gesture of one hand while pointing with the other at the kneeling infant St John, who is about to move out of the Virgin's embrace to step down from a stone. The angel and the Christ Child are placed exactly in front of him, but the angel's finger pointing at him along a straight horizontal line is the only element which clarifies the position of the figures in their space relationship. In the London version the angel's gesture is suppressed and his hands are both supporting the Christ Child, who is in an even more precarious position by the edge of the cliff. St John's added cross reaches the flat ground in front of the Christ Child and is thus made a visual device to explain that he is kneeling on top of a stone. His relation to the Christ Child is made unmistakable and is stressed by the modified tilt of the Christ Child's head to a profile view which only admits of a glance directed to the top of the cross. Sixteenth-century copies (both paintings and drawings) from the Lombard circles of Gaudenzio Ferrari and Cesare Magni show clearly the position of the individual figures in the group.

XII, XIII The juxtaposition of the two versions of the *Virgin of the Rocks* is the most effective illustration of the development of Leonardo's artistic theories from a Quattrocento scheme of subtle tonal values and alluring attitudes to the High Renaissance approach to form as an expression of clarity and reason – thus turning the iconographic programme into a readable statement. Even the setting is changed. Leonardo retains the configuration of the scene, but his approach to it is profoundly different. In the early version, the rock formation gives way to a strip of sky at the top, with some vegetation relieving the harsh contour of the rock. In the

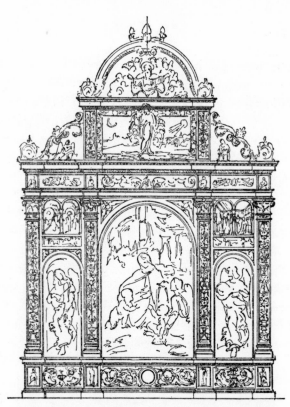

Reconstruction of the altarpiece for the *Virgin of the Rocks* according to the 1483 contract. (After Malaguzzi-Valeri.)

second version, both the rocks and the figures seem to be amplified by some optical process, with the effect that the mountains, which have taken over the whole background, are now suggesting the idea of enveloping the group of the human figures. There is now a sense of architectural logic in the idea of enclosing a central nucleus as in Bramante's project for the Tempietto in S. Pietro in Montorio. And one is reminded of the conceptual affinity in Leonardo's drawing of the foetus shown in the womb. Even the eloquent gesture of the angel had to be eliminated in order to avoid the suggestion of flatness originated by the dominant element of the red garment. No element of the group, not even a glance, could be directed away from it, so that the angel is no longer looking out at the spectator, but his pensive expression shows that his vision is blurred at the image of the cross. Not a single detail of rocks, vegetation, or drapery is repeated in the second version. A drastic revision was called for by the garment of the angel. Not only is its colour toned down and kept

142

50 away from direct light, but its whole system of folds is changed for a more
logic definition of the body underneath. This revision can be followed in
the only drawing that can be taken with certainty as a study of the second
version of the painting and which is therefore a precious document to
date that version about 1506–08. In fact its style and technique reflect
Leonardo's theories of that time. It has a fullness of form which recalls
the human figures as rendered at the time of the *Battle of Anghiari*, and
anticipates the studies for the drapery of the Louvre *St Anne* even in the
intensity of the black. The image is slightly distorted as if it were shown in
a convex mirror, conveying the remarkable effect of a foreshortening in
all directions. Not even the kneeling *Leda* could suggest such a sense of
volume, and the drapery on the ground, with the bold definition of its
contour, is conceived as the round base for a piece of sculpture.

A comparison of the two versions of the *Virgin of the Rocks* provides
also an excellent means of illustrating Leonardo's subtle approach to
iconography – his keen sense of *finzione* as related to the development
of his style.

Mantegna's *Madonna delle Cave* (*c.* 1489) is often mentioned as a
counterpart to Leonardo's idea of placing the Virgin and Child against a
rock formation which curves around as a framing device, and its icono-
graphy has been explained as an illustration of a passage in St Bridget's
Revelations about her presiding over the precious stones which are 'for
ever carried up from our valley unto the mountain of God, for the restora-
tion of the heavenly Jerusalem.' As the link between mankind and God
the Virgin takes part in Salvation and is therefore in keeping with the
doctrine of the Immaculate Conception. As specified by St Bridget, she
has an afflicted look by reason of her foreknowledge of her Child's
Passion, so that her majestic presence and the melancholy of her expression
show the close connection between the Immaculate Conception and the
Passion. At about the same time, Leonardo was carrying out the altarpiece
for the Confraternity of the Immaculate Conception in Milan, and he
could hardly neglect to plan its iconography accordingly, even though he
was to stress the elements symbolic of the Passion. Thus the figure of the
infant St John the Baptist was to be made the focus of the picture, to the
point of having the spectator's attention directed to it by means of the
angel's gesture; and the vegetation was to be symbolic of the Passion
(aconite, palm tree, iris). In fact, the whole group constitutes a narrative

unfolding from right to left, the direction of such 'mental action' being spelt out by the conspicuous, almost paw-like foot of the angel firmly set on the ground, itself directed to St John. (It might have been intentional that the angel should look like a griffin, as if to symbolize the pagan world giving way to the Christian era.) In the London version, both the pointing hand and the foot are suppressed, so that the emphasis is immediately moved to the central, magnified figure of the Virgin. A straightforward symbol of the Passion is introduced – the cross carried by the infant St John. But the idea of the Immaculate Conception is brought to the forefront, as the Virgin's body is given a towering quality, on the same axis as the monolithic formation on her back which reaches the top of the painting like the high altar in a church. By now Leonardo must have become aware of Mantegna's *Madonna delle Cave*, finding his way into the same source, St Bridget's *Revelations*, from which he could derive the idea of replacing the flowers of the Passion with those symbolic of the Virgin's purity and humility, such as violets, lilies and roses. Such flowers are shown in a famous drawing at Venice, which has always been considered a very early work, and which should be dated well after 1500, at the time of the London version of the *Virgin of the Rocks*. This has the metallic quality of a scientific study, and may have been inked-in by Francesco Melzi. A flower of the identical type and style is on a sheet of the Arundel MS., which contains Leonardo's notes on light and shade of about 1506.

There might be some truth in the assumption that the stress on the symbolism of the Passion in the first version could have been at the root of the controversy with the confraternity, on account of the resulting emphasis on the figure of St John the Baptist, the patron saint of Florence. But it is probably safer to assume that the change in the iconography was more in the way of a clarification according to the idiom of the High Renaissance – a statement in the language of the architect.

A drawing in the Metropolitan Museum, New York, containing four sketches for a Nativity, is always considered as an idea that preceded the conception of the *Virgin of the Rocks*, and even Kenneth Clark dates it 1482–83. A sketch for a Nativity is on a Windsor drawing of about 1485 (and possibly as late as 1490), and the subject may be related to a lost painting which is recorded by the anonymous biographer and by Vasari as a Nativity that Lodovico Sforza commissioned from Leonardo for the

51

emperor. The painting is last recorded by Carducho in 1633 as being in the collection of Charles V. The relationship that the New York drawing can claim with the *Virgin of the Rocks* is in terms of the format of the panel as indicated in two of the sketches, in the similar (but not identical) kneeling position of the Virgin, and in the inclusion of the infant St John in one of the sketches. But the subject is unquestionably a Nativity because of the reference to a hut in the background. Indeed, the motif was well suited to being turned into that of the kneeling *Madonna with the Children at Play*, which Leonardo was to produce (at least as an idea or cartoon) about 1500, as proved by a drawing formerly at Weimar. The date of the New York drawing has never been questioned – on the contrary, it is sometimes anticipated to Leonardo's first Florentine period. But the vigorous penwork is characteristic of drawings as late as 1497, and in fact there is a fragment at Windsor showing a draped figure of the identical type and technique which comes from a folio of the Codex Atlanticus datable about 1497 on which is another drapery study and the sketch of a kneeling Madonna. (A silverpoint sketch at Oxford showing a seated Madonna with a Child on her lap and an infant St John attended by a grown-up angel – a suitable composition for a tondo – is on a sheet which has on the verso diagrams of perspective of about 1490–92.) There is also some evidence that in 1497 Leonardo met the General of the Franciscans at Brescia and that he was considering an altarpiece of a Madonna with a number of Franciscan saints. The evidence of the possible commission is very slight and nothing conclusive can be reached on the basis of hints alone. It is only the style, therefore, that suggests dissociating the New York drawing from the preliminary studies for the 1483 version of the *Virgin of the Rocks*. As a drawing dating from the last years of the

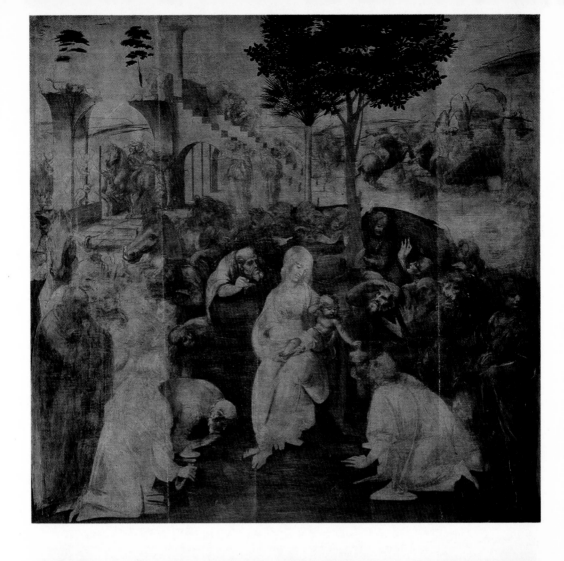

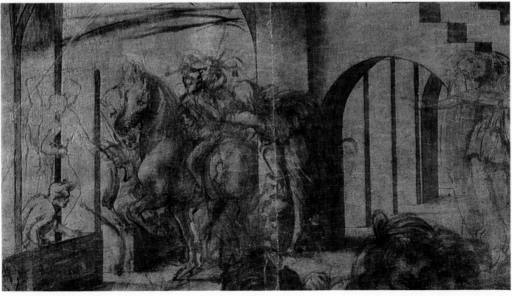

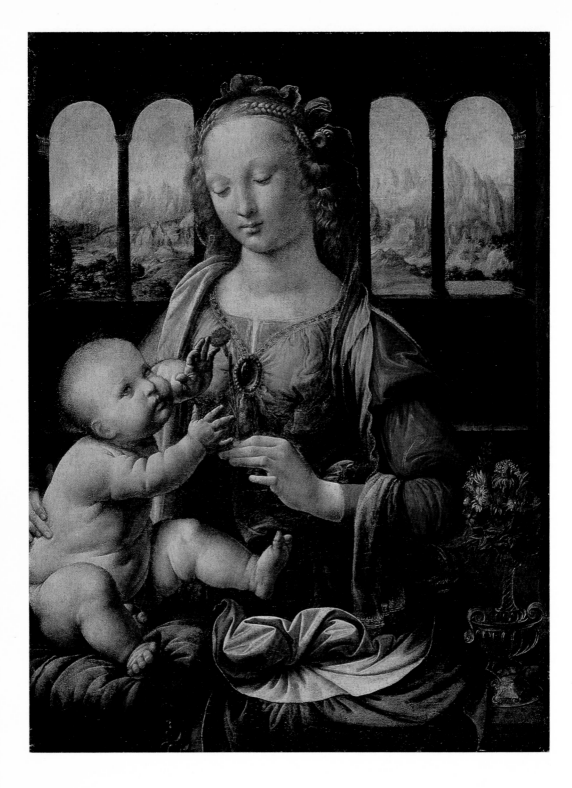

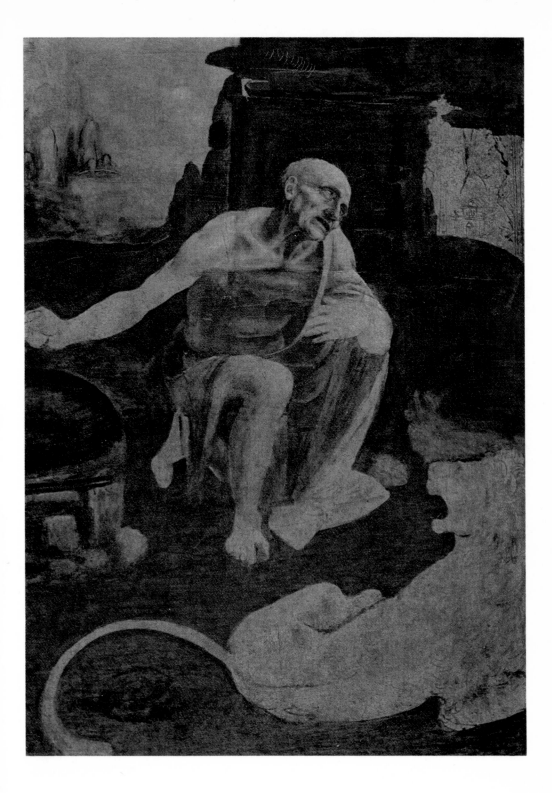

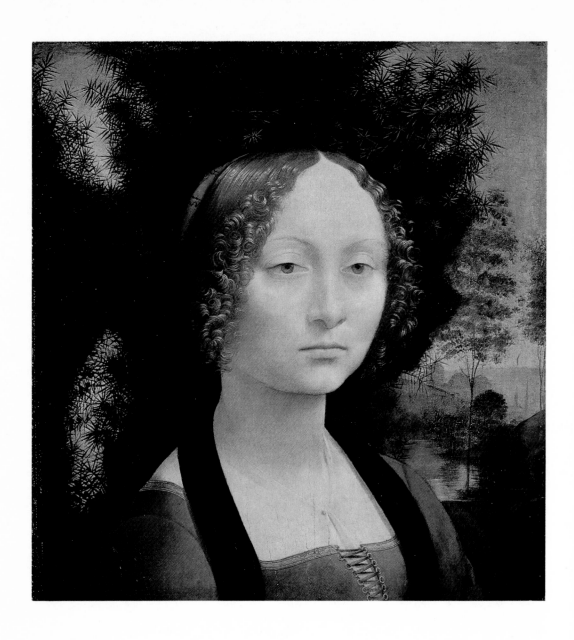

century, it has a density in the definition of the drapery which is comparable to that of the Windsor study for the arm of St Peter in the *Last Supper*. And the lines of shading already show a tendency to curve after the form.

The seventeen years of Leonardo's activity in Milan (1482–1499) correspond to the years of the artist's full maturity. His output during that time was varied and extensive, ranging from architectural planning to engineering work, from the organization of festivals to stage design, and from the ambitious programme of erecting the equestrian monument to the founder of the Sforza dynasty to the undertaking of vast canalization and urban plans. About 1492, at the age of 40, he was beginning to collect observations on painting and on a variety of scientific and literary subjects, with a view to gathering them in the form of treatises. As a court painter he was obviously to benefit from ducal patronage. The official commissions included not only major programmes of decoration, such as work in the refectory of S. Maria delle Grazie, in the Sforza Castle and in the Sforza residence at Vigevano, but also easel paintings with portraits of persons associated with the court. In addition he might have been requested to produce small-size paintings of religious subject for decorative purpose. When Matteo Bandello describes a typical decoration of a Renaissance house he specifies what type of furniture should be chosen and adds the advice of hanging pictures by Leonardo da Vinci.

The *Lady with an Ermine* at Cracow is not only a painting of un- *XIV* believable beauty and elegance, but also a revealing document in the development of Renaissance portraiture. One is tempted to say that Lombard suppleness is gradually replacing the Tuscan *maniera secca*, which Leonardo, however, had never taken literally. (A memory of it is retained in the elongated, bony, yet sensitive hand.) It is as if Leonardo were turning away from the cold beauty of Desiderio's or Rossellino's busts, suitable for a tomb setting, to come under the spell of Francesco Laurana's portraits, which do not idealize the female features but enhance their courtly elegance and air of intellectual stature by an added touch of softness and lustre. One should not forget that Leonardo's residence at the Corte Vecchia in Milan, near the Cathedral, was in the same building as the apartments of Isabella of Aragon.

The gradual change of attitude towards female beauty can be followed through Leonardo's drawings dating from the late 1480s, and in

drawings by such Milanese associates as the brothers De Predis. A first symptom of it after the time of *Ginevra Benci* is in a large drawing in
53 silverpoint at Windsor, which shows the bust of a lady in three-quarters view with the head turned in profile to right – a portrait evocative of a
54 Tuscan type and in fact reminiscent of the profile of the *Lady with the Primroses*, yet with a quality of softness and plasticity that Leonardo must have acquired in Lombardy as soon as he began working on the *Virgin of*
55 *the Rocks*. A silverpoint drawing of identical style at Turin is generally taken as a study for the head and bust of the angel in the 1483 version of the *Virgin of the Rocks*, but it is unquestionably the portrait of a young lady and not necessarily a study for the angel. In Tuscan paintings of the Quattrocento, especially in the frescoes by Filippo Lippi and Domenico Ghirlandaio, one may find the motif of the figure looking over its shoulder, but Leonardo has brought it into the format of an individual portrait which has no precedent and which was to be taken up by Raphael and Andrea del Sarto. The emphasis is now brought to the curve of the shoulder, which is made the introduction to the contrapposto element of the facial features. In so doing, Leonardo is discovering the resources of contrapposto as applied to the representation of a bust. With the *Lady with an Ermine* it is again the shoulder revealed in its fullness of form (the almost horizontal band in the forehead indicates the level of the spectator's eye), which provides a visual introduction to the facial features. One should take into account that originally the background was not uniformly dark but showed an interior space as in the *Benois Madonna*, with a window open just above the shoulder so that the light coming in through it was to explain the area of the shoulder as an irradiating surface. As it is now, the portrait has the artificial sophistication of professional photography, but with an effort of the imagination it may be brought back to its context to reveal the harmonious relationship between the colours of the extraordinary costume and those of an interior space which can only be thought of in terms of the warm and diffuse light of a Vermeer painting.

The *Lady with an Ermine* has been identified with the portrait that Leonardo made of Cecilia Gallerani, the learned mistress of Lodovico Sforza. Here she has adopted the traditional symbol of purity, the ermine, which is shown in a pose even more heraldic than in a medal by Pisanello, and yet as naturalistic as that of the lion of *St Jerome*. Its fur appears sensitive at the aristocratic touch of the lady's hand, and its body, which

is amplified almost to the size of that of a cat, arches out with pleasing gravity to repeat the curve of the lady's shoulder as it follows the affectionate support of her arm. The animal is turned into a literary amenity by way of the Greek word *galé* for ermine, which can be taken as an allusion to the sitter's name – Gallerani. The portrait is one of Leonardo's most exhilarating inventions and I am inclined to date it about 1485. It is the best tribute that the thirty-three-year-old artist could pay to a *mondaine* female beauty.

The Lombard type of female beauty appears in the so-called *Madonna* 56
Litta, a painting which must date from about the same time as the *Lady with an Ermine*. A silverpoint study for the head of the Virgin is in the same style as the study related to the angel in the 1483 *Virgin of the Rocks*. In the painting the features have become stereotyped, providing a school model that was to affect even Leonardo's own drawings as soon as pupils were allowed to go over them to give shape to images that Leonardo had only suggested with the airy line of the silverpoint. The impeccable brushwork in the *Madonna Litta* may not have displeased Leonardo and may have given his pupils the illusion that they could carry out his work.

Some of the same feeling is conveyed by the portrait known as the *Belle Ferronière*, but the facial features show unmistakably the full character 57
of Leonardo's work. They are not sharply outlined as in a glazed terracotta, but emerge out of a play of light and shade, and anticipate those of the *Mona Lisa* even in the intensity of the magnetic eyes. The lower part of the bust, including the hands, is deliberately hidden behind the archaic device of a window-sill, so that the attention is lifted up to the face. It has been suggested that this may be the portrait of Lucrezia Crivelli, another of Lodovico Sforza's mistresses, and that it probably dates as late as 1497. Such a date seems to me well in keeping with its style. And certain Latin epigrams celebrating Leonardo's portrait of Lucrezia are found on a folio of the Codex Atlanticus which contains Leonardo's notes on geometry dating from the last years of his Milanese period.

Leonardo's most gifted pupil in Milan was Giovanni Antonio Boltraffio (1467–1516), to whom the *Belle Ferronière* is sometime attributed. His work becomes best known about 1500 when he painted the *Casio Madonna* in the Louvre, the portrait of Gerolamo Casio in the Brera Gallery and the portrait at Chatsworth which is probably that of a lady (Ginevra Bentivoglio?) with Casio's *memento mori* on the back. Indeed there is much in

58 his paintings to remind us of the controversial portrait of a *Musician* in the Ambrosiana. Yet the curly hair of the *Musician* shows the kind of movement that Leonardo was to compare to that of the water and is reminiscent of the hair of the *Ginevra Benci*, and the bony structure of the face recalls that of the *St Jerome*. The vitreous eyes are Lombard, but those of the angel in Verrocchio's *Baptism* show that Leonardo would have found them of a congenial type. The mouth has the hint of a smile as in one who is about to speak – or perhaps to sing. Only Leonardo with his sense of *finzione* could have thought of catching the fleeting moment that precedes a musical performance, when a *cantore* (Franchino Gaffurio?) is about to start with his score. As the portrait of a Lombard subject the painting combines a Tuscan character of structure with a Northern feeling for light and colour which might have come to Leonardo from Antonello da Messina.

About 1495 Leonardo was to receive the first major commission sponsored by ducal patronage: the decoration of the refectory of S. Maria delle Grazie, the Dominican church which Bramante had begun to reconstruct according to a programme that was to turn it into a kind of *59* Sforza Mausoleum. A slight sketch in a Leonardo note-book of 1497 shows how Bramante's new apse was to be linked to the longitudinal element of the pre-existing nave so as to retain its character of centralized structure. At the same time Leonardo was taken by architectural projects in the area which included a plan of urban systematization. But the French invasion of 1499 was to put an end to the ambitious ducal programme. The rebuilding of S. Maria delle Grazie ended with the new apse which came to be unsatisfactorily attached to the old nave. By 1497 Leonardo's *Last Supper* was finished and he had moved to the decoration of the *Sala dalle Asse* in the Sforza Castle.

60 As Leonardo's most celebrated painting, the *Last Supper* has been the subject of many studies, beginning with Bossi's monumental monograph of 1810. (A convincing analysis of its iconography as a classification of temperament combined with a fourfold interpretation of the mystery of the Eucharist – literal, moral, mystical, and anagogical – is in a brief but perceptive essay by Edgar Wind of 1952.) Bossi owned the Leonardo drawings which he reproduced, but did not know the preliminary studies now at Windsor, which were published for the first time by Richter in 1883. However, after the publication of his book, Bossi came into posses-

sion, in 1812, of a red chalk sketch of the whole composition, the authen- *61*
ticity of which has since been rejected with contempt. I believe it is a much
retouched original. It must have been originally a very light sketch, with
a quick and spidery line, like the red chalk sketches of 1493 at Windsor,
but it has been gone over with a clumsy retouch that has distorted Leon-
ardo's intentions almost beyond recognition. Only the lower portion of the
figure of Judas, on the left, appears genuine, and perhaps the outline of
the hands of the figure on the left of Christ. The names of the apostles are
given in Leonardo's handwriting, which is unquestionably authentic and
which shows the style of his notes of 1493–95. Unpublished notes by
Bossi show that he intended to write about the architecture of Leonardo
in general and that of the *Last Supper* in particular, but a limited number of *62*
sources was available to him, so that the project was abandoned, and no
one has yet taken it up again. A pen and ink drawing at Windsor, of
almost Rembrandtesque energy, dating from about 1495, includes a hint
at an architectural background which appears somewhat incompatible
with the actual architecture of the wall, that is, with the large lunette
flanked by two smaller ones, a part seldom reproduced together with the
Last Supper. In the sketch, the architecture is made up of a horizontal
sequence of lunettes, which are even in size and which would have had
no relation to the three lunettes of the wall, as if the sketch had been
intended for one of the longer sides of the room or for a bas-relief. As the
actual lunettes were decorated with the coat of arms and vegetable motifs,
there is no reason to doubt that it was Leonardo's intention to include them
in his composition; in fact they can be taken as screens placed against the
upper part of the architectural background of the *Last Supper*, which
could have been seen through the vegetation according to an illusionistic
device that Leonardo was to apply in the *Sala dalle Asse* shortly afterwards
and that Mantegna had already applied in the *Camera degli Sposi* at Mantua.
The orthogonals of the painted ceiling, which are truncated by the
horizontal band at the base of the lunettes, can be brought to the fore-
ground behind the lunettes, thus suggesting a room which has almost the
proportions of the nave of a church. (Leonardo's intentions become clear
once we turn a reproduction of the *Last Supper* upside down.) Such an
architectural background acquires greater significance from the newly
discovered evidence of Leonardo's involvement at the time with Bram-
ante's project of rebuilding the church of S. Maria delle Grazie. Hitherto

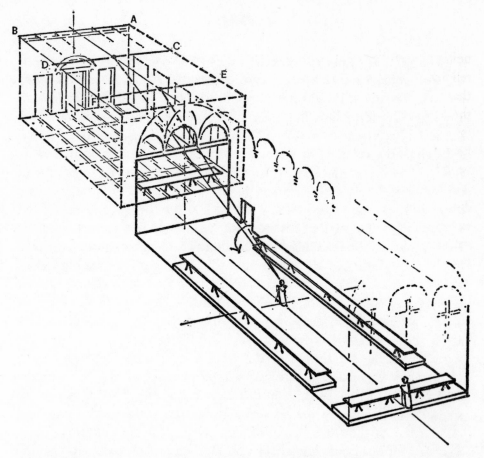

neglected for its archaic, Brunelleschian linearity, the background of the *Last Supper* has the same importance as the figures at the table, themselves having an architectonic quality in their grouping. As such, they participate in the general organization of the picture: a tripartite scansion which is projected from the lunettes in the foreground to the three apertures in the background. Only the central aperture is surmounted by a round pediment (the only curved element in the whole background), a device to single out the figure of Christ as an icon, at the same time relating Him to the groups on both sides, as in a drama performed on a stage.

The perspective of the *Last Supper* has puzzled generations of scholars. There is no place in the refectory that a spectator can take in order to experience the painted space as a continuation of the actual space of the refectory. There is no optical trick as in Bramante's apse of S. Satiro. The mural is placed well above the spectator's head, and even if the floor of the painted room were level with the spectator's eye, that floor could

never be seen according to the worm's-eye perspective adopted by Dona-
tello and Mantegna at Padua. In his *Treatise on Painting* Leonardo states
that the vanishing point in a mural ought to be placed 'opposite the eye of
the observer of the composition'; but whoever looks at the *Last Supper* is
far below the axis perpendicular to the vanishing point (in the Christ's
head), no matter how far back one can step. This 'false perspective' may
be the same as the 'accelerated perspective' of a stage set as in Palladio's
Teatro Olimpico, which presages the scenic effects of the Baroque, from
Borromini's ciboria to Bernini's Scala Regia, and which has a precedent
in antiquity as shown in one of Montano's Tempietti. It is a perspective
suitable for conveying the speed with which the eye plunges to the
bottom of a deep space, as if aiming at the exit of a tunnel – enhancing,

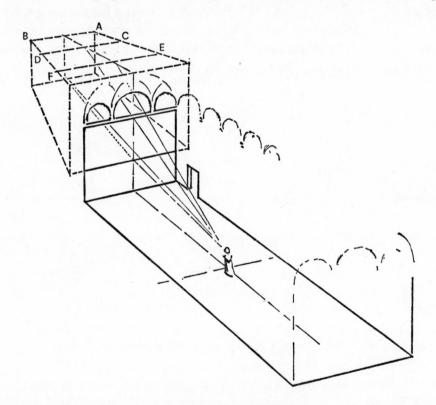

The architecture of the *Last Supper* according to: (left) worm's-eye-view, showing
only the ceiling; (above) 'accelerated perspective' showing both the ceiling and the
floor. ABCD: portion of ceiling shown in the painting. CDEF: portion of ceiling that
could be seen through the lunettes

at the same time, the physical and spiritual stature of the foreground figures. As in precedents by Masaccio, Uccello, Donatello and others, this perspective does not require a fixed point for the observer. Each of the monks sitting at any place of the long tables in the refectory could view the *Last Supper* with the illusion of standing in front of it in the centre of the room. Much later in life, in France, Leonardo was to write an observation which may be taken to explain the 'false perspective' of the *Last Supper*: 'That countenance which in a picture is looking full in the face of the master who makes it will always be looking at all the spectators. And the figure painted when seen below from above will always appear as though seen below from above, although the eye of the beholder may be lower than the picture itself.' A spirited diagram reminiscent of the side view of a seated apostle is found on a sheet of studies for the mechanism of a fountain at Amboise and is inscribed with a sentence of an almost epigraphic brevity, which expresses the same thought: 'The figure is made according to a fixed eye and is seen from any place.'

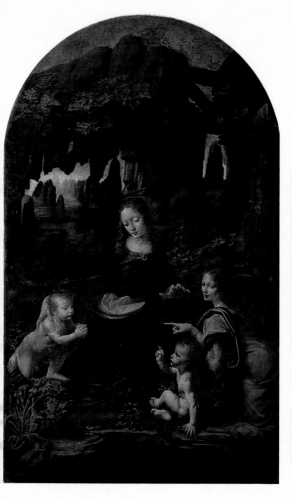 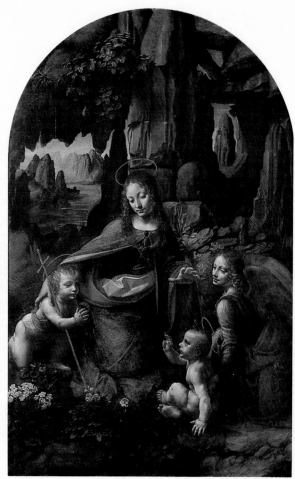

'Item, to urge Leonardo the Florentine to finish the work that he has begun at the refectory of the Grazie, so that he may start with the other wall in the same refectory; and have him sign a contract obliging him to finish the work within the stipulated time.' This is on a sheet of instructions that Lodovico Sforza gave to his secretary on 29 June 1497. As soon as Leonardo had completed the *Last Supper* he was to take over the opposite wall. But since that wall was already decorated with a scene of the *Crucifixion* painted by Donato Montorfano in 1495, it has been surmised that Leonardo was requested to add the figures of the kneeling donors (Lodovico Sforza with his first son, Maximilian, on the left, and his wife Beatrice with her son Francesco on the right), and in fact both Vasari and Lomazzo speak of them as Leonardo's work, which was already deteriorating at that time because it had been painted in oil over the fresco surface. In spite of the historical evidence, those figures could hardly have had anything to do with Leonardo. Their sinopias exposed during the 1943 bombing have revealed a type of drawing which is certainly not by Leonardo. The 1497 document, however, may be taken to show that the iconographic programme of the *Last Supper* was to be complemented by the decoration of the facing wall – again a major undertaking as implied by the expressed need to have Leonardo sign a contract. Unfortunately there is no other evidence of the Duke's intentions to have Montorfano's fresco replaced by another Leonardo mural. It might be that whatever was meant to take its place was to include the figures of the patrons, and that those figures came to be added to Montorfano's fresco as a compromise, only after the original project was abandoned. Perhaps the subject of the *Crucifixion* (alone, or with other scenes of the Passion, as in the background of Rosselli's *Last Supper* in the Sistine Chapel or above Castagno's in S. Apollonia) was the obvious counterpart to that of the *Last Supper*. As shown by the precedent of Masolino and Masaccio in S. Clemente at Rome, the subject would have afforded Leonardo the opportunity to deal with two important elements which he had not yet displayed on a monumental scale: horsemen in action and landscape. But since a suitable *Crucifixion* was already there (each cross brought up to occupy one of the three lunettes, and an almost Bramantesque representation of the walled city of Jerusalem placed in the centre), Leonardo might have simply suggested having some assistant add the figures of the patrons. Montorfano's fresco was thus given the place of greater importance in the room

and in fact one of the refectory tables was placed underneath it, so that the prior of the convent would face the *Last Supper* while his back was turned to the *Crucifixion*. The original arrangement of the tables was still visible at the end of the eighteenth century as recorded by Goethe:

'We have, in our travels, seen this refectory, several years ago, yet undestroyed. Opposite to the entrance, at the bottom, on the narrow side of the room, stood the Prior's table; on both sides of it, along the walls, the tables of the monks, raised, like the Prior's, a step above the ground: and now, when the stranger, that might enter the room, turned himself about, he saw, on the fourth wall, over the door, not very high, a fourth table, painted, at which Christ and his Disciples were seated, as if they formed part of the company. It must, at the hour of the meal, have been an interesting sight, to view the tables of the Prior and Christ, thus facing each other, as two counterparts, and the monks at their board, enclosed between them. For this reason, it was consonant with the judgement of the painter to take the tables of the monks as models; and there is no doubt, that the table-cloth, with its pleated folds, its stripes and figures, and even the knots, at the corners, was borrowed from the laundry of the convent. Dishes, plates, cups, and other utensils, were, probably, likewise copied from those, which the monks made use of. There was, consequently, no idea of imitating some ancient and uncertain costume. It would have been unsuitable, in the extreme, in this place, to lay the holy company on couches: on the contrary, it was to be assimilated to those present. Christ was to celebrate his last supper, among the Dominicans, at Milan.'

Stendhal was delighted at Leonardo's historical inaccuracy, and mentioned Poussin's Apostles reclining on couches as a scene almost incomprehensible and deprived of emotional intensity.

'As for trees, a beautiful motif has been invented by Leonardo, that of making their branches interlace in bizarre groups; this weaving together of branches was also used by Bramante.' Thus wrote Giovan Paolo Lomazzo in 1584, referring to Leonardo's decoration of the so-called *Sala dalle Asse*, a large room in the north tower of the Sforza Castle. The 1498 commission is well documented (the designation 'dalle Asse' originates from the documents in which the room is mentioned as being occupied by the boards of the scaffoldings), but the decoration was discovered only at the end of the last century and 'restored' according to the taste of the time. The overwhelming result was effective in showing how painting could provide an architectural model: the trees replacing

the columns and their branches constituting the ribs of a Gothic vaulted room. But a recent restoration, which has brought back some of the original delicacy of the decoration, has revealed a fragment which shows *64* that Leonardo intended to represent the lower part of the tree trunks as emerging from a base of rocky ground seen in section, with the roots working their way through its stratifications. It was to be a *finzione* of the powers and intricacy of the generative processes of nature rationalized into a scheme of geometrical order. One is tempted to attach some political connotation to it, as the ducal arms are prominently placed at the top of the pergola in the central of the several openings which reveal the sky behind. But its iconography is lost to us and it has become customary to consider it as a virtuosity in room decoration carried out by Leonardo's assistants, even though the design is unmistakably his. Two beautiful drawings in the Codex Atlanticus are studies of interlaces which might have been intended for the floor of the *Sala dalle Asse*: one of them, which represents a detail of the motif and which is pricked for transfer, is an actual-size design for a tile. *65*

The interlacing motifs began to fascinate Leonardo early in Florence with Verrocchio's work on the Tomb of Giovanni and Piero de' Medici in San Lorenzo and with Verrocchio's drawings of female heads showing an elaborate system of braided hair and ribbons. In north Italy he must have found another source of inspiration in Mantegna and above all in Bramante, whose *gruppi* (knots) he mentions in a memorandum. But the characteristic knots, which he elaborated into the emblem of his ideal academy, appear in Leonardo's manuscripts and drawings throughout his life, from the earliest sheets of about 1480 to the latest of 1517–18. Some have the appearance of delightful doodles, others are clearly studies for details of female dresses in pictures (those of the *Lady with an Ermine* are magnificent). A female figure in the nude, the *Leda*, was to display them so conspicuously in her braided hair that the preliminary drawings even show *103* how they turn to the back of the head. They are made a device to stress the plasticity and dynamics of the human figure, and it is no surprise that they should be shown even in the *Battle of Anghiari*. Eventually they were *XVII* to become associated with the idea of circumvolution in the movement of water and smoke. When they reappear in the garments of the later masqueraders they no longer have the metallic sharpness of embroidery but *78* the softness and delicacy of the vegetation in the *Sala dalle Asse*.

Chapter Three

HERCULES

'The Labours of Hercules for Pier Francesco Ginori. The Medici garden.'
This is a memorandum in one of Leonardo's sheets of geometrical studies
of about 1508. The reference to the Medici garden in which Leonardo had
studied in his youth may suggest that the work for Ginori was to be a piece
of sculpture or even a series of representations of the Labours of Hercules
to be placed in the nearby house of the Ginori family, like the Bertoldo
reliefs in the courtyard of the Palazzo Scala. Nothing else is known of the
possible commission. On the other hand, in the original Italian the mem-
orandum may be taken as a reference to a work that Pier Francesco
Ginori owned: 'fatiche dercole a [= ha] Pier francesco ginori . . .' The
two items in the memorandum would therefore indicate two locations in
which Leonardo was to look for something that was occupying him at the
time. And so the 'Labours of Hercules' owned by Ginori could have been
a manuscript copy of the celebrated *De laboribus Herculis* by the Florentine
chancellor Coluccio Salutati, a moral treatise written about 1390, which
stirred the civic pride of the Florentines as they were reviving the spirit of
antiquity in their form of government. For over a century the seal of the
state of Florence had displayed the figure of Hercules as a symbol of
Fortitudo. And as early as 1260 Niccolo Pisano had placed Hercules on the
pulpit of the Pisa Baptistery – a mythological figure in a Christian context.
In the perpetuation of the communal sense of freedom, Hercules had come
to be associated with the artistic programmes of the greatest religious
institutions, so that when work was resumed at Florence Cathedral in
Salutati's time the figure of Hercules was to be introduced in the decora-
tion of the Porta della Mandorla about 1393 – again a standing figure
reminiscent of Pisano's. Shortly afterwards the Cathedral authorities
decided to carry out the programme of decorating the buttresses of the
tribune with colossal statues which were to represent Prophets, except

78

for one which was to be a figure of Hercules. A model for this was actually prepared by Donatello and Brunelleschi in 1415. But the project was not carried out and the model was last recorded in 1449, when the city had considered acquiring it, probably as a complement to Donatello's *David* of 1408–09. The Prophet-programme was revived in 1463 with the commission of a huge terracotta statue from Agostino di Duccio. The statue, now lost, was completed in several parts within a year and was recorded as 'a giant or truly a Hercules.' Then the same sculptor was commissioned a similar figure to be made of marble, but the project fell through in 1466 when Donatello, who might have inspired it, died. And the abandoned block of marble was eventually given to the twenty-five-year-old Michelangelo, who was to make his famous *David* out of it in 1501. Vasari's account of the origin of the work is somewhat inaccurate and in conflict with the documents. Indeed, Michelangelo must have been well aware of what the allegedly useless block of marble stood for. His *David* for the Palazzo Vecchio resulted in an eloquent parallel to the allegorical figure of Hercules which he had produced earlier for the court-yard of the Strozzi Palace and which remained there until 1527 when it was moved to France. (In the early 1530s Bandinelli's *Hercules and Cacus* was set up as a companion to Michelangelo's *David*.) According to Vasari, it was that block of marble that Soderini, the head of the Florentine re-public, 'had frequently proposed to give to Leonardo da Vinci'. But Soderini became *gonfaloniere* in 1502 when the *David* was already born. And yet something must have associated it with Leonardo soon after his return from Milan in 1500 – probably with a change in Leonardo's concept of the human figure as he was moving from the graceful type of sophisticated beauty to the heroic type of Herculean proportions expres-sive of the pride taken in a communal tradition of civic virtues.

Leonardo had left Florence in 1482, moving to Milan with a store of knowledge and craftsmanship that was a somewhat empirical synthesis of the artistic, technological, and scientific achievements of the Quattrocento. From the Pollaiuolos he had learnt the nervous, spidery quality of line that disposed of the slow, Gothic definition in favour of a more romantic, heroic concept of the human body in action. When he used the neat, continuous line again, it was only to explain a scientific theory. His famous drawing of the Vitruvian canon of proportions shows a human figure *66* devoid of volume as a superimposition of transparent surfaces, most

suitable for illustrating the principles of proportion in one of Alberti's façades. The tradition that accompanied Leonardo to Milan was not only a sculptural one but also an architectural one, and Leonardo's earliest

67 studies of the skull measured for proportion resemble cross-sections of architectural models. It was precisely at that time that he was submitting his models for the *tiburio* of Milan Cathedral, and his Paris MS. B, which is almost entirely on architectural studies of sacred buildings, begins with notes on human proportions which can be related to a whole series of studies at Windsor dating about 1490. Notes on proportion appear again in manuscripts of a later period. But this is one discipline that occupied him intensely at one period of his life and could not be resumed in a systematic re-elaboration after 1500 because it was a Quattrocento subject fully investigated according to Quattrocento principles. (One is reminded of Alberti's *De Statua.*) A decade later, his canon of proportions would have looked almost archaic: a new ideal of the human figure was born in Florence, exemplified by the gigantic proportions of Michelangelo's *David* and by the Herculean figures of Leonardo's *Battle of Anghiari.* It can

68 be seen in the heroic stance of the heavily built warrior in a drawing at Turin, which is vigorously modelled as an *écorché*, and which was in fact

XV to become the model of his anatomical studies. Another drawing in the same collection shows that this may have originated from an idea for a

69 Hercules and the Nemean Lion, a representation of one of Hercules' Labours suitable for translation into a statue as a fitting counterpart to Michelangelo's *David.* In the studies for *Anghiari*, there is often a juxtaposition of the head of a lion and the profile of a warrior, in one instance as a

70 physiognomical study which anticipates the theories of Giovan Battista Della Porta. The features that Leonardo intended for his Hercules are

71 shown in another drawing at Turin in which the crowned head is turned in full profile to the right, as in a coin, and the mane of a lion is hinted at by the hero's chest. The lion's head appears again beside the chest of an

72 old *condottiere* seen full face in a drawing at Windsor of about 1508, probably an ideal portrait of Marshal Trivulzio. There is plenty of evidence, therefore, that at the beginning of the Cinquecento Leonardo had set himself to portray the human figure with all its characteristics of full manhood. In one of his physiological notes he writes with scientific detachment that 'testicles are the cause of boldness'. Testicles are shown in the coat-of-arms of the *condottiere* Colleoni. In his figures of men and horses

from the time of *Anghiari* and the equestrian monument for Trivulzio, Leonardo displays them with a disarming directness which has escaped psychoanalysts.

The type of Leonardo's warrior is shown as a figure ready for action, his limbs tense as the body is exerting its weight on both legs, which are kept straight and emphatically apart. It is no longer the graceful contrapposto shown in the early drawings of youths, which are reminiscent of 73 Donatello's bronze *David* and which are still favoured by Raphael. Legs become the focus of Leonardo's studies. They appear time and again in his drawings, with the insistence of an *idée fixe*. They are shown from sur- 74, 75 face modelling to bone structure, from proportional relationships of their parts to the mechanics of their movement. In a drawing of about 1508, 76 showing three views of a leg in which muscles are reduced to wires to indicate their lines of force, Leonardo has an observation on the proportion of the foot, according to which a foot would correspond to one-seventh of the total height of a man. This measure would be intermediary between the Vitruvian six-foot proportion and the proportions requiring eight feet, as occasionally accepted by Leonardo. It appears that after 1500 Leonardo had come to prefer a rather small foot, as shown by the figures dating from the time of *Anghiari* and later, including such late masquer- 77, 78 aders as the youth standing in a Herculean position. An *Anghiari* study showing a warrior standing in profile to right exemplifies the change in 80 the proportions of the human figure: the man no longer has the Quattrocento stillness suggested by the long, bony feet. Alertness and quickness of movement are the new qualities implied by the small feet, which are like those of a light-footed boxer. The same model seems to be turned to a front and back view in other drawings at Windsor, again showing 81, XVI a curious reduction in the size of the foot. And in a later sketch of the same 79 subject the feet are almost obliterated!

Leonardo's notes on the human movement, first collected about 1497–98 in a lost book on painting mentioned by Pacioli, were most suitable to being taken up again and developed according to the new ideal of the human figure. Many notes on the subject date from the time of *Anghiari* and found their way into the *Treatise on Painting*. The somewhat elusively Classical connotations of Leonardo's figures can also be accounted for, as there is no doubt now that he visited Rome at the beginning of 1500. But it was above all the composition of the *Battle of Anghiari*, about

1505, that afforded him the opportunity of a total reconsideration of the human figure, from structure to surface modelling, and from ideal proportions to expression. As the emphasis was on the rendering of movement, the mood set by the battle-piece was bound to remain with Leonardo's artistic conceptions until the end of his career.

The mural for the Council Hall was commissioned from Leonardo with a contract of 4 May 1504, signed by Machiavelli as secretary of the Republic; but Leonardo had already begun working on the cartoon in the Sala del Papa in S. Maria Novella, which had been assigned to him on 24 October of the preceding year. On 6 July 1505, he began painting in the Palace with the help of a few assistants. The official accounts of the expenses for the project make it possible to follow the progress of Leonardo's work and give an idea of the type of painting he was planning, but do not offer any hint at the general programme of the decoration; nor is there a way of telling which was the wall, or portion of wall, assigned to Leonardo. The architecture of the room was considerably different from what we see today. As the upper story of an edifice which had been built between 1495 and 1498 in the back of the Palazzo Vecchio, it had a much lower roof, and the ceiling was of the traditional coffer type. The only access to the new room was through a passage from the Sala dei Dugento. (Only later, about 1510, independent stairs were built with an entrance approximately in correspondence with the present door of the studiolo of Francesco I.) In plan, the room had a somewhat irregular trapezoidal shape on account of the pre-existing urban situation, which included the fourteenth-century Palace of the Captain, a building that was to be partly demolished and later turned into the so-called Medici apartments. The room was planned and built by order of Savonarola with the advice of a number of architects, including the Sangallos, Cronaca, Baccio d'Agnolo, and the young Michelangelo. According to Vasari, even Leonardo was called in for advice, but in 1495 Leonardo was in Milan and there is no evidence that he went to Florence on that occasion. The final phase in the programme of building a suitable seat for the council of the Florentine Republic came by deliberation of Soderini after 1500, when the wooden furnishing designed by Filippino Lippi was to be carved by Baccio d'Agnolo. This included the benches all around the walls like stalls in the choir of a church, and benches in the middle of the room for the citizens. At the centre of the east wall, which was the longest in the

room, was the loggia for the *gonfaloniere*, somewhat like a tempietto, to be surmounted by Andrea Sansovino's statue of the Saviour, and facing it at the centre of the opposite wall, was an altar and a monumental frame for an altarpiece that Fra Bartolomeo was to begin about 1510. The unfinished painting, which is now in the Museum of S. Marco, represents the Virgin and Child with St Anne and the infant St John the Baptist (the patron saint of Florence), surrounded by those of the Florentine saints on whose days the city had its victories. There is no doubt that the iconographic programme of the decoration, as inferred from Vasari's description of the room, was to be an exaltation of the civic virtues from which the Florentine Republic was to derive its moral strength. A revealing item in the accounts related to the building construction is the payment to the mathematician Luca Pacioli, Leonardo's friend, for the models of geometrical bodies – the same that Leonardo had designed for Pacioli's *84* *Divina Proportione* of 1498. The official commission can only be interpreted as a reference to the symbolism of geometry in state government as postulated in Plato's *Republic*. Such an elaborate programme in the building of the Council Hall provides the iconographic framework for Leonardo's battlepiece, which was to represent an episode of the battle fought by the Florentines against the Milanese in 1440. Another portion of the decoration was to be assigned to Michelangelo a year later to provide a companion-piece representing the *Battle of Cascina* of 1364, but Michelangelo's work was not carried beyond the cartoon.

Leonardo was certainly acquainted with the precedent of Paolo Uccello's *Battle of S. Romano* for the Medici Palace. He adopted a similar principle of tripartite composition, focusing on the central element of the confrontation of horsemen which became famous as the group of the fight for the standard. As the earliest record of it is in a drawing by Raphael *83* of about 1505, it is probably this part that Leonardo had begun to paint on the wall. And it was certainly the subject of a trial panel that he painted in his studio in S. Maria Novella in order to test a new colour technique of oil on plaster. It is the group known from sixteenth-century copies and above all from a celebrated drawing by Rubens, which must have been *85* made from the trial panel or from an engraving of it (what Leonardo had painted on the wall was no longer visible), for it contains several mistakes which can be explained by the unfinished condition of the model or by misinterpretations in second-hand copies of it. Thus the horse on the left

is headless (only in Rubens' copy at The Hague does it show the ghost of a head), the spear of the horseman on the right has become the upper part of the broken staff of the standard, and so forth. In fact, the known copies of the group can be arranged in a chronological sequence on the basis of differences which show the derivation of one copy from another, just as the copies of the *Treatise on Painting* can be sorted on the basis of differences in their texts and illustrations. The archetype of the group of the *XVII* fight for the standard can now be recognized in the painting formerly in the collection of Prince Doria d'Angri at Naples, which was recorded in a guidebook of Genoa in 1766 as 'the battle-piece on panel, unfinished, believed to be by Leonardo'.

86 A copy at the Uffizi used to be considered as the exact reproduction of what Leonardo had painted in the Council Hall, but the theory is no longer acceptable. The argument that the lower part of the Uffizi panel could not include more details of the figures below because the copyist did not intend to complete the fragmentary mural is contradicted by the Doria picture, which has plenty of space for the missing parts of the figures and horse's legs. According to contemporary reports, the failure of Leonardo's colour technique was to affect especially the upper part of the mural, a condition that was recognized in the Uffizi copy. But the corresponding part in the Doria picture is the best worked out, including the splendid knot decoration on the scabbard of the sword of the horseman on the left. One may reasonably conclude that the Doria picture is what is left of the trial panel that Leonardo had produced to test his technique of oil painting on a wall. Because of the experimental nature of the panel, Leonardo did not need to complete the whole composition.

87 A well-known engraving by Lorenzo Zacchia of 1558, which is inscribed EX TABELLA PROPRIA / LEONARDI VINCII OPVS . . ., has been taken as an accurate record of the trial panel, but it can be shown to be an unsuccessful attempt at reconstructing a fragmentary model. The flag's staff on the right is still missing, as in the Doria picture. One of the two fighters on the ground, who is thrown on his back, has a shield attached to his right arm, which makes him a left-handed fighter. Raphael's sketch at Oxford, which is probably from the cartoon because of the reference to a horse of the group on the right, shows that Leonardo did not at first intend this warrior to have a shield. (And Rubens renders him with three arms, as if he were drawing from two different sources.) Only later, in a

study at Venice, did Leonardo reconsider the motif, showing an altogether *88*
different way of interlocking the two bodies so as to stress the diagonal
arrangement of the fighting horses above, and with a shield correctly
attached to the left arm of the fighter on the ground. With this in mind,
it is safe to take the other differences in the engraving as alterations by
the engraver, notably the warrior behind the horseman on the right,
whose helmet is without the elaborate dragon shown in the Doria
picture, and whose right arm brandishing a hatchet is raised above the
head. This particular, which Rubens took from Zacchia, replacing the
hatchet with a sword, is not shown in Raphael's sketch after the cartoon,
but Vasari speaks of the warriors on the right as both brandishing swords,
and a red chalk sketch on the verso of one of the Budapest drawings of
warriors' heads shows that Leonardo may have considered one such motif.
Zacchia may have incorporated a motif that Leonardo had considered as
an alternative in some preliminary drawing. Vasari describes the cartoon,
and yet mentions a detail in colour (the red cap of the older warrior), so
that he may well be describing the battle for the standard as painted on the
wall. As he refers to the group as a 'knot' (*groppo*) and to the action as a
'flight' (*fuga*), he shows a keen understanding of Leonardo's principles of
design. He also stresses the physiognomic element in the comparison
between the ferocity of horses and men, which was indeed in Leonardo's
intentions, as shown in a preliminary study at Windsor. Finally, his *70*
reference to the decorative elements in the costumes of the soldiers can
now be fully appreciated in the Doria picture. Vasari was writing at a *89, 90*
time when three major works pertaining to the *Battle of Anghiari* were
still in existence, the trial panel, the cartoon (at least the portion with the
central group), and the fragment of mural. It is possible, therefore that
some overlapping of recollection affected his description. Thus he mentions
four horsemen in addition to the one on the left, and even though the
fourth is not accounted for, Raphael's sketch after the cartoon shows the
heads of four warriors. Vasari does not mention the crouching warrior
on the left who protects himself with a shield, a detail recorded by
Raphael and seen in the Zacchia engraving and in the Doria picture.

There is evidence that the complexity of the central group was tested
and achieved by means of wax models. 'Have a small one, one finger long,
made of wax', writes Leonardo next to the sketch of a galloping horse. *91*
The flag's staff placed diagonally across the figures not only serves the

purpose of keeping them bound together but also indicates their rela-
tionship in space. A somewhat parallel line receding in space is suggested
by the position of the prominent buttocks of the two horses which appear
at first to be both running to the left, like a motif in an antique frieze.
But the horse closer to the foreground is only apparently running away to
the left. Its head, which is not shown in Rubens' copy and which in the
Zacchia engraving appears as the formless haunchback of the horseman, is
directed to the centre of the picture, as if the horse were about to circle
around the group to add a new direction of forces. The elements of the
composition can be analysed as those of an architectural structure and
visually taken apart, as in a wax model. Leonardo began with the motif
of the headlong confrontation of two horses, as in the background of the
Adoration of the Magi (this can be traced through the preliminary drawings),
but has made them ferociously biting each other, their legs tightly inter-
locked in wrestling. Then only part of the horse on the left is shown, as
the horse in the foreground has moved in by its side, running apparently
away from it but in actuality turning to its back. Thus the group, including
another horse, of which only part of the head is sticking out in the centre,
conveys the effect of spiralling forces in space, like a wind storm advanc-
ing diagonally to the left in a vortex of forms. The horses' tails repeat
the spiral motif, as in a diagram of the idea, a motif which did not escape
Raphael, who records it as the central element of the group and reproduces
it in its abstract essence just below the sketch. The general effect of *fuga*
to the left, as understood by Vasari, was to be kept in check and even
counteracted by the sense of centrifugal movement produced by the body
and costume of the horseman on the left, who exposes his highly decorated
breast to a full frontal view and reveals above his shoulder the neck of his
horse seen from full back. This extraordinary invention, which is on the
brink of caricature, must be the part of the painting which Leonardo
looked on as his greatest achievement and which is in fact the best worked
out in the Doria picture. (Is is also the subject of a highly finished drawing
by a pupil in the Louvre.) The warrior has grasped the flag's pole with
both hands and has managed to place it on his back so as to use his whole
body against it as against a lever, which is in fact pivoting at the point
grasped by the warrior in the centre. The arms placed in a swastika
position make the grasp as tight as in a vice. As the bust comes to be twisted
back in line with the direction of the lower part of the body, the tremen-

dous force exerted on the flag's pole is liable to throw the enemy horsemen out of their mount. The warrior has a sinister grimacing in his devious purpose – and in fact he is not fighting with weapons but with the power of his own body, which he has made one with that of his horse. This concept is stressed by the display of his magnificent sword still inside a scabbard richly decorated with the familiar knots. The coiling forms of the hat, the epaulettes (which are made of huge shells of the nautilus type) and the ram's head on the breastplate all contribute to the sense of vortex which is the principle of dynamics inherent in the whole composition. It is a concept best illustrated by the studies of water, flight of birds, and mechanics of the human body that Leonardo was carrying out at the same time. The arm lifted in the centre in the attitude of brandishing a sword is fully exposed in the Doria picture, as if part of the armour had been dropped in the fight to reveal its musculature and articulation with the solemn emphasis of a statement. Only the drawings of arms and hands in the anatomical manuscripts at Windsor can be compared to it.

Before undertaking the project Leonardo was given a detailed historical account of the battle to inform him of the motifs suitable for representation in painting. This is still preserved in the Codex Atlanticus and has additional notes on mechanics and flight by Leonardo dating from 1503–04. At one time it was believed to be an autograph by Machiavelli; then it was recognized to be by the same hand as Leonardo's letter to Cardinal d'Este at Modena of 1507. Much has been written about these documents, but I have now the indisputable evidence that they were written by Machiavelli's assistant, Agostino Vespucci. Leonardo must have used other sources to gather information on the event (including earlier representations of the battle on *cassone* panels), and Dr Peter Meller has shown me that the historical account in the Codex Atlanticus is an abridged translation of the story as told in Latin by Leonardo Dati. It was essential for Leonardo to reconstruct the topography of the battlefield in relation to the decisive moment which was to lead to the victory of the Florentines. He could then visualize the narrative unfolding in three parts: the Florentine army on the right ready to move towards the cavalry confrontation in the centre as the enemy was coming from the left. As Leonardo chose to represent the concluding phase of the battle, he had to take into account the direction of the light as determined by the approaching sunset. This was an important element in the narrative, for it explains

the strategic moment when the Florentines took advantage of having the light behind them in order to overcome the enemy. In the central group, then, the figures moving in from the right are the Florentines and those on the left, including the one who is using the flag's staff as a lever, are the Milanese. As clearly shown in the Doria picture, the light comes from the right, enhancing the horses' buttocks and the flaming faces of the Milanese horsemen (Niccolo Piccinino and his son), while the faces of the Florentines are kept in shadow and are defined only by reflected light.

92 One of the preliminary drawings for the *Battle of Anghiari* shows that the group of the fight for the standard was to be flanked on the right by a semicircle of cavalry, with horses prancing towards the right as if about to move out into the battlefield. A horse in the foreground is shown from the back as galloping straight into the picture space, with the horse-man jumping from it onto another horse – obviously the figure of a *condottiere* changing horse in order to run into the battlefield on his courser. The group is abruptly interrupted by light vertical lines on the right to indicate the end of the mural, so that only half of one of the horses is shown. On the left, the cavalry is getting ready for the attack, and one of the horses is shown already separated from the group. This may be approaching a bridge which was to join the two groups and which is in

93 fact shown in a drawing at Venice containing a first idea for the central group. The stream in between was to be large and deep enough for infan-try to jump from one side to the other by means of long staffs. This

91 action is carefully studied in a diagram which illustrates its principle of mechanics and which becomes a device to show the different phases of it, to imply, therefore, a continuous movement as in a cinematographic

94 sequence of images. Other figures are shown wading across the river as in a commando attack, some with a feline quality as they scramble out of the water – a motif that may have inspired Michelangelo's central theme of the bathers in his *Battle of Cascina*. The group on the left, which is recorded in a quick sketch by Michelangelo as well as in Leonardo's preliminary drawings, included galloping horses and infantry, their action directed to the right towards the central group. It was there that the Herculean figure of a warrior in heroic stance was to be shown in the foreground, his back turned to the spectator as in the Turin drawing – a model which was to be made popular by Raphael and Andrea del Sarto, and which is hinted at in Bertoldo's battle-piece of 1480. First ideas for the left and

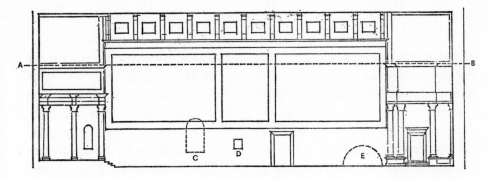

The east wall of the *Salone dei Cinquecento* (presumed location of Leonardo's and Michelangelo's murals). A-B: level of the original ceiling. C: window (same type as those on the south wall). D: small window (loop-hole type). E: arch filled with bricks and stones. (Author's drawing.)

central groups together exist in a sheet at Venice, showing that the action was to take place on a light promontory which was meant to give prominence to the group in the middle. From the beginning, the whole scene was visualized from a high point of view, almost a bird's-eye view which might well have excluded the sky, unfolding the action against a landscape of topographical character as in Paolo Uccello's battle-pieces, and with a light which would have stressed the plasticity of the figures in the foreground affecting the definition of forms in the distance as they merged into clouds of dust. It is obvious that the landscape in Zacchia's engraving has nothing to do with Leonardo's intentions. It is most unfortunate that we know nothing about the location of the mural in the room, for a mere indication of the position of the group known in the Doria picture would add greatly to our understanding of its principles of design.

A reconstruction of the original aspect of the room, as suggested by Wilde on the basis of Vasari's description, is somewhat contradicted by recent investigations in the structure of the walls. On the east wall a large window has been found next to a small one resembling a loop-hole, and a deep supporting arch, which may have been used as a passage, has been located in correspondence with the incorporated portion of the Palace of the Captain. It is not even certain now that the east wall was to be subdivided into two sections, one for each painter to decorate. It is certain, in fact, that there was plenty of space above the windows for a decoration on both walls in the area taken over by Vasari's paintings.

The fragment of Leonardo's mural was to be protected with a wooden frame in 1513, soon after the return of the Medici, when the rest of the room was dismantled and eliminated, as was everything referring

95

to the preceding republican government. The amount of wood used for the frame suggests a painted area of about the same size as the *Last Supper*, so that the whole picture would have been three times as big, and would reasonably have taken Leonardo ten years to complete. In 1506 Leonardo was taking a three months' leave of absence to go to Milan in the service of the French governor Charles d'Amboise, who commissioned the project of a house and garden from him. The occasion developed into a relationship with the French court, and in 1507 Louis XII wanted to meet Leonardo in Milan. Leonardo may have worked again on the painting in 1508, but it is more probable that he had already given up any hope of carrying it out, as the plaster preparation proved to be defective. He might have left the work in a rage, since an early report points to the cause of the failure in the bad quality of the linseed oil assigned to him. There might have been some talk about finding a successor to Leonardo in order to finish the work (an occurrence even foreseen in the contract), and it is revealing in this connection that Raphael, shortly before moving to Rome in 1508, wrote to his uncle to seek a letter of recommendation to Soderini, 'which would be most useful to me, in view of a certain room to decorate, the commission of which has to come from him'. By the end of 1508 Raphael had already moved to Rome and Leonardo had returned to Milan in the service of the king of France.

The fragment of Leonardo's mural is recorded in Albertini's guide-book of 1510 and is mentioned again in 1549 in a brief guide of the art treasures of Florence, published by Anton Francesco Doni, in the form of a letter to his friend Alberto Lollio: he is leading the visitor into Palazzo Vecchio through the entrance-way flanked by Michelangelo's *David* and Bandinelli's *Hercules*; points out Donatello's *David* placed on a column in

XV Studies of legs and comparative anatomy (man and horse), c. 1503–4

XVI Back view of standing nude man, c. 1506–8

XVII The Fight for the Standard. Fragment of the trial panel, c. 1503–4

XVIII, XIX Studies for the Trivulzio Monument, c. 1508–10

XX Dissection of the principal organs of a woman, c. 1508

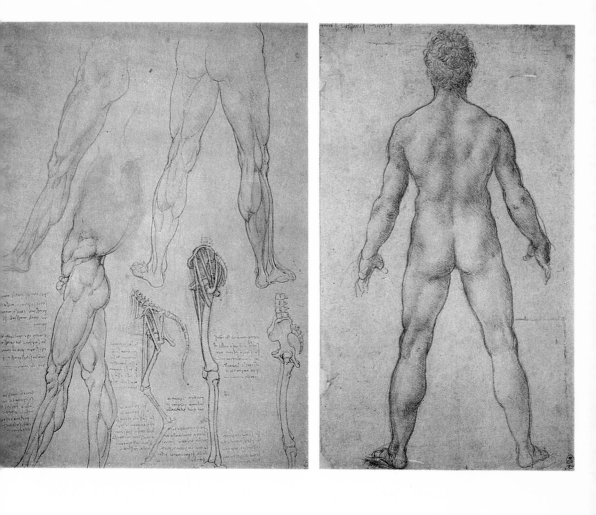

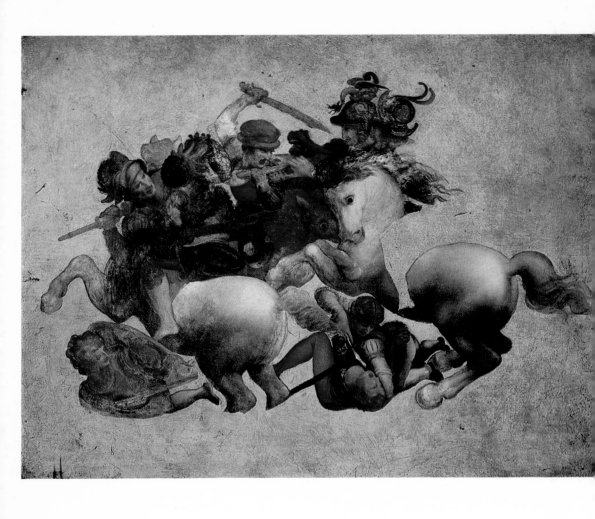

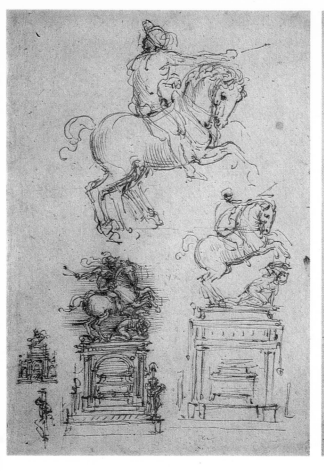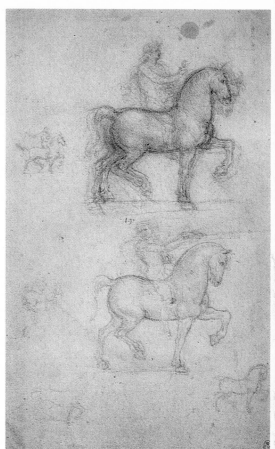

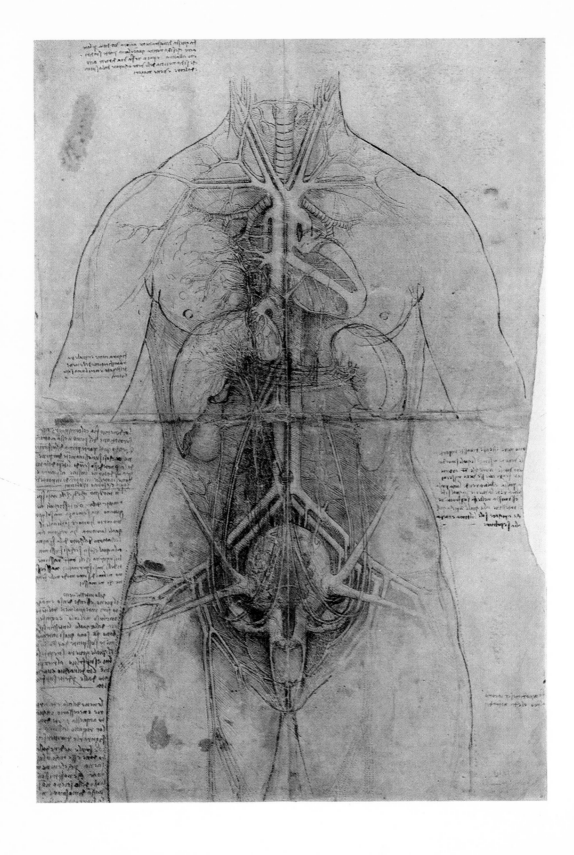

the courtyard; and, having directed him up the stairs of the great hall (those built about 1510 to provide an independent entrance), suggests taking a diligent look at a group of horses and men, the fragment of Leonardo's battle-piece, 'which will appear a marvellous thing to you'. One is tempted to believe that the mural was facing the entrance, as something that one could see immediately. The painting was to disappear about fourteen years later, in 1563, when Vasari was asked to turn the old room into a sumptuous seat suitable for the Grand Duke. He had to modify its structure to make it a more regular shape: parts of the walls are lined with bricks, others present the original bricks and stones hewn away. It might be that Vasari was able to cover the painting, as he did with Masaccio's *Trinity* in S. Maria Novella, for the whole right half of the east wall needed to be lined with bricks. The time may be not too far off for the buried masterpiece to come back to light.

Leonardo's work on the cartoon of the *Battle of Anghiari* was suddenly interrupted in the last months of 1504, and he went to Piombino on a somewhat official mission as a military architect. (During his absence Michelangelo was to receive the commission for the *Battle of Cascina*.) His mission was preceded by a diplomatic action conducted by Machiavelli himself. It can be inferred, therefore, that it was Machiavelli who suggested Leonardo's name for the programme of fortification projects requested by Jacopo IV Appiani, Lord of Piombino, an ally of the Florentines at the time of the Pisian war, 1503–04, when Leonardo had already been consulted on the project of diverting the Arno River for strategic reasons, and when Antonio da Sangallo the Elder was the chief military architect of the Florentine Republic. Leonardo's activity at Piombino, revealed by newly discovered evidence, included the study of the city walls, the citadel and the main gate. He produced a series of fortification 96 drawings, the character of which is profoundly different from that of his drawings of the early 1490s. The structures are now lowered to squat forms without sharp profiles to avoid the impact of hurtling missiles. They are in fact shaped after the trajectory lines of gun fire, which impart a dynamic quality to them. As in the representation of the human figure, forms have acquired a boldness which conveys the effect of power, and the lines of shading follow their curves to stress their plasticity. One of the drawings includes a sketch of a dodecahedron of a type shown in Pacioli's 97 *Divina Proportione*, thus pointing to the time of *Anghiari*, just as one of the

91 *Anghiari* sheets contains sketches and diagrams of excavation machines for the Arno canal.

 During the first years of the sixteenth century, Leonardo's style evolved towards a sense of monumentality which is often associated with his study of the antique. He might have visited Rome as early as 1502 at the time of his activity as an architect in the service of Cesare Borgia, and again at the time of *Anghiari*. A booklet on Roman antiquities printed about 1500 and dedicated to him opens with an invitation to him to join his anonymous friend there, perhaps Bramante. There is much in the conception of the *Battle of Anghiari* that reflects antique models (it has been shown, for example, that the central group was inspired by the representation of the Fall of Phaëthon in a sarcophagus which was kept on the stairs of the Ara Coeli), but it is above all the spirit of antiquity that he revives in Florence with the new ideal of the heroic figure. Shortly

XVIII, afterwards, in 1506–08, he was to bring it to the French rulers in Milan
XIX in the form of his projects for an equestrian monument to Marshal
98 Trivulzio and of his first ideas for a royal residence. One of these shows a low building with corner towers and galleries which is still reminiscent of the fortification drawings of 1504 and which anticipates the conception of the château of Chambord. The sheet contains a poetic description of the mythical garden of Venus at Cyprus, which is inspired by Poliziano's *Stanze* and which might have been intended to suggest a type of garden architecture suitable for the villa that Leonardo was planning about 1508 for the French governor of Milan. Finally, the sheet contains the drawing of a standing Neptune with sea horses, probably the idea of a Neptune fountain of a kind that was becoming fashionable in garden architecture in France, as shown by the bronze David that Michelangelo had made for the garden of the château of Bury. Leonardo had treated the subject of

24 Neptune in a presentation drawing of 1504 for his friend Antonio Segni. It was a front view of the god on his chariot driven by sea-horses, an illustration of the Virgilian *Quos Ego*, which became the model of six-teenth-century bronze medals, as shown by a letter that Annibal Caro wrote to the medalist Alessandro Cesati in Rome in 1540. As Leonardo revived the subject for the project of a fountain, he recalled the *David* that Michelangelo had carved out of a marble block which was intended for a Herculean Prophet, and gave his Neptune the Herculean proportions of an Anghiari warrior.

Chapter Four

LEDA

By the side of a famous anatomical drawing at Windsor, which dates from *XX*
about 1508 and which shows a dissection of the principal organs and the
arterial system of a female figure, facing front, seen from throat to mid-
thigh, Leonardo writes: 'females of messer Alfeo and Leda at the Fabbri'.
The enigmatic memorandum may be taken as a reference to models for
female figures, the word Fabbri designating one of the city gates of
Milan in the neighbourhood of the vineyard that Lodovico Sforza had
donated to Leonardo in 1498. (The Italian term 'femine' in the first item
probably designates Messer Alfeo's daughters.) Leonardo never mentions
Leda as the subject of a painting, but the memorandum may be compared
to an earlier one about the search of a model for the figure of Christ in the
Last Supper: 'Christ – Count Giovanni, the one who lives with Cardinal
of Mortaro'. His idea for a Leda can be shown to have originated at the
time of the *Battle of Anghiari*, but the conception must have developed
slowly, reaching the final phase only about 1508. The original was
apparently in the collection of the king of France and was last recorded
in 1625 when Cassiano dal Pozzo saw it at Fontainebleau. Galeazzo
Arconati owned a cartoon of it, which must have come to him together
with a number of Leonardo's manuscripts from the estate of Pompeo
Leoni. In fact, an item in an inventory of that estate dating from about
1614 includes three cartoons, the *Leda*, the so-called Burlington House
cartoon of the Virgin and St Anne, and a female Saint seen from below
the waist. *Leda* is described as 'standing and with a swan which plays with
her by a swamp, with certain putti or cupids on the grass'.

The *Leda*, which is known only from preliminary drawings and from
sixteenth-century copies, pertains to the period of Leonardo's greatest
concern for anatomical and physiological studies. The anatomical draw-
ing containing the reference to a possible model for it shows a female body

with characteristics that can be identified with those of Leonardo's standing *Leda*: broad shoulders and hips as well as small and high breasts. The identical type, shown again from throat to mid-thigh, but placed almost in profile to left, is on another drawing at Windsor belonging to a series of studies on the genito-urinary system.

100

99

The earliest studies for *Leda* are on one of the *Anghiari* drawings at Windsor which can be dated about 1503–04. These are two sketches in black chalk gone over with pen and ink, showing a kneeling Leda which is obviously derived from the type of Venus Anadyomene. (If Leonardo had already visited Rome at the time he could have seen the statue in the Massimi collection which is described in the *Antiquarie prospettiche Romane*, the poem dedicated to him, as 'a shell on which is a fine nude female with gainly features and gracefully poised'.) She appears about to be moving her children from one side to the other as she takes them out of their shells, which are placed on a projection of the terrain by her left side. A school derivation at Neuwied Castle may suggest that Leonardo's initial intentions were to represent Leda in the disguise of a *Caritas* about to separate one pair of twins from the other. With the omission of the swan, the stress would have been on the iconographic element of the antithetical twins – Castor and Pollux for *Concordia* and Helen and Clytemnestra for *Discordia*. Leonardo must have been acquainted with the 'mystery of Leda' as presented in the *Hypnerotomachia Poliphili* (1499) with an illustration which shows a flame issuing from one egg and two stars from the other. Even though he may have been acquainted with the Orphic-Neoplatonic 'principle of generations' as identified with the union of Discord and Concord, he had plenty of information in the *Hypnerotomachia* to play around with an iconographic game which was to be centred on the explanation of four theogamies as corresponding to the Four Elements, so that the union of Leda and the swan was to represent Water. His versions of the kneeling *Leda* in the finished studies at Rotterdam and Chatsworth have no clear indication of the presence of water, but have an unmistakable reference to water in the type of vegetation which is bursting all around the coiling forms of the female and the swan. These are aquatic plants, such as bulrush, for which there are several studies at Windsor. In some of the copies of the standing *Leda*, water is clearly shown behind the group, and the movement of water is suggested by Leda's curly hair. And we know now that the lost cartoon once in the

101, 102

8

Leoni collection showed Leda as emerging from a swamp. Subtle as the changes may be in developing an iconographic idea, they cannot be dissociated from a formal approach to the subject of a female body shown in the nude so as to enhance its sensuous appeal. 'Lust is the cause of generation.' Thus wrote Leonardo in the 1490s, and there are several passages in the *Treatise on Painting* in which he speaks of the painter's power to excite man's desire for love (meaning sexual intercourse), which he qualifies as 'the most important thing among the living'. In his advice to represent erotica in disguise by means of subtle pictorial devices, Lomazzo in 1584 was to refer to the views of 'such witty and prudent painters as Leonardo, Michelangelo, Raphael and Cesare da Sesto, who considered an unworthy subject that which would not include figures suggesting lascivious attitudes'. Interpreters of Leonardo's thought often quote a famous text which he wrote in the early 1490s and which is a poetic meditation on the theme of love, reminiscent of Neoplatonic theories: 'The lover is moved by the beloved object as the senses are by sensible objects . . . When that which loves is united to the thing beloved it can rest there; when the burden is laid down it finds rest there.' This is curiously contrasted by a text of tremendous directness in a manuscript of 1506–08, exactly at the time of *Leda*: 'Man wishes to find out whether the female is consenting to prospected lust, and as he finds that out and that she desires the man, he asks her and carries out his intention. And he cannot find that out if he does not confess, and as he confesses he fucks.'

The enraptured expression of the swan belongs to the moment that precedes confession, after having landed by Leda's side. The children out of their shells are an adjunct that illustrates the outcome of the act, an episode far separated in time. In painting, Leonardo avoids the directness that, as a Tuscan, he cannot refrain from in his language. Michelangelo chose to be direct in his *Leda* according to an antique model that he was to transfer into the pose of his *Notte*, with a result that would have appealed to Giulio Romano and Aretino. Filarete had been even more direct in his bronze doors for the Vatican, in which he introduced the detail of a swan showing its erect member as in a human being.

This is a painting begun in one of Leonardo's busiest periods of activity, probably without a commission and not even in view of a prospective buyer. He must have done an incredible number of preliminary drawings, several of the plant studies for it having survived. He may

103, 104 even have made a wig to help in drawing Leda's elaborate system of plaited hair. In fact, one of his drawings for it is inscribed: 'This can be taken off and put on again without damaging it.' It is a work which parallels in time his extensive theoretical writings on the working of nature, on anatomy, physiology, botany and zoology, and it was certainly meant to display an application of his latest views on light and shade, and colour, and on the way the landscape should be represented through different degrees of density of the atmosphere. Only hints of this can be sensed in the copies. And the statuesque nude figure has lost much of what the artist intended it to stand for.

Even though the preliminary drawings can be dated with reasonable accuracy within the period 1504–08, it was always difficult to trace the development of Leonardo's conception through them until Kenneth Clark showed that, after the first idea of a kneeling *Leda*, Leonardo went through two phases of the standing type, the first of which, probably not carried beyond a cartoon, is recorded in a drawing by Raphael, in a school

105 drawing in the Louvre, in the Borghese copy attributed to Bugiardini, and, probably more accurately, in the copy formerly in the Richeton collection in London. The standing Leda is shown in a sharp contrapposto, as in an effort to bring her right shoulder on a line perpendicular to her left knee, enhancing the serpent-like twist of her body, which repeats the sinuous curve of the swan's neck, her small breasts lifted over the arching of her chest to expose their fullness to the enraptured gaze of the swan. The pose implies tension, or at least the sensitive quiver which suggests a response to the touch of the bird's wing. Some of the copies, including Raphael's, show that the wing is seizing the whole curve of

106 Leda's thigh, adding to the intensity of the sensuous pose. Soon after, Leonardo must have reverted to the idea of a more restful pose to convey the pleasing effect of an harmonious flow of forms, as if Leda were about to glide away from the swan in a dance movement.

A sheet of geometrical and anatomical studies at Windsor includes the half-effaced sketch of a standing Leda of the sharp contrapposto type. The sheet used to be dated to the time of *Anghiari, c.* 1504, and its drawing of the cross-section of a male torso showing the digestive organs, accompanied by a programmatic note of anatomical investigations, was taken to indicate that the related series in a Windsor manuscript was also to be dated to the same time. But the approach to the chronological problem

must be reversed to show that the *Leda* sheet can be dated closer to 1508, probably in 1507. The anatomical series at Windsor is, in fact, related to the dissection of a centenarian in the hospital of S. Maria Nuova at Florence, an event described by Leonardo as a poetic record of his inquiry into the causes of ageing and death, but not dated other than by the advanced style of the drawings and by an indirect reference to it in a note-book of 1508. In the same note-book Leonardo has carried on the geometrical studies of the *Leda* sheet, the problem of the means proportionals which he had translated from Philoponus' commentary to Archimedes as published by Valla in 1501, and which is in fact the foundation for the famous Delian problem which was occupying him in 1508, together with other stereometry problems on which he had been working systematically since 1505. There is enough circumstantial evidence, therefore, to date the Windsor sheet to 1507 at the time of Leonardo's dissections in Florence, a date now confirmed by a dated drawing by Peruzzi in the Uffizi, which includes a sketch after the first type of the standing *Leda*.

The *Leda* sheet at Windsor is also famous for a note which has been taken as a prayer: 'Thou, O God, dost sell us all good things at the price of labour.' Its heading, 'oratio', is in fact translated by Richter as 'Prayer', but it should be translated 'Horace' as designating Horace's famous dictum (Sat. I. ix): 'Life gave nothing to mortals without hard work.' No doubt Leonardo intended his text as a quotation from Horace, but its deviation from the original can be explained by the source he had possibly used, that is, Petrarch's *De remediis utriusque fortunae* (II, xii): 'Haven't you read in Horace that this life does not give anything to men without toil? Haven't you heard how another Poet not less elegantly said that although all things are given to us from Heaven as a gift, they are not, as he says, donated to us, but sold; and the price is labour?' Petrarch quotes Horace first and then an unidentified poet. With an overlapping of recollection, Leonardo took the second quotation, attributing it to the author of the first. He was not after literary accuracy but after a suitable motto for his scientific researches.

The principles of balance and contrapposto that Leonardo was to apply throughout his studies for the *Leda* are those on which he was writing extensive notes for his projected *Treatise on Painting*. One of these, which dates from the time of *Anghiari*, is illustrated by two draw- *107*

ings of male figures shown in three-quarters view to left, about to mount with one foot on the step of a stair. In the first drawing Leonardo indicates the central vertical axis of the body to show the man balancing himself with a graceful play of his arms and an elegant bend of his body, as in some of the early studies for the *Adoration of the Magi*. But one leg is lifted, with its thigh in a foreshortened view, as in the kneeling *Leda*. And in fact, in the second sketch (Leonardo went from right to left in drawing as in writing) the presence of *Leda* is felt as a more obvious suggestion, in that the foot of the lifted leg is now resting on the step, and the upper part of the body, which arches to direct the left arm to its support on the lifted thigh, results in a system of contrapposto movement which is identified with the action of climbing stairs. Significantly, the second drawing omits the straight vertical axis because it represents an action in progress, which implies a direction of movement along a spiral line. The drawing resembles a sketch of the kneeling Leda about to rise to a standing position. Leonardo has moved from a Classical model into the mechanics of the human body.

108

The exhilarating motif of a standing figure lifting one leg to rest its foot on a support appears early in Leonardo's drawings and accounts for the undisguised quality of affectation that he likes to impart to his figures up to the time of *Anghiari*. His drawing for a St Sebastian at Hamburg best exemplifies the stereotyped, provocative use of contrapposto, but other renderings of the same motif, as in the drawings for the *Adoration of the Magi*, are suspiciously melodic so that it is even possible that Leonardo was aware of its erotic connotations from some Bacchic sarcophagus illustrating the female approach to a herm of Priapus. It is the pose of the *Anghiari* warriors about to jump across a river, suitable for translation into that of Michelangelo's unfinished *St Matthew* of 1506 and the later *Rebellious Slave*. The erotic quality of the first version of the standing *Leda* has much to do with a sharp contrapposto which relates back to the antique by way of the figure of Prudence in Leonardo's early allegory of Statecraft at Oxford: the female body, sitting on a cage, arches around to protect and defend a cock (to be interpreted as Gian Galeazzo, nephew of Lodovico Sforza), which happens to occupy a position corresponding to that of Leda's swan. As the erotic quality was too obvious, Leonardo produced the relaxed pose of the 1508 *Leda*. The next step was to be the Virgin in the Burlington House cartoon.

109

111

112

For the last twenty years I have been stressing my conviction that the London cartoon should be dated after the time of *Anghiari*, about 1508, and *XXI* not about 1498-99, as used to be accepted on the basis of a statement by an early collector. The later date is based on its style in general and on the style of the preliminary studies in particular. These are on a sheet in the British Museum which includes the head of a man in profile to right, of a *113, 114* type which evolved from the Herculean figure of the *Anghiari* warrior. The style of the sketches is that of the kneeling *Leda* on the *Anghiari* sheet but with a broader sense of the definition of forms which is produced by a thick, deliberate line, as in certain drawings for the Trivulzio monument. *115* It is precisely with the latter than I can now indicate the origin of the misconception about the date of the London cartoon. A famous sheet in *116* the Codex Atlanticus, which contains the draft of the narrative of a feigned journey to the East together with a number of witty riddles best known as Leonardo's Prophecies, and which includes a large drawing of rocky mountains and waters, has always been dated 1497-99 by reference to related material in notebooks of that period. Kenneth Clark alone, as early as 1935, put forward the theory that the feigned journey to the East 'must date from the busiest years of Leonardo's residence in Florence', which can be taken as a reference to 1500-05. It is easy to understand why that drawing should be considered as one of the most important documents in the development of Leonardo as an artist. A. E. Popp, in 1929, took it as the basis for dating the famous Windsor drawing of a storm over *117* a valley to 1499, thus affecting the date of a series of related drawings, including some of the Trivulzio studies, which she in fact also dated 1499; and consequently the British Museum studies for the Burlington House cartoon. Indeed, the folio in the Codex Atlanticus is a crucial document in the chronology of Leonardo's drawings. Its drawings of mountains are sometimes indicated as close in type to the landscape of the *Mona Lisa*, but this is not evidence that the *Mona Lisa* should be dated soon after 1500. The landscape in the painting, as in the Louvre *St Anne*, is more in keeping with Leonardo's scientific views of 1508 or later. The landscape in the drawing is a product of pure imagination. The impressionistic rendering of a large sheet of water (notice the almost microscopic vessels), recalls the Arno landscape of 1473, but the form of the mountains is rendered with a thin outline, as in an illustration of the *Hypnerotomachia Poliphili*. And just as the romantic exuberance of the Arno landscape is projected into the

early descriptions of caverns and prehistoric animals, so the continuous, almost melodic line of these drawings has the same flowing quality as the narrative of the fantastic description of Mons Taurus, to which the long series of prophecies serves as a contrapuntal motif.

118 A drawing with two sketches for a Mary Magdalene in the Count Seilern collection in London, which Popham has dated as early as 1480, has been shown to anticipate the spirited way of rendering figures in contrapposto, as in the British Museum studies for the Burlington House cartoon. And the framing-out of the image recalls that of the kneeling *Leda* in the *Anghiari* sheet. Such characteristics are now to be explained by a re-dating of the drawing. It is in fact a drawing of about 1508–09, evocative of the fine heraldic quality of the sketches of emblems in a
119 famous sheet of geometrical studies at Windsor, which contains the same type of female heads seen in full-face view with straight lines to indicate the vertical and horizontal axes. (The Windsor sheet used to be dated about 1498, but is now dated indisputably 1508–09 by the geometrical notes which preceded the sketches of emblems.) One of the emblems even shows the same exhilarating sharp turn of the head as in the Seilern drawing. In both the Seilern drawing and the Windsor sheet the type of female head, shown in its splendid cameo quality with a suppleness reminiscent of Palma il Vecchio, suggests the same model as the Virgin in the Burlington House cartoon. The Seilern drawing may be the only evidence left of the subject of the lost Arconati cartoon which showed a female Saint from below the waist; a reflection of this may be found in Raphael's *St Catherine of Alexandria* in the National Gallery, London, more than in Luini's *Mary Magdalene* in the Metropolitan Museum, New York. Raphael's Saint, which can be dated about 1506–08, may even be related to the *Leda*, and in fact a sheet of preliminary studies at Oxford includes sketches of a nude female figure reminiscent of a kneeling *Leda*.

 With the evidence of the preliminary studies, the London cartoon of the *Virgin and St Anne* can be placed in the development of Leonardo's style immediately after the *Leda*. It was probably done in Florence in 1508 and was to be followed soon afterwards by the studies for the Louvre *St Anne*. It is iconographically unrelated to an earlier cartoon of the same subject which is lost and which is so accurately described by a contem-
120 porary that its subject can be recognized in a drawing at Venice. Leonardo

himself revealed his *finzione* to his visitor, explaining how the Virgin was to express a human feeling in restraining her Child from seizing the symbol of Passion, the Lamb, and how her mother St Anne, symbolizing the Church, her arms open to bring the Virgin and Child closer to the Lamb, was to express the idea that the predestined sacrifice was a celestial arrangement. There is no evidence to support Vasari's statement that the early cartoon was done for the church of SS. Annunziata, but this is possible. Leonardo's father, who died in 1504, was the notary of the convent and might have arranged for the commission to be given to his son. Furthermore, the marquis of Mantua, Francesco Gonzaga, whose wife Isabella d'Este had been portrayed by Leonardo in 1500, was a benefactor of the Florentine convent; and one is tempted to think that Isabella's correspondent, who sent her the detailed description of the cartoon, did not specify who commissioned it because he expected her to know this.

The London cartoon used to be considered as having been done for the king of France, Louis XII, who was in Milan for one month in 1499. But the king had come to know Leonardo's work through a small painting of a Madonna brought to France not long before 1507. This is clearly stated in a document, and the small painting may be identified with the lost *Madonna with the Yarn Winder*, which was done for the King's secretary Robertet in 1501 and which is known in copies and preliminary drawings. In 1508 Leonardo was already in the service of the king of France and was writing from Florence to his French patrons in Milan announcing his imminent return there and his intention to bring 'two pictures of Our Lady' on which he was currently working and which were for 'His Most Christian King or for whoever His Majesty wishes'. It has been surmised that the lost Madonnas represented such subjects as the *Madonna of the Lake* and the *Madonna of the Children at Play* as know in school replicas. But the first must have been a small tondo probably derived from a Raphael painting, while studies for the second are on a Leonardo drawing, formerly at Weimar, which contains notes datable about 1500. One may reasonably assume that one of the pictures mentioned by Leonardo in 1508 was a painting or a cartoon of the *Virgin and St Anne*.

Like the groups of the *Battle of Anghiari*, the composition of the Virgin and St Anne in the London cartoon must have been studied in a wax model. (One such model for the figure of the Christ Child is recorded by Cardinal Borromeo in 1625.) The statuesque bodies are those of the seated

Muses from Villa Madama, which were to be restored in the sixteenth century with heads that almost betray a memory of Leonardo's female figures. Leonardo's involvement with sculpture in 1508 is documented by the assistance that he offered to his friend Rustici in preparing the statues for the Florentine Baptistery. With the *St Anne* cartoon he was to provide a model of inspiration for Sansovino's group in S. Agostino in Rome of 1516, and for Sangallo's group in Orsanmichele of about 1521. In its amplitude of flow, the drapery has a softness that can only have been intended as a deliberate imitation of the antique, and once again we are reminded of the evidence of Leonardo's first visit to Rome at the time of the first studies for *Leda*. His famous advice about imitating the Greeks and the Latins in the manner of revealing limbs when the wind presses draperies against them, goes on with the recommendation of making only 'few folds'. And I have shown that this text belongs to a series of notes which developed from an outline still existing on a folio at Windsor of about 1508–10. A text of the same series explains how the spirit of antiquity could be revived in the kind of drapery displayed in the London cartoon: 'Draperies that clothe figures should show that they cover living figures. Show the attitude and motion of such figures with simple, enveloping folds, and avoid the confusion of many folds, especially over protruding parts of the body, so that these may be apparent.' The 'relieui' (protruding parts) in the London cartoon are the knees of the two figures and the breasts and shoulders of the Virgin, which have in fact the lustre of the smooth surface of marble or clay and which are therefore sensitive to the light just as the exposed parts of the bodies are. These are the parts of the cartoon that Leonardo has heightened with white worked in with the black of the shadows to a high degree of finish.

121 The faces of the two women are often criticized for showing little difference of age. Leonardo knew well what aged facial features should 122 look like. In a preliminary drawing in the Louvre the body of St Anne emerges prominently with the spirited attitude of an old lady, her face exposed as the toothless expression of a laughing mask to amuse the child who is the object of her affectionate attentions, while her daughter reclines on her lap with the playful grace of an adolescent. But in the London cartoon St Anne makes no effort to bring her face out of a shaded area as she looks at her daughter, whose delicate and ripe features are exposed to full light. The intensity of her glance comes from large areas

of deeper shadow which have assumed the contour of the orbital openings in a skull. Her smile is kept on the skin surface as if almost calligraphically defined by the thin, sharp line separating the lips. The light reflected from the left shoulder and bust of the Virgin reveals the bony structure of a face which was once as smooth and fleshy as that of the Virgin. In fact, the whole body of St Anne is kept away from scrutinizing eyes, and she is just a presence emerging from a background of rocks and waters to remind us of the ageing process in nature.

Another point of criticism which is often directed to the cartoon is the overwhelming size of the Vigin's body: if she were to stand up she would have no room in the picture space. The format is reminiscent of a Quattrocento bas-relief, but Leonardo must have intended the group to have a different relation to the background by including a greater space at the top. This is clearly shown in the preliminary drawing in which the group is framed out to indicate the size of the picture. The figures are *113* seen from the same high point as the one chosen for the *Battle of Anghiari*, so that the landscape unfolds in the back as in the bird's-eye views of the cartographers. And I believe that the landscape drawings at Windsor, which are related in style to the famous drawing of a storm over a valley, were done as studies for the landscape in the London cartoon. In the area corresponding to the lifted finger of St Anne one can detect the presence of a village in the far distance, just as in some of the drawings. The group is seated on a rocky ledge by a winding stream of water in which St Anne seems to be placing one of her bare feet. Pebbles are shown in the foreground underneath the surface of transparent water, and the preliminary drawing includes a bridge in the middle distance – again an element reminiscent of the *Battle of Anghiari*. There is no longer the tension which was required by the iconography of the 1501 version. The Virgin is no longer expressing her motherly fears. The Lamb, symbol of Passion, is now replaced by a more subtle equivalent, the Christ Child's playmate, the infant St John, who is kneeling by the side of St Anne with his chin lifted to the fondling hand of his friend. The whole atmosphere of the picture is restful and peaceful, except for the curly hair of the children, especially that of St John, which has the same suggestion of vortexes of wind and smoke and clouds as in the Windsor drawings of heads of youths *154* and men of about 1510, and which is thus made a visual element of attraction as the focal point to which the Blessing Child is aiming. It is as if the

composition were to be read as a triangle, with its base in the Virgin's body and its apex in the head of St John. The Virgin may easily take her Child back but she is listening to her mother and turns her gesture into an offering.

There is hardly a painting from the beginning of the sixteenth century which does not invite the viewer's eye to follow a clockwise rotatory movement, as if to suggest that the composition can be inscribed in a circle. This is obviously true of Leonardo's work, even in those composi- tions which have been read as pyramidal. The London cartoon is an example of such a composition, and yet the rotatory movement it suggests is slow in tempo, as is the gesture of one who wants to convey an idea of the picture's grandeur. And then, after a full circle, the movement comes to a point – the Virgin's right shoulder – where it seems to slow down for a while, or even to take another direction, circling around the group down to a horizontal axis, which is in fact a circle seen in foreshortening. The powerful arch of the Virgin's shoulder, which is made more prominent by its being brought perpendicular to the raised left knee, this magnificent arch is not something shaped by our imagination, but something repeatedy shaped by Leonardo himself, who is seeking to make it (and successfully so) the real focal point of the picture. If we observe it in isolation, we are almost ready to confess that this gentle creature has developed a too powerful, an almost Michelangelesque build. But this is not a massive group, the weight of which sinks earthward with the oppressive feeling of a block of marble. What we get is rather the warm feeling of terracotta with the silvery dust of age lit up by an opening in the cloudy sky above. The arch of the Virgin's shoulder is not only a pictorial trick to tempt the eye, but also a subtle device to set the figure of the Virgin in a prom- inent, ingratiating position, with the weight of her majestic body com- fortably balanced on her mother's lap, so that what is felt of it is just that which can be taken affectionately. And we sense that her feet are ready to act against the ground to keep the balance in check in the event that the Christ Child were to succeed in twisting around and make a less formal approach to His playmate. As the centre of interest is switched from the figure of the Christ Child – and again it is a curved line originating from the Virgin's shoulder that leads to it – the balance of the composition is not affected. This Child could be heavy enough to make such a position quite uncomfortable for His mother, who is holding Him, and for us,

who are beholding Him. And yet He appears to be almost floating, as if His mother were about to place Him in the water for His first swimming lesson: nothing of the Child, except for the tips of His fingers, is set against the space of the background, so that He appears to be supported by the mass of drapery, whereas His weight is really all directed to His mother's arms, one of which rests firmly on her left thigh and the other can be sensed as resting on the left thigh of St Anne. This harmonious flow of forms across the group is resolved upwards into the eloquent gesture of the pointing hand of St Anne. The gesture is just as subtle iconographically as it is pictorially. The Virgin seems to pay no attention to it, taken up as she is by her motherly occupation of holding her Child. But the light inclination of her body reveals what is happening to St Anne's other hand, which we cannot see. In fact, if we were to move around the Virgin's body, following the invitation spelt out by the prominent arch of her shoulder, we would find that hand pressing affectionately against her back, to call her attention and to remind her of their celestial relations.

In rising from her kneeling position, Leda has become the Virgin of the London cartoon, who is set out so prominently that it seems Leonardo intended to suggest a motif. We can call it a Classical motif for that aspect of it which is reminiscent of the pose of a Nereid riding on the back of a Triton. The diagonal swing of such floating figures was handed down from antiquity to the Middle Ages to become the most familiar pose of Christ or the Evangelists of Gospel illuminations, and Duccio simply transcribed it in the panel of the *Three Maries at the Tomb*. In Leonardo's case the dynamic quality of the pose is enhanced by the addition of a twist, which changes the direction of forces to an almost vertical line, as in the contrapposto of a standing figure. This resulted from a deep understanding of the mechanics of the human body and became a motif of its own, to which we would expect an immediate response. But when Titian revived the ancient motif it was again the one which had survived in the works of medieval illuminators and Duccio. In fact Leonardo's motif never became popular, and was seldom reproduced. It appears in *123* Melzi's *Vertumnus and Pomona* of about 1510, and in a *Madonna and Saints* *124* at Berlin, which is attributed to the Spaniard Fernando de Llanos (one of Leonardo's assistants at the time of *Anghiari*) but which is more probably by Leonardo da Pistoia or Sogliani, after 1515. Cesare da Sesto, who was first with Leonardo and then with Raphael, also used the motif, turning

125 the Virgin's pose into that of a St Sebastian. But the pose is not one which can convey the abandonment of a dead body. It is indeed a pose full of possibilities in the way of relieving a figure of much of its weight, thus conveying the effect of the exertion of lifting. Leonardo must have realized this if he looked back at his early *Adoration of the Magi*, in which the Madonna, poised almost like the Virgin of the London cartoon, seems to be suspended in mid air, ready to float away from her earthly adorers. Raphael was to place the very same figure in a cloud of angels.

XXII For the Louvre painting of the *Virgin and St Anne* there are several drawings, the style of which points to a period about 1510–11, even though some of them may be slightly earlier, about 1508. It may well be that Leonardo was still working on the painting in the last years of his life, in France. In fact, some of the drapery studies for the unfinished garment of the Virgin are in a technique (black chalk on black prepared paper) that Leonardo was to adopt especially in France, after 1517. For the iconography, Leonardo has reverted to the early theme of the Child reaching out for the Lamb. But the group had to be studied afresh, incorporating

126 an idea formulated in the lost *Madonna of the Children at Play*, in which the Christ Child clutches a Lamb tightly and turns his head to the infant St John, who is approaching Him to offer Him a bird in exchange for the Lamb. In the lost cartoon of 1501 the Child was shown about to seize the Lamb, in spite of the Virgin's effort to hold Him back. The early cartoon must have been paralleled by a number of alternative solutions tested in drawings, some of which may have led to school derivations. This would

127 explain the origin of a painting by Brescianino which was once regarded as the best record of the lost cartoon. In it the group of the Child and the Lamb is the reverse image of that in the Louvre painting and may well

128 have been the source of the same motif in Raphael's *Holy Family* of 1507 in the Prado.

XXI Virgin and Child with St Anne and Infant St John, c. 1508

XXII The Virgin and Child and St Anne, c. 1510–11

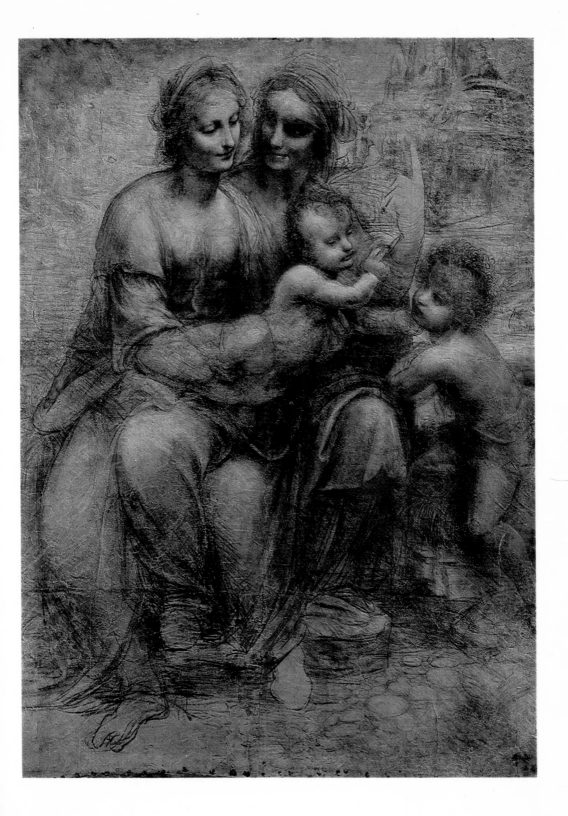

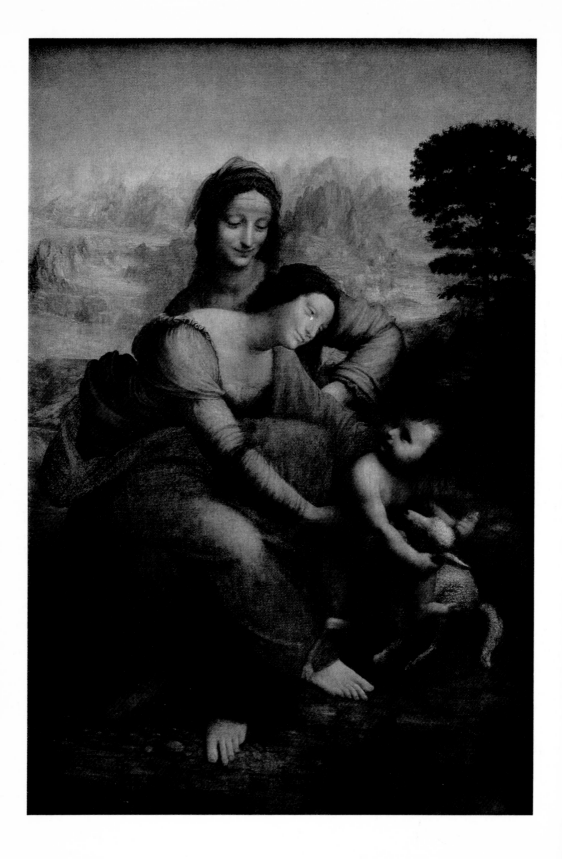

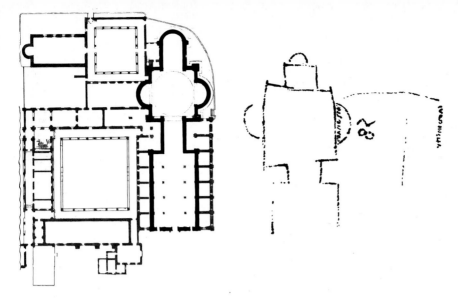

59 S. Maria delle Grazie, Milan. Ground plan and Bramante's original project as preserved in Leonardo's sketch

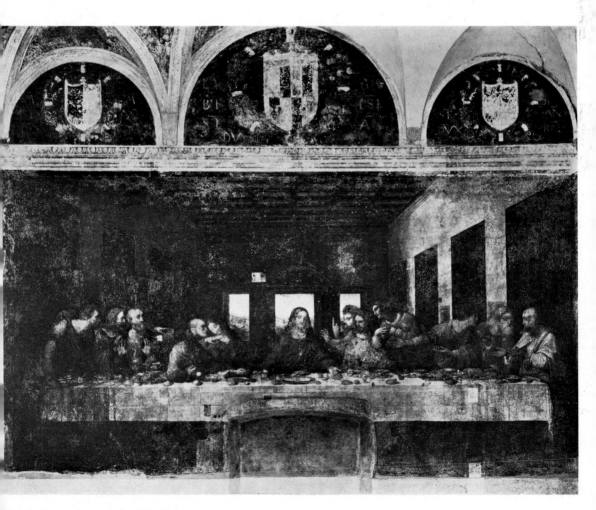

60 The Last Supper, c. 1495–7

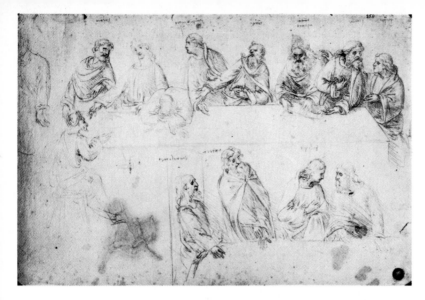

61 Studies for the Last
Supper, c. 1495

62 Studies for the Last
Supper, c. 1495

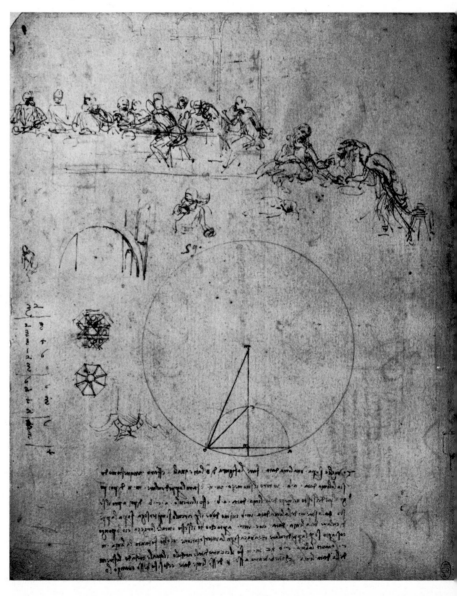

63 Sala dalle Asse, Milan, c. 1498

64 Sala dalle Asse. Recently discovered graffiti

65 Design for a tile, c. 1498

66 The Vitruvian Man, c. 1490

67 Cross-section of a skull, c. 1489 (detail)

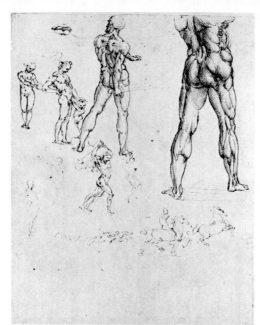

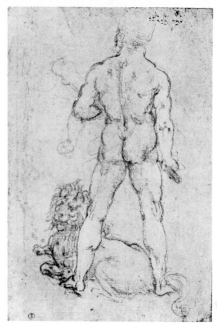

68 *Studies for a standing warrior in the Battle of Anghiari and other sketches,* c. 1503–4

69 *Hercules and the Nemean Lion, c. 1504*

70 *Physiognomical studies of horses and warriors for the Battle of Anghiari,* c. 1503–4

71 *Head and bust of a man in profile to right, c. 1506–8*

72 *Full face of an old man and lion's head, c. 1508*

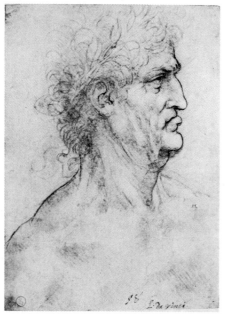

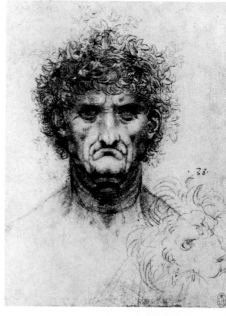

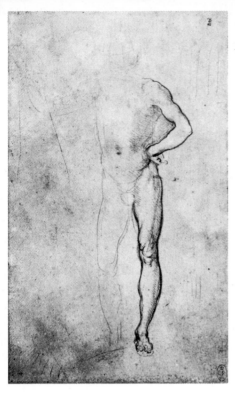

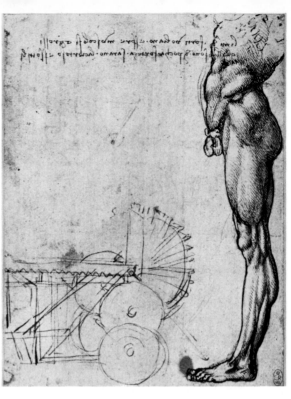

73 *Study of a nude man with left arm akimbo, c. 1490*

74 *Study of legs, c. 1490*

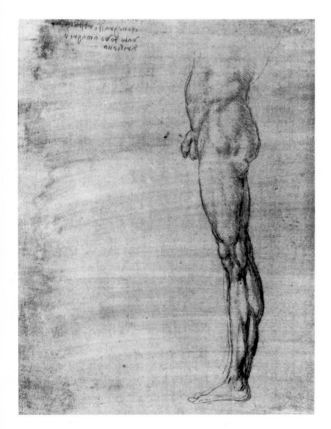

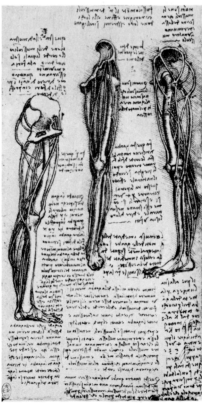

75 *Study of legs, c. 1506–8*

76 *Anatomical studies of the structure of the leg, c. 1508*

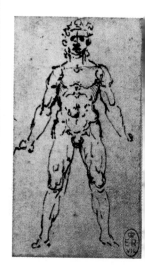

77 *A youth with a lance*, c. 1515

78 *A female masquerader, wearing an elaborate bodice*, c. 1515

79 *Sketch of a standing nude man in front view*, c. 1509

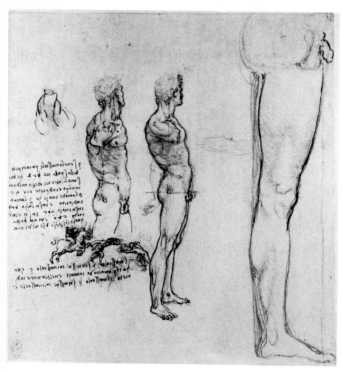

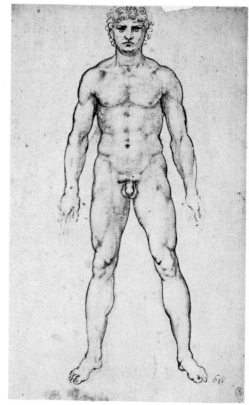

80 *Anatomical studies and sketch for the Battle of Anghiari, 1506–8*

81 *Front view of standing nude man*, c. 1506–8

A

B

C

82 The south wall of the Salone dei
Cinquento in Palazzo Vecchio,
Florence. A: Window arrangement
according to Wilde's conjectural
reconstruction. B: Window arrange-
ment as detected in the wall from
outside. C: The location of the same
windows in the wall inside

83 Raphael. Sketch after the central
group of Leonardo's Battle of Anghiari,
c. 1505 (detail)

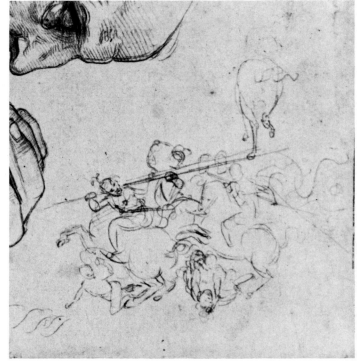

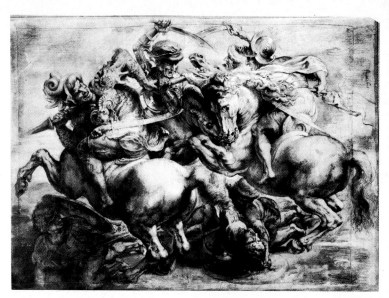

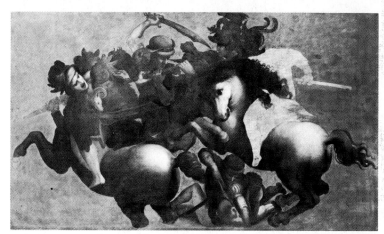

84 Model of a dodecahedron, from Luca Pacioli, Divina Proportione, 1509

85 Rubens. Drawing after the central group of Leonardo's Battle of Anghiari, 1600–8

86 The Fight for the Standard. 16th-century copy of the trial panel (Pl. XVII)

87 The Fight for the Standard. Engraving by Lorenzo Zacchia after the trial panel, 1558

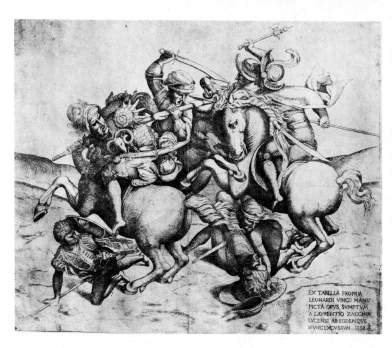

88 Studies for a man poniarding a fallen foe, c. 1506–8

89–90 Details of the Doria picture (See Pl. XVII)

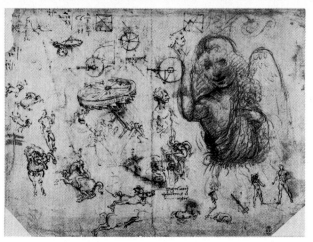

91 Sheet of studies for the Battle of Anghiari, with a pupil's sketch of the Angel of the Annunciation, c. 1503–4

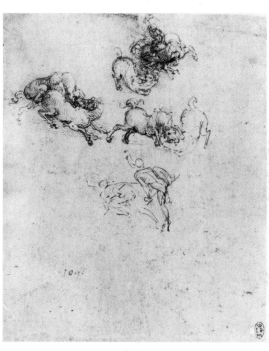

94 Sketches for the Battle of Anghiari, c. 1503–4

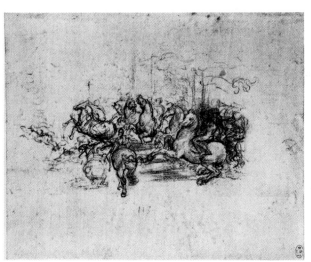

92 A cavalcade. Study for the right group of the Battle of Anghiari, c. 1503–4

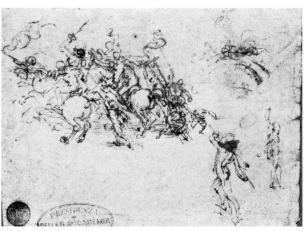

93 The Fight for the Standard and a bridge. First idea for the central group of the Battle of Anghiari, c. 1503–4

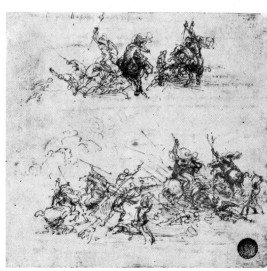

95 Studies for the central and left groups of the Battle of Anghiari, c. 1503–4

96 *Study of fortifications, c. 1504*

97 *Study of fortifications and sketch of a dodecahedron, c. 1504*

98 *Studies for a royal residence and a Neptune fountain, c. 1506–8*

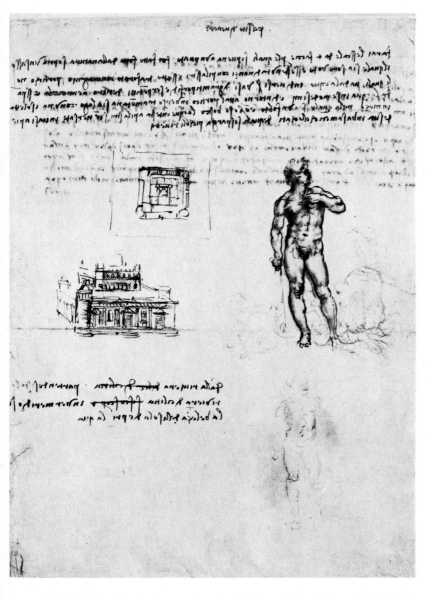

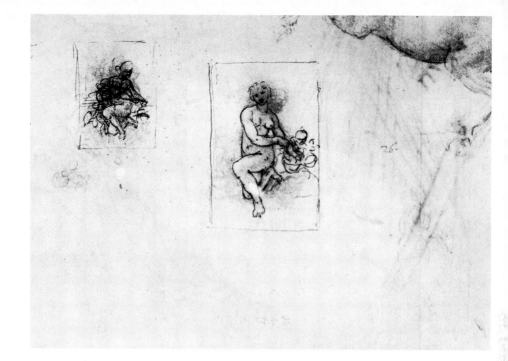

99 *Studies for a kneeling Leda and a horse of the Battle of Anghiari*, c. 1503–4 (detail)

100 *Cross-section of a woman in profile to left*, c. 1508

101–102 *Studies for the kneeling Leda*, c. 1504–6 and c. 1504

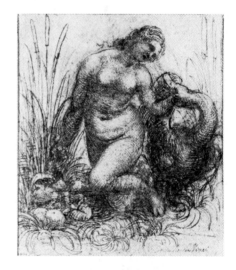

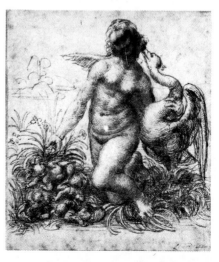

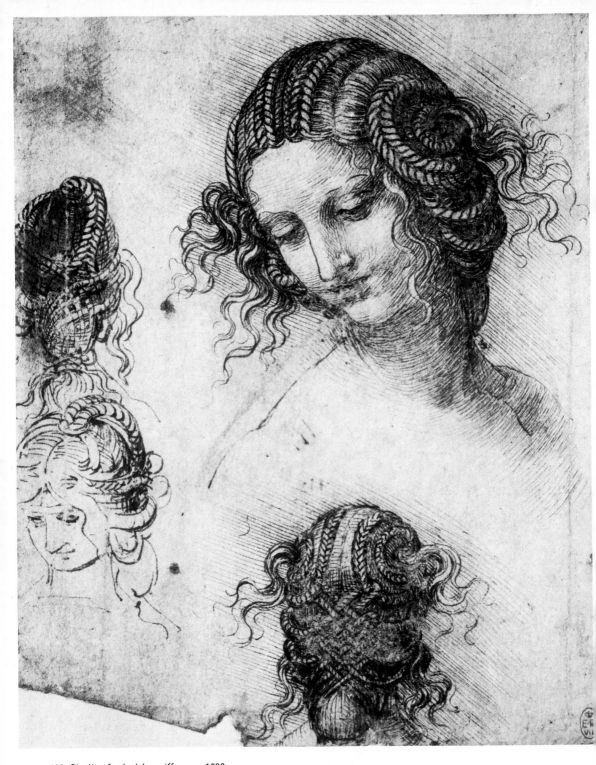

103 *Studies for Leda's coiffure, c. 1508*

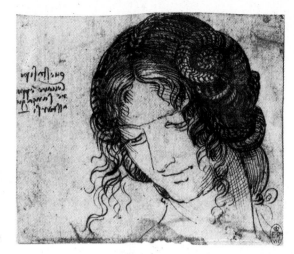

104 Study for Leda's coiffure, c. 1508

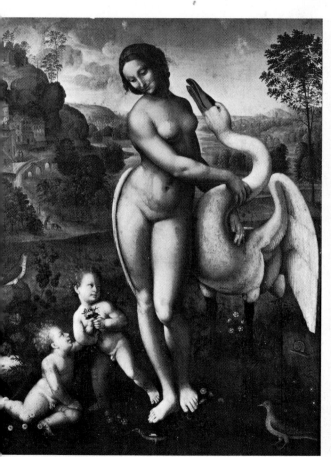

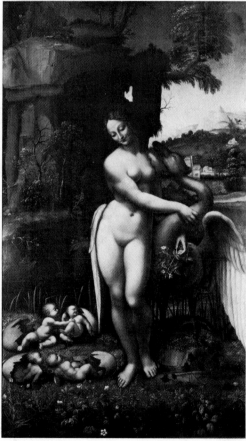

105 G. Bugiardini (?). Copy of Leonardo's standing Leda (after the first cartoon, c. 1504)

106 Francesco Melzi (?). Copy of Leonardo's standing Leda (after the second cartoon, or painting, c. 1508)

107 Studies of human movement, c. 1506 (detail)

108 Sketch of a standing figure with a foot resting on a support, c. 1482–5 (detail)

109 Study for a St Sebastian, c. 1490

110 Sheet of studies for the Adoration of the Magi, c. 1480

111 Pierre Averline. Engraving of a Rubens drawing after the antique 112 Allegory of Statecraft, c. 1485

As an intermediary between Leonardo and Raphael, one should consider Cesare da Sesto, whose sheet of studies for a Madonna, which *129* combines the type of the *Alba Madonna* with that of the *Children at Play*, is found among the Leonardos at Windsor. Thus the group of the Christ Child in the Louvre painting came to be developed out of a series of studies which had already made it popular. Studies in red chalk on red prepared paper (a medium that Leonardo was using after 1506 and especially in 1510–11), showing the Child and parts of His body, are at Venice and at Windsor and prove how carefully Leonardo had come to reconsider the motif. The head of the Child in the two drawings at the top of *130* the Venice sheet (the authenticity of which cannot be questioned, even though it is occasionally attributed to Cesare da Sesto) is remarkably close in type to that of the infant St John in the London cartoon. The Child is now stepping up to move astride the Lamb, His head turned around to look up at His mother, who is supporting Him as she sits in her mother's lap. The heads of the two women and that of the Child come to be on a straight diagonal line which repeats the direction of the Virgin's arms and right leg. The principle of the diagonal direction of forces, applied in the central group of the *Battle of Anghiari* as a means to stress a sense of violent action, now serves the purpose of presenting the elements of the group in a situation of equilibrium which can be translated into a diagram of mechanics and which becomes the device to charge the central iconographic theme of the painting with an unprecedented intensity. Critics have often wondered why Leonardo should have abandoned the most satisfactory Classical sense of balance achieved in the London cartoon in favour of a pose that has always been taken as conveying a sense of uneasiness. The answer is precisely in the Virgin's garment, which Leonardo left unfinished, and the shape of which was turned by Pfister into the absurd suggestion of the figure of a vulture. Leonardo was keeping for last (everything else in the painting is quite advanced towards completion) a detail which was to be crucial in the composition and for which he produced some of his most inspired and best finished drawings. One of them, at Windsor, is a miracle of delicacy in rendering the effect of the *131* soft fabric on the extended thigh; another, a small fragment also at *132* Windsor, shows a much broader treatment of the drapery of the whole leg, in a way that recalls Michelangelo. Another study of the blue garment *133* shows the folds turning around the hips to sustain the complex bunch of

folds of the red garment, which appears in two preliminary drawings (probably the latest of the series) almost with the effect of an organic growth. Indeed, the Virgin's body seems to be crushing St Anne's legs, which are lightly inclined to the left. And yet Leonardo's intentions can

134 be revealed with the help of a highly finished drawing in the Louvre, which explains the position of the Virgin's left leg as sensed under the drapery. In the painting, that leg appears almost perpendicular to the foot of the right leg, and its knee is brought too far out from the perpendicular descending from the chin – which is where it should be. There is no way of bending one's body forward and keeping the legs in this position, unless one folds one of the legs underneath the thigh and makes the foot of it the support for the whole body in balance, as shown in an early

136 drawing at Bayonne of a girl seated in front of an elaborate column. This is exactly what we can sense underneath the drapery in the Louvre drawing, a position curiously akin to that of Adam in Michelangelo's *Creation of Man* on the Sistine Ceiling, which, in turn, is related to the

91 action of the *Anghiari* jumpers in a sheet of studies at Windsor. Of course, only part of the weight of the body is directed to the foot of the left leg – part of it goes to St Anne's lap, and in fact her legs are lightly inclined to show that they may respond to some modification in the balance of the Virgin's body brought about by a simple pressure of St Anne's right hand against the Virgin's back. This extraordinary idea of placing a human body in a position of rest according to a mechanical principle of balance makes for the most subtle refinement in presenting an iconographical theme which was taken up again from the early version of the subject: the Virgin, with her melancholic smile, knows that she can take her Child away from the Lamb by lifting her head just the little that is necessary to affect the balance of her body, which would move back to transfer its weight entirely on St Anne's lap. But St Anne (who is still symbolizing the Church as in the early cartoon), by a simple pressure of her hand, is in the position of persuading the daughter that she should let the Child do what He wants. St Anne's left arm akimbo is reminiscent of the attitude of a fencer: hence the other hand, which we do not see, must be kept ready for action. Some of the early copies, probably originated in Leonardo's studio, are much closer to his intentions. Such is the case with the copy in the Brera Gallery, in which not only are the Virgin's legs understood in terms of their function, but the fingers of St

Anne's hidden hand are brought out in the open to show that they are ready to act against the Virgin's back. And the once famous copy, which was in the Church of S. Celso in Milan and is now in the depot of the Gallery of the University of California at Los Angeles, shows the Virgin's left leg sharply bent back with its foot that must be firmly set on the rocky ledge below.

The time of the Louvre *St Anne* is that of Leonardo's extensive studies on balance and percussion, and there are sketches of human figures in notebooks and drawings of this time which show a body oscillating on the foot of a bent leg as in the early sketch at Bayonne, the bust arching over the bent leg, the other leg being extended down. This is the position of the slaves for the Trivulzio monument, or even that of the wolf (or dog?) in the Windsor allegory of the boat with a tree. And the same position is taken to illustrate a note on painting on how to raise oneself from sitting on the ground. And so one comes to think back of a pose which had been already associated with that of *Leda*, but the erotic connotations of which are now disguised by a principle of mechanics.

The idea of a measureless past as conveyed by the landscape of mountain chains in the back, which are visually dominated by the head of St Anne and by the dark shape of the trees on the right, has given rise to a number of attractive interpretations of the painting as symbolic of time, cosmos, humanity, and intellect. I believe that this is fundamentally a religious painting, which Leonardo has made the ultimate expression of his keen sense of design. And with his love for surprising details he has introduced what we may call his colourful signature, a beautifully variegated stone close to the right foot of St Anne and next to a smaller fragment of stone, perhaps a fossil, which exposes its structure to relate a geological past. Recent psychoanalysis has interpreted this beautiful motif as a bloody embryo dropped amongst the rocks – a gruesome reminder of another age in man's life, and an insult to Leonardo's sense of *decorum*. Leonardo was so fond of fossils and stones that he collected them (his memoranda mention a 'pietra stellata' – a diopsite – and a 'book on jaspers' given to Giovanni Benci), and he must have made the intricacy of their design a projection of his own thoughts. Again it is impossible to dissociate this painting from his views on nature as presented in his writings of the time. Leonardo looks at the twirling movements of smoke or water or at the fleeting images on the iridescent surface of ancient glass, not with

135

20

138

scientific detachment but with a painter's delight for form and colour.

137 Notebooks and sheets of about 1508 contain a number of notes on 'mistioni' (mixtures), a plastic material of his own invention with which he aimed at imitating the colour and design of semi-precious stones. He describes his production process and how, once the objects were thus produced, he spent much time finishing them with his own hand to a smooth and glossy surface.

A first indication of his love for strange forms in nature might be found in the opinion that he was to express to Isabella d'Este in 1502 about antique vases formerly in the Medici collection. Isabella's correspondent reports that 'the one of amethyst, or jasper, as Leonardo baptizes it, shows various mixtures of colours and is transparent, and has the base of solid gold with many pearls and rubies around for an estimated price of 150 ducats. *Leonardo likes it very much because it is unusual and because of the*

139 *admirable variety of its colours.*' Some of the vases from the collection of Lorenzo de' Medici are still preserved in the Museo degli Argenti in the Pitti Palace at Florence. One of Leonardo's notes on 'mistioni' concludes with the observation: 'And if in the transparent part exposed to the sun you make with a small style a mixture of different colours, especially of black and white opaque, and yellow of burnt orpiment, you can make very beautiful patterns and various small stains with lines like those of agate.' Such notes are often illustrated with small drawings of delightfully complex patterns, which recall those of his equally complex studies of water currents dating from the same time. Indeed, he was studying water with a painter's eye. 'And from this experiment', he writes, 'you will be able to proceed to investigate many beautiful movements which result from one element penetrating into another'. At the same time he was much taken by anatomical studies, so that when he described the production process of his 'mistioni' he came to specify the effect that was to be achieved: '. . . then you will dress it with peels of various colours, which will look like the mesentery of an animal.' Two drawings of a mesentery in one of the anatomical studies at Windsor look remarkably

137 like the decorative motif of his 'mistioni'. And it is no surprise, therefore, that the beautiful stone in the Louvre *St Anne* should have been taken as an embryo.

Walter Pater's celebrated description of the *Mona Lisa* contains a hint of historical accuracy: '. . . and trafficked for strange webs with Eastern

merchants, and, as Leda, was the mother of Helen of Troy, and, as Saint Anne, the mother of Mary; and all this has been to her but the sound of lyres and flutes.' In the development of Leonardo's artistic conceptions the *Mona Lisa* can only have come after the *Leda* and the *St Anne*. Yet its traditional date, which has been assigned to the years from 1503 to 1506 at the time of the *Battle of Anghiari* and of the first studies for the *Leda* and *St Anne*, is still tenaciously held as correct. Any attempt to modify that date would be simply dismissed as yet another of the many tales which have made the painting so obtrusively famous. One ought to be bold enough to wipe away centuries of intellectual distortions and to start afresh – looking into the painting for a painting. Even though the conditions of the panel are miraculously excellent, a dense film of varnish and patina has become a shield to our understanding of Leonardo's intentions and has turned the painting into a mythical image unrelated to the period of art history to which it belongs. In defiance of tradition (any suggestion of having the picture cleaned has always been rejected with contempt), I am reproducing the *Mona Lisa* from an excellent black and white photo- *140* graph, which is the best means of penetrating the murky area of the drapery to reveal the shape of the body underneath. The relation of the figure to the background is something that Leonardo must have achieved in terms of a direct passage from volume to atmosphere, as with the head of the Louvre *St Anne*, yet using the veil's hem to define the contour of the figure. The colour of the sky was originally a pure and brilliant blue fading into a vaporous atmosphere behind the mountains. The nature of this colour can be ascertained in various parts of the landscape where it is perceptible through the varnish. As in the *St Anne*, the mountains in the far distance would have had the delicacy of watercolour, and those in the middle distance, crossed by a river and a winding road, would have had the sonorous glow of a red chalk drawing. A cleaning of the *Mona Lisa* would dispose of the submarine atmosphere with which it is so often associated and which has made it a distasteful symbol of decadence. It would result in a vision of almost architectural clarity, comparable to that of the perspective panel at Urbino – a panel that after its recent cleaning *141* well exemplifies the category of intellectual approach to form and colour to which the *Mona Lisa* once belonged.

The comparison is not as extravagant as it may appear. The recently discovered inventory of the Leonardo manuscripts and drawings from the

estate of Pompeo Leoni available for sale in 1614 records a cartoon 'a little over a braccio (about 2 feet) in which is reproduced from a living model a lady Saint shown from below the waist, in black chalk, with a perspective of buildings'. This must have passed on to Galeazzo Arconati, who purchased the other items, and must be the one that he was to offer, together with the *St Anne* cartoon now in London, to Cardinal Barberini in 1639: 'The portrait from nature of the Duchess of Bourgogne, who was the wife of Louis XII, placed in a garden with a beautiful perspective.' Something of a composition that he may have produced about 1508 (the time when Louis XII expressed the intention of having Leonardo paint his portrait) must have been projected into the later conception of the *Mona Lisa*, in which the mountainous landscape curving around the foreground figure suggests the principle of a structure conceived as the nucleus of an architectural setting as in Bramante's original project for the Tempietto. Mona Lisa is more than a statuesque figure. Her position in space is that of the model of one of Leonardo's centrally planned buildings, an effect stressed by the arm of the chair which is shaped like the cornices of a round building – in fact this monumental chair is made of a row of balusters as in Bramante's Tempietto. The lady sits by the parapet of a loggia, which was originally extended at each side to include two columns framing the landscape, as in a window. These are now reduced to little more than vertical strips, but their bases are easily visible and their foreshortening offers the only element of linear perspective in the picture. Originally, then, the overwhelming presence of the lady was kept in check by the architectural structure of her setting. Much more of the wall of the parapet was to be seen on the right through the veils hanging from the lady's shoulder and through the others arching around her elbow. As early as 1625, when the painting was described by Cassiano dal Pozzo, the whole area of the dress had already lost it original freshness: 'The dress must have been either black or dark fawn-coloured, but it has been covered so badly by a certain varnish that one can hardly see it.' As the whole system of a delicate play of veils is no longer readable, the first impression is that of a matronly body overloaded with drapery. But once the presence of the arm and elbow is detected, the bust acquires a different posture and proportions, and a more ingratiating turn which disposes of a deceiving effect of frontality. The whole area in shadow, which keeps the hands out of direct light, must have been very intense from the start,

black having been worked in with great deliberation as in Leonardo's latest drawings of drapery, for which he adopted the technique of black chalk on paper tinted black. Early copies show a misunderstanding of the position of the lady's left arm that must derive from the painting's having already darkened almost beyond recognition. She wears a dark green décolleté gown pleated across the front of the bust and embroidered with Leonardo's familiar 'knots'. The bust is in three-quarters view to the left, but the head is turned lightly to face the spectator. (The position is detected better by looking at the picture in reverse, as reflected in a mirror.) Her dark chestnut hair hangs in ringlets onto her shoulders and is covered by a dark but transparent veil; this is very long, since it falls not only over the shoulders and on her back, but also by both sides of her bosom down to her lap. It appears coiled over her right arm and thrown up across the bust over her left shoulder, from which it hangs all the way down by the chair. It is possible that she is wearing more than one veil, since there is a puff of it at the beginning of the sleeve which is tightened by a ribbon and covered by another veil. One is reminded of a lost painting recorded by Lomazzo in 1590: 'By Leonardo is the smiling Pomona who is covered on one side by three veils, which is a most difficult thing in this art; a painting that he made for Francis I, king of France.' The depiction of veils was becoming the speciality of Leonardo's latest period, at a time when he was proclaiming the painter's superiority over the sculptor in rendering them. A finished study for the right arm of the Louvre *St Anne* shows the kind of preliminary drawings that he must have produced for the *Mona Lisa*. But not one of the preliminary drawings has survived and we therefore lack the best means for dating the painting.

The character and style of the painting would fit well into the period 1513–16 when Leonardo was in the service of Giuliano de' Medici, the Pope's brother, staying with him not only in Rome but also in Florence and north Italy. Recently identified evidence of Leonardo's architectural projects for the Medici in Florence in 1515 (he was planning a new palace for Lorenzo di Piero, the Pope's nephew) may be related to the fact that both Lorenzo and Giuliano were in Florence at that time, where Giuliano was to die in 1516. It is not known why Leonardo was summoned by Giuliano to Rome in 1513, and one may only surmise that the two had already met on a previous occasion. But there is at least an indisputable piece of evidence about Giuliano's patronage, and this comes from Leon-

ardo himself. This is the report of a visit that Cardinal Louis of Aragon paid to Leonardo in France in 1517, in which it is recorded that the Cardinal was shown three paintings: a St Anne, a St John the Baptist, and 'the portrait of a certain Florentine lady made at the request of the late Magnificent Giuliano de' Medici'. The *Mona Lisa* is recorded at Fontaine-bleau in 1625, together with other paintings that Leonardo had left in France. Hence the painting seen by the Cardinal in 1517 is likely to be identified with that which we now call 'Mona Lisa', but which was baptized 'Gioconda' (Mona Lisa del Giocondo) only in 1625 when Cassiano dal Pozzo proposed to identify it with a portrait described (but not seen) by Vasari. Earlier inventories at Fontainebleau designate the painting as the portrait of *une courtizene in voil de gaze*, that is, of a court lady dressed in gauze, the court lady personifying the Renaissance ideal of female beauty as postulated by Giuliano de' Medici himself in one of the dialogues of Castiglione's *Courtier* (III, viii): 'Since women are not only permitted but bound to care more about beauty than men ... this lady must have the good judgment to see which are the garments that enhance her grace. ... And when she knows that hers is a bright and cheerful beauty, she must enhance it with movements, words, and dress that tend towards the cheerful; just as another who senses that her own style is the gentle and grave ought to accompany it with like manners, in order to increase what is a gift of nature. Thus, if she is a little stouter or thinner than normal, or fair or dark, let her help herself in her dress, but in as hidden a way as possible; and all the while she keeps herself dainty and clean, let her appear to have no care or concern for this.'

143 In a sheet containing geometrical studies of about 1515, in the Codex Atlanticus, there is the drawing of a left eye carefully shaded in pen and ink with a long ringlet of hair by its side, exactly as in the *Mona Lisa*. This may be only a doodle suggested by the painting, but it is significant that just above it is the topographical sketch of the Medici quarter in Florence, showing the project of a new Medici palace. There is historical evidence of several ladies having been the subject of Giuliano's attentions about this time, but their names are not mentioned. There is, however, a hitherto unnoticed detail which may help to throw light on the identity of the sitter. The report of the visit to Leonardo in 1517 indicated the portrait as that of a 'certain Florentine lady', yet the report of the subsequent visit to the château of Blois touches upon the portrait of a Lom-

bard lady which is recognized as being of excellent quality, but 'not quite as good as the portrait of Signora Gualanda' – obviously a reference to a painting seen the day before.

I keep referring to the Louvre painting as the portrait of Mona Lisa even though I am convinced that it has been given the wrong identity. Vasari's identification of the sitter's name (though he never saw the painting) must have derived from some tradition or written source. One of Vasari's sources is the biography written by the Anonimo Gaddiano who records that Leonardo painted the portrait of Piero Francesco del Giocondo, not that of his wife. This can be shown to be the origin of the comedy of errors caused by the Louvre painting, but the wrong tradition established by Vasari was to discredit even the early biographer who is now considered to have made a mistake! The main objection to a date of the painting in Leonardo's latest period, after 1513, is that the *Mona Lisa* could not be later than 1506 because it is to be recognized as the source of inspiration for Raphael's portrait of *Maddalena Doni* and Raphael's drawing of a girl in the Louvre, which includes the device of the framing columns as in the *Mona Lisa*. But Raphael could have seen other female portraits by Leonardo, certainly the intact *Ginevra Benci* which once included the hands, and the cartoon for the portrait of Isabella d'Este, again with hands, and probably the cartoon owned by Pompeo Leoni, the half figure of a 'Santa' in a perspective of buildings. The contemporary who recorded his *St Anne* cartoon of 1501 added a reference to the activity of his studio, specifying that two pupils were doing portraits, 'to some of which he would occasionally lend a hand.' On the verso of one of the *Anghiari* studies at Windsor is a pupil's rough sketch (not reproduced in *144* Clark's *Catalogue*) showing the sleeves and bodice of a woman.

The great number of sixteenth-century copies of the *Mona Lisa* are interesting only as documents of the popularity of the painting, especially in France and Lombardy. This is also an indirect evidence that the painting was not long in Italy, as it must have appeared in Florence and Rome for the period of Leonardo's stay there from 1513 to 1516. The version which shows *Mona Lisa* in the nude is important in a different way, in that it may have originated from a Leonardo model. Kenneth Clark has suggested that this was in fact the model with which Leonardo studied the pose of Mona Lisa. A cartoon at Chantilly is often mentioned as the copy *146* closer to Leonardo's lost original, and is occasionally attributed to Leon-

ardo himself. This is pricked for transfer, but none of the several painted versions shows the same tilt of the head nor the sensitive spacing of the fingers. And the face turned to a front view, framed as it is by curly and braided hair, is a deliberately Classical mask suitable to the subject of Flora, an impression that can no longer be perceived in the paintings. (The wax bust at Berlin illustrates the type of Classical Flora as interpreted in the Renaissance and may also reflect a Leonardo idea.) A large school drawing in the Ambrosiana appears to be a study for the same head and reflects the style and technique (red chalk on red prepared paper) of Leonardo's drawings of about 1510–11. I am therefore venturing the suggestion that Leonardo and his pupils (Melzi and Salai) were occupied at that time with commissions of paintings of mythological subjects and that a first idea of the pose of Mona Lisa was taking shape as the subject of a Flora. The French governor of Milan must have had a taste for such subjects, which would include the *Nympha Egeria* in the Brivio collection at Milan, a painting attributed to Gianpetrino and recently interpreted as a symbolic reference to the mistress of Charles d'Amboise. It can be

123 shown that about 1510 Melzi was working on his *Vertumnus and Pomona*, for which the figure of the Virgin in the Burlington House cartoon served as a model. In turn, Pomona was easily transferred into a half-bust *Flora*, retaining the motif of the loose shirt to reveal one breast, a motif well known in antique statuary and also in antique painting, even though

145 the alleged antique at Cortona, the almost Leonardesque *Muse Polyhymnia*, may be a sixteenth-century imitation. Such paintings, in fact, must have been unknown in the Renaissance, as can be inferred from Bandello's report of a conversation between Leonardo and a French cardinal and his following on the occasion of their visit to the *Last Supper* when Leonardo was still working on it: 'It was reasoned about several things and particularly of the excellence of painting, someone expressing the desire that some of those antique paintings, which are so much celebrated by the good writers, could be seen today, so as to judge whether the contemporary painters equal the ancient.' The best version of the *Flora*, perhaps

148 by Melzi himself, is at Leningrad, but the one even closer to the spirit of
147 antiquity is that formerly in the collection of the late Prince Baranowicz in Paris, which is an unmistakable illustration of Ovid, *Fasti*, V, 255–378.

There is some indication that Flora in the Renaissance was gradually being interpreted interchangeably as a Goddess and as a Courtesan – and

it is fitting that on the path of a subtle iconographic development the next in line should have been the *Mona Lisa*. This may help to explain Lomazzo's puzzling statement of 1584, in which he mentioned two paintings by Leonardo at Fontainebleau 'ornamented after the fashion of a Primavera, such as the portraits of Gioconda and Mona Lisa, in which he has most admirably expressed amongst other things the mouth in the act of smiling.' There is a theory that the Leningrad *Flora*, which comes from the French royal collection, might have been the *Mona Lisa* mentioned by Lomazzo. In fact that painting was recorded as Leonardo's by A. Bosse in 1649 together with a *Joconde* as having belonged to the *cabinet de la feuë Reyne mère Marie de Médicis*. Lomazzo, who was blind at the time he was writing, may have had some information, possibly from Melzi himself, about the *Joconde nue* and another painting which he called *Mona Lisa* but which cannot be the *Mona Lisa* we know. (In another passage he refers to it as the 'Neapolitan Mona Lisa', probably a portrait of Isabella of Aragon, which would be unrelated to the Florentine *Mona Lisa* of Vasari's story.) The two paintings would be symbolic of Primavera, and therefore would have included flowers, which are the attributes of Flora, as in Botticelli's *Primavera*. But the known paintings of the *Joconde nue* display a peaceful landscape in the background, and only a later version at Bergamo shows a dark background covered by flowers and a wreath of flowers on the lady's head. This painting comes from the Settala Museum in Milan and is recorded in the 1664 catalogue of the collection as 'a woman believed to be a prostitute, a work by that great painter Leonardo da Vinci'.

149

The cartoon at Chantilly is our only evidence that the Louvre painting may have been intended to be the personification of the Renaissance ideal of female beauty as inspired by the Classical model of Flora and therefore associated with the concept of the *cortegiana*, a term flexible enough in the Renaissance to designate both the court lady and the prostitute. But I must confess that this would be a little too clever even for Leonardo. The *Joconde nue* became famous on its own, providing the model for the celebrated subject of the ladies in their bathtub of the Fontainebleau School. At the same time, the *Mona Lisa* we know was to be hung in the king's bathroom.

Chapter Five

BACCHUS

150 A small drawing of a spear-bearing youth, in the British Museum, is seldom reproduced as if its authenticity were questionable. Berenson states that it is retouched and the shading of the background added. The penwork is homogeneous and I have no doubt that it is all by Leonardo, including the lines of shading in the background which slope from right to left. The youth is completely naked, shown in the lively, Classical pose reminiscent of the so-called 'Alexander type'. The body surface is defined by a system of parallel horizontal lines of shading which curve to follow the form, and the musculature of the torso is brought out by sensitive touches of the pen. The light comes from top right, as if directed to the figure according to the suggestion of the diagonal shading, and the youth lifts his face to its source, so that dense areas of shadow are on his neck, mouth and eyes. The curly hair has a glow, as if it were blond and fully invested by the light. This relation of body to light, taken in conjunction with the Classical inspiration, recalls the figure of a standing nude youth

152 in Correggio's *Camera di San Paolo* or the statue of Apollo that Raphael placed in the architecture of his *School of Athens*. Panofsky has given a convincing interpretation of Correggio's enigmatic figure as a representation of Virtue, which is the counterpart of Fortune represented at the other end of the wall. The two figures are brought together, as in antiquity, on a medal for Giuliano de' Medici (Leonardo's patron after 1513) to illustrate the Ciceronian motto about Fortune being the companion of Virtue. And it was Cicero who explained why 'Virtue' should be represented as a man (in this guise it appears in coins showing a spear-bearing youth, as in Leonardo's drawing): '*Virtus* is named after *vir*, and the chief property of a man is fortitude, contempt for death and physical pain.'

When he moved to Rome, on 25 September 1513, together with his pupils Melzi, Salai and Il Fanfoia, Leonardo was sixty-one years old and

was probably showing already a decline of physical strength. The draw-
ing of the beautiful youth dates exactly from this time, its style being
identical to that of the Windsor drawings of table fountains and of the *151*
Venice drawing of dancing maidens. It shows a type of youth that was to *153*
appear frequently in the last decade of Leonardo's life, especially in the
youths of his masqueraders. If one were to fancy a name for it one could
call it Bellerophon, with reference to the hero that Ripa was to choose for
Virtue: 'By Bellerophon, exceedingly beautiful youth mounting Pegasus,
with a spear in his hand to kill Chimera, one represents Virtue.' But such
intellectual fabrications may be dangerous, and could be paradoxically
compared with Leonardo's concept of virtue as presented in a long lost
manuscript by Lomazzo, a somewhat crazy fantasy written about 1560
which is entitled *Gli Sogni* and which has been recently located in the
British Museum. Lomazzo revives the antique literary model of the dia-
logue of the dead (Guarna preceded him in making Bramante talk to St
Peter) and presents Leonardo conversing with Phidias:

Leonardo:	. . . Salai, whom in life I loved more than all the others, who were several.
Phidias:	Did you perhaps play with him the game in the behind that Florentines love so much?
Leonardo:	And how many times! Have in mind that he was a most beautiful young man, especially at about fifteen.
Phidias:	Are you not ashamed to say this?
Leonardo:	Why ashamed? There is no matter of more praise than this among people of merit [*virtuosi*]. And this is the truth I shall prove to you with very good reasons . . . Understand that masculine love is solely the product of merit [*Virtù*] which joins together men of diverse feelings of friendship so that they may, from a tender age, arrive at manhood, stronger friends . . .

The dialogue goes on with Leonardo explaining how masculine homo-
sexual attachments are the only ones worthy of a truly philosophical turn
of mind, the heterosexual form of love being of secondary importance as
necessary for the perpetuation of the species. He shows no appreciation for
women and, after having cited illustrious examples of homosexuals in
antiquity, he concludes: '. . . Besides this, all Tuscany has set store by this

embellishment and especially the savants in Florence, my homeland, whence, by such practices as fleeing the volubility of women, there have issued forth so many rare spirits in the arts, of whom in the field of painting I reminded you of some a little while ago and shall go on to remind you of more, whom the Neapolitans have adopted the practice of following.' (Eissler's translation)

This whole fantasy may be set aside from the category of documentary evidence, yet truth may often be told in jest, and Lomazzo may have had more information about Leonardo's pupils than documents can ever provide. Be this as it may, Gian Giacomo Caprotti, to whose father Leonardo was to rent the vineyard which he had received from Lodovico Sforza in 1498, entered his house in 1490 at the age of 10. His behaviour won him the nickname 'Salai' for Devil – and yet the boy continued to receive Leonardo's undivided affection, and when Leonardo was given a precious garment by Cesare Borgia in 1502 he simply handed it over to Salai. In Leonardo's notebooks there are countless references to purchases of clothing for Salai and records of money given or loaned to him – one time with the specification that the money was to be used for his sister's dowry. About 1508 he was joined by a well-educated youth of approximately eighteen years of age, Francesco Melzi, the son of a Milanese aristrocrat – again a most beautiful *fanciullo*. Both Melzi and Salai followed Leonardo to Rome, and eventually to France. In 1513 Salai was thirty-three, which could possibly be the age of the youth in the British Museum sheet.

In a number of drawings and manuscript pages dating from the 1490s onwards, there appears frequently the familiar profile of a youth, with lips lightly parted and a dreamy, almost empty expression of the eyes. At time it is only a doodle which includes the lower part of the nose, the mouth and the sensual, round chin slanting down to the elegant line of the throat. Occasionally the stress is on the curly hair. There is a theory that all these drawings reproduce the same model, the notorious Salai, whom Vasari mentioned as 'a graceful and beautiful youth with fine curly hair, in which Leonardo greatly delighted'. The theory is convincing in that the chronological sequence of the drawings shows the model's features becoming affected by age. Salai's features must have changed little up to the age of thirty, so that about 1508–10 he may still have had the look of a

154 twenty-year-old boy, as shown in a delicate black chalk drawing at Wind-

sor in which the head is placed in profile to left and the bust turned to an
almost front view. (One is reminded of the definition of adolescence in
Matteo Palmieri's *Vita Civile*, a moral treatise known to Leonardo: 'This,
the third stage in man's life, is considered to last until about the twenty-
seventh year of age.') The hair is short and woolly, and the vaporous
softness of the drawing may contribute to the general effect of adoles-
cence. The same type of drawing is used for the head and bust of a
mature man on the verso of the British Museum sheet of studies for the
Burlington House cartoon. Two or three years later the same youth is
represented in a drawing of completely different technique, red chalk on
red prepared paper, the hair being touched with black. Long, almost
horizontal lines of shading curve to a slow definition of form, the arti-
ficial hair resembling the coiling clouds of the Deluge drawings. An
otherwise pensive expression is spoilt by the hint of a smile in the curled up
mouth with a result which is more vulgar than disagreeable. One is temp-
ted to believe that a wig could change the youth into anything, including
a Mona Lisa. A large pen-and-ink sketch of the same head, but with
angel-type hair, is on an anatomical sheet at Windsor of 1513, and it
appears again in the full figure of a masquerader standing with his legs
apart, his left arm akimbo, his right hand holding a long staff. Clark has
made a point about the short forearm and wrist, as well as the quality of
the drapery, being typical of Leonardo's late style. It all goes back to the
nude model in the British Museum sheet – and the same youth reappears
in a small drawing at Windsor which is in red chalk on red prepared paper,
style and technique suggesting again the date 1510–11.

 It might be dangerous to consider the several drawings of the Salai-
type head of a youth as studies for some kind of a Dorian Gray portrait,
but it is also improbable that they were done for the sole purpose of draw-
ing practice. Vasari mentions two paintings, now lost, which Leonardo
did in Rome for Baldassare Turrini of Pescia, datary of Leo X, and which
he saw in Pescia: one of a Madonna holding her Son, the other a small
panel (*quadretto*) with the portrait of a 'fanciulletto, che è bello e grazioso
a meraviglia' – a marvellously beautiful and graceful boy. This is usually
interpreted as the head of an Infant Christ. On the other hand, one is
reminded of Scannelli's reference in 1657 to a small painting by Leonardo
which was then in the gallery of the duke of Modena and which repre-
sented the 'head with somewhat of the bust, smaller than life size, of an

155

156

157

armed youth (*giovinetto armato*) in a dignified and quite graceful attitude'. This might have had something to do with Boltraffio's so-called *St Sebastian* at Bergamo, which shows the bust of a crowned youth of the Salai-type in profile, holding an elegant spear and with a halo (probably added) inscribed S. SEBASTIANVS.

Leonardo's drawings of a Classical-looking youth may well be taken to symbolize a depraved society within and around the Vatican, at a time when some of the best examples of antique statuary were displayed in the courtyard of the Belvedere, a few steps from the apartments in which he was accommodated. He made a sketch of the reclining *Ariadne*, which is the first accurate record of the statue before restoration. Unfortunately, there are only hints of Leonardo's attitude towards what might have been a widespread licentiousness in his time. (In the *Treatise on Painting* he mentions that 'Others have represented lust and sensuality in such a way that they excited beholders to the same excesses' – an obvious reference to pornography.) We lack such evidence as the two drawings of sex monstruosity which he made in Milan out of the portrait of a beautiful young man, and which are described by Lomazzo in 1584: 'One of them, which was a most beautiful youth, was shown with the penis on the forehead and without nose, another face being on the back of the head, with the penis below the chin and with the ears attached to the testicles; these two-heads-in-one had faun's ears. The other monster had the penis just above the nose and the eyes by the side of the nose, the rest showing again a most beautiful youth. They are both in the possession of Francesco Borella, the sculptor.' (These must have shown the whole bodies as in a famous allegory at Oxford, for the heads alone would hardly have retained anything of a beautiful youth!) I have unpublished evidence of one such monstruosity (a youth with a penis on his nose) having lived in Milan at the beginning of the sixteenth century, but Leonardo's lost drawings must have had the character of a deliberate joke, somewhat in *158* the mood of the Dantesque monster in a Windsor drawing (combined red and black chalks on red prepared paper, as in one of the Salai heads), who displays huge testicles disguised as goitres hanging from his chin and with eyebrows turned into coiled horns which are actually male members of the faun type customary in the representation of devils. And I have seen a beautiful, unpublished drawing of the head of a youth, from a collection which included a number of Leonardo drawings, itself being

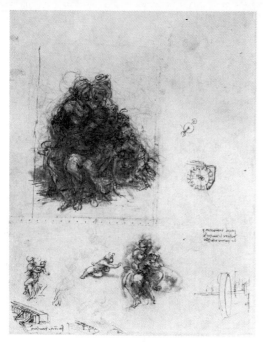

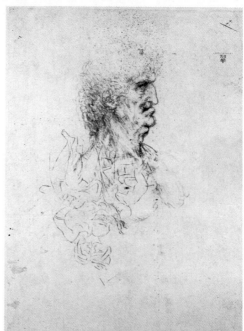

113 Studies for the Burlington House cartoon, c. 1508

114 Head and bust of an old man in profile to right and reversed
sketch of the composition of the Burlington House cartoon,
c. 1508. (verso of Ill. 113)

115 Study for the Trivulzio Monument, c. 1508

116 Sheet of notes on the feigned journey to the East, with
'Prophecies' and landscape sketches, c. 1500–5

117 A storm over an alpine valley, c. 1506–8

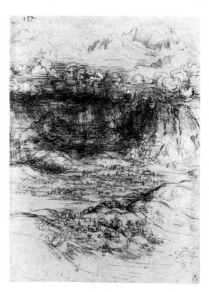

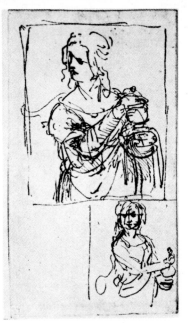

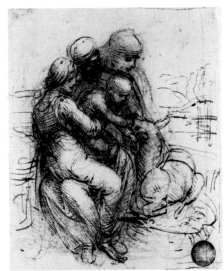

118 *Studies for a St Mary Magdalene, c. 1508*

119 *Sheet of geometrical studies and sketches of emblems,* c. 1508 *(detail)*

120 *Study for the 1501 cartoon of the Virgin and St Anne*

121 *Burlington House cartoon. Detail of the heads of the two women (see Pl. XXI)*

122 *Study for the Virgin and St Anne, c. 1508*

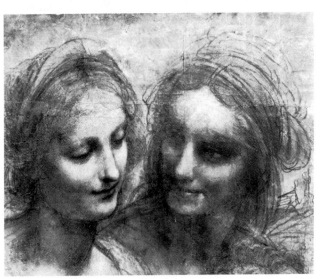

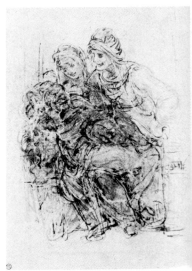

123 Francesco Melzi. Vertumnus and Pomona, c. 1510

124 Leonardo da Pistoia (?). Madonna and Saints, c. 1515–20

125 Cesare da Sesto. St Sebastian, c. 1510 (or later)

126 16th-century copy of the lost Madonna of the Children at Play

127 A. Brescianino. Virgin and St Anne, early 16th century

128 Raphael. Holy Family, 1507

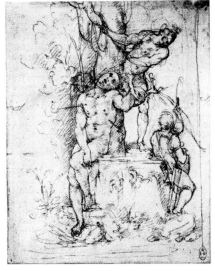

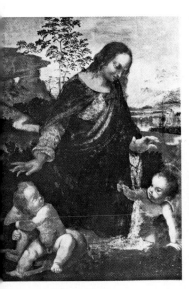

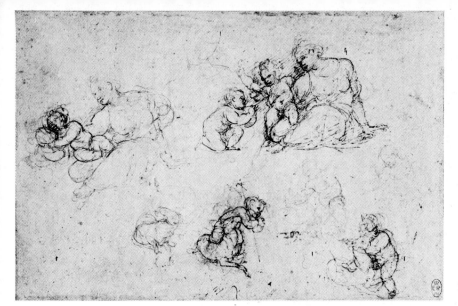

129 Cesare da Sesto. Studies for
a seated Madonna, c. 1510

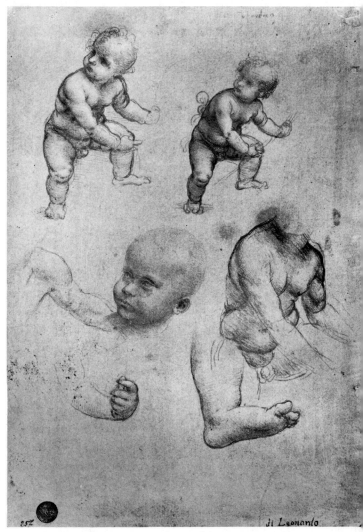

130 Studies for the Christ Child
in the Louvre St Anne, c. 1510

131–132 *Studies for the drapery of the Virgin in the Louvre St Anne*, c. 1510

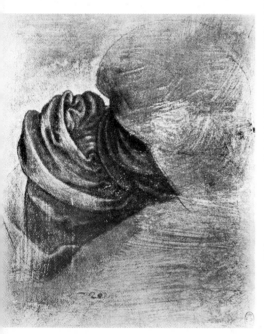

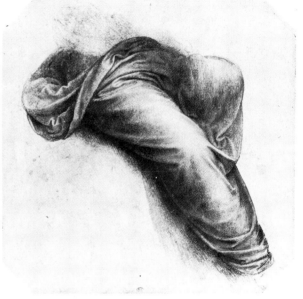

133–134 *Studies for the drapery of the Virgin in the Louvre St Anne*, c. 1517

35 *Study of seated nude figures*, c. 1508 (detail)

136 *A seated woman approached by a man*, c. 1480 (detail)

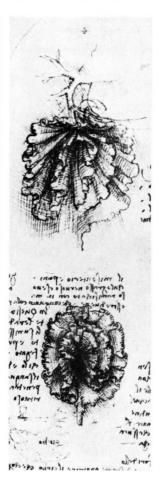

137 Leonardo's 'mistioni' and anatomical sketch of a mesentery, c. 1508

139 Medici Vase

138 The Louvre St Anne. Detail of the stones in the foreground (see Pl. XXII)

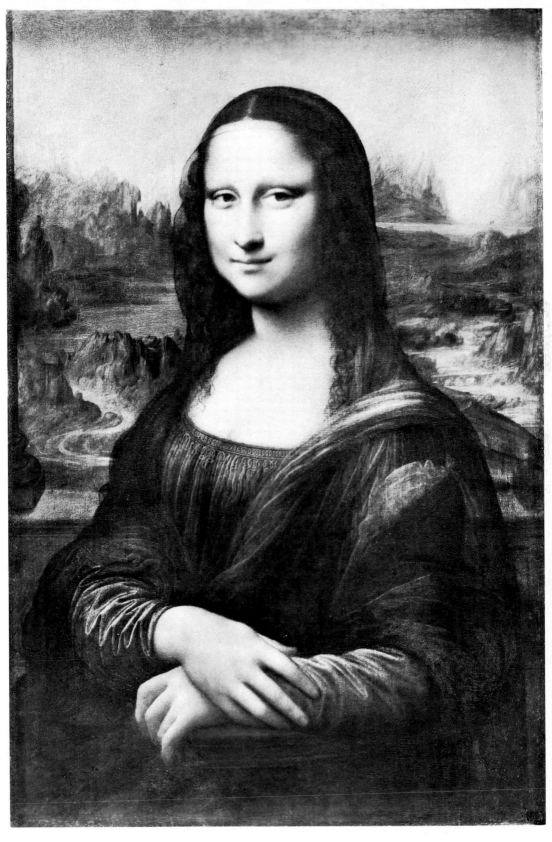

140 The 'Mona Lisa', c. 1513–16

141 Circle of Piero della Francesca. Perspective of buildings

142 Bramante. Tempietto (and ground plan of the original project, after Serlio), after 1510

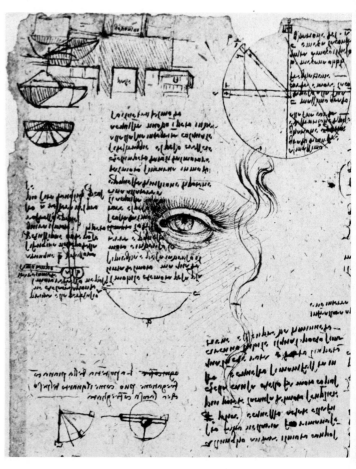

143 Sheet of geometrical studies with sketches of a woman's eye and hair ringlet, and with the plan of a new Medici palace in Florence, c. 1515 (detail)

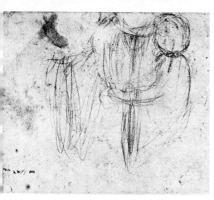

144 Sleeve and bodice of a woman
(not by Leonardo), c. 1503–4

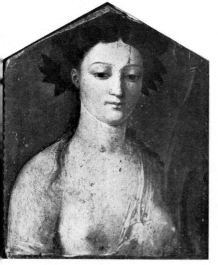

145 Muse Polyhymnia. First century AD or
Renaissance imitation

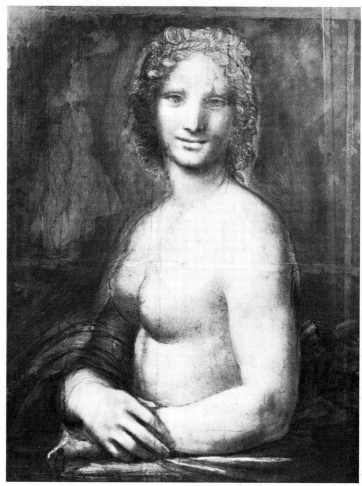

146 Leonardo School. Joconde Nue (after Leonardo's lost drawing),
c. 1513

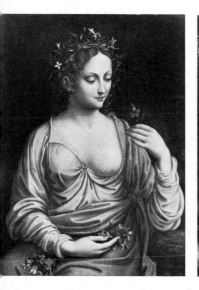

147 Francesco Melzi (?). Flora,
c. 1510

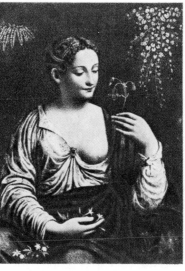

148 Francesco Melzi. Flora, c. 1510

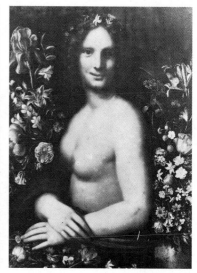

149 Joconde Nue. Anonymous,
early 17th-century

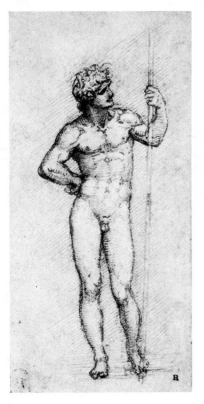

150 Standing youth in the nude,
holding a spear, c. 1513

151 Table fountains, c. 1513

152 Correggio, Virtue, c. 1519

153 Dancing maidens, c. 1513

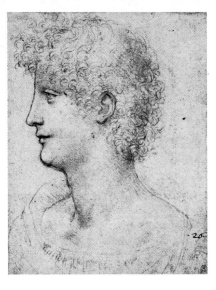

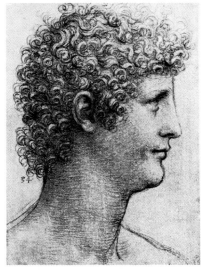

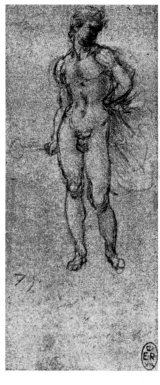

154 *Head and bust of a youth in profile to left, c. 1508–10*

155 *Head of a youth in profile to right, c. 1513*

156 *Head and bust of a youth in profile to right, c. 1513 (detail)*

157 *Standing youth in the nude, c. 1513*

158 *Dantesque monster, c. 1513 (copy by Francesco Melzi)*

159 *Sketch of an epigastric parasitic thoracopagus, 1513 (detail)*

160 *Title-page of Giano Vitale's Teratorizion, 1514*

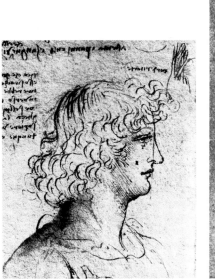

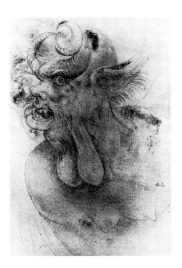

IANI VITALIS PANORMITANI

TERATORIZION.

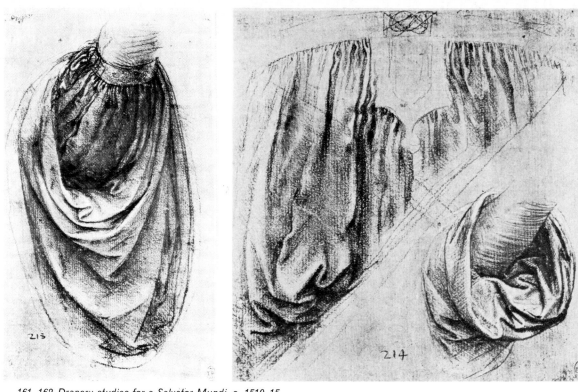

161, 162 Drapery studies for a Salvator Mundi, c. 1510–15

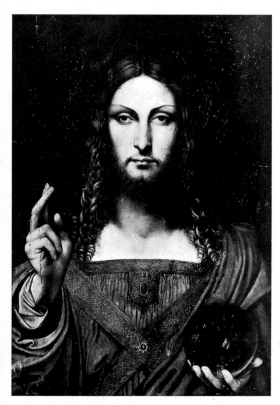

163 Salvator Mundi (after Leonardo)

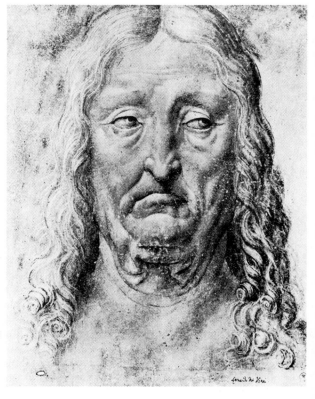

164 Head of an old man (after Leonardo), c. 1510–15

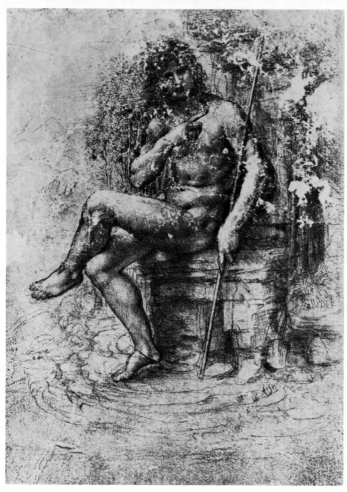

165 *St John the Baptist*, c. 1513

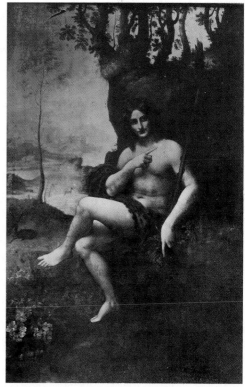

166 *St John-Bacchus* (Leonardo and pupils), c. 1513–15

167 St John the Baptist, c. 1509

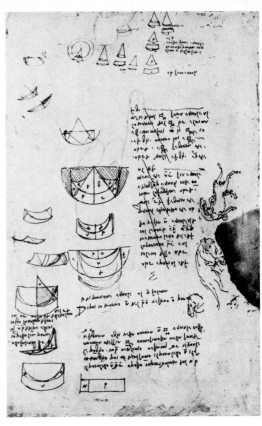

168 Sheet of geometrical studies, with pupil's sketch after the pointing hand of St John the Baptist, c. 1509

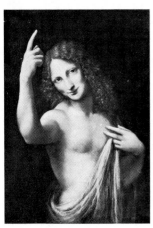

169 Angel of the Annunciation (after Leonardo)

170 Angel of the Annunciation (after Leonardo)

171 The Louvre St John. Detail of the head (see Ill. 167)

172 *Plans for a royal palace at Romorantin, c. 1517*

173 *Studies of horses, a cat and dragon fights,*
c. 1516–17

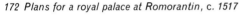

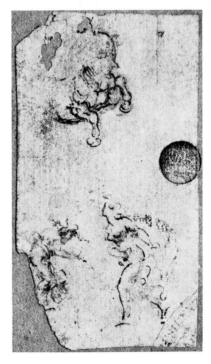

174 *Fontainebleau artist. Project for the*
engraved plate of a horse's head-piece,
c. 1540 (detail)

175 *Horse and rider, early 16th century*

176 *Sketch of a horse and two nymphs,*
c. 1516–17

177 *Sketch for the Trivulzio Monument, c. 1508*

very close to the calligraphic style of Leonardo's late period: the whole image is an assemblage of phalli, as in a Dionysiac ritual. And just as Arcimboldo would have made a portrait out of vegetables, Leonardo may well have originated a pornographic joke that was to be made famous by a medal of Pietro Aretino. These fantasies, then, may be taken as an expression of Leonardo's love for the abnormal, both physical and moral, but it is pointless for us to make an effort to understand them out of their *159* context. In a sheet of the Codex Atlanticus, Leonardo sketches with impeccable scientific detachment a fully developed human being in a graceful upright stance, his left arm akimbo, the other sustaining a headless child who is attached by the neck to his chest. This is no fantasy. One such monster, an epigastric parasitic thoracopagus appeared in Florence in October 1513, and is therefore a precious testimony to Leonardo's presence there on his way to Rome. It was shown around as a curiosity and it was even portrayed in the frontispiece of Giano Vitale's *Teratorizion*, *160* published in Rome in 1514.

By the time Leonardo was settled in Rome, in 1514, Michelangelo had received the commission of the Christ at the Minerva, which he started in a block of marble that was to be abandoned because it proved to be defective. His statue of Christ came out eventually as a Classically poised figure, the alert yet moderately muscular body showing a smooth and delicate surface (as in his earlier Bacchus), especially on the back, which is almost an illustration of Leonardo's views on the rendering of the human figure in the nude. It is in fact so close in type to the Leonardo 'Bellerophon' in the British Museum sheet that one is tempted to detect in it the same erotic connotations. This reminds us of an obscure episode pertaining to Leonardo's early Florentine period, which is hinted at by Leonardo himself in a note dating from the time of the *Battle of Anghiari*, and which reveals his involvement – otherwise unknown – with the representation of a figure of Christ: 'When I made Our Lord as a Child you put me in prison – Now if I were to make Him as a grown-up man you would do worse to me.' And next to this: 'When I think I learn to live and in fact I learn to die.' It has been surmised that Leonardo intended to refer to a painting of the Infant Christ in the early *Madonna with the Cat*, which would have raised a controversy with Church authorities. It is more probable that the 'Domeneddio putto' (in Renaissance literature one finds references to a 'putto' as designating a fifteen-year-old boy) was

a work, not necessarily a painting, for which Leonardo had the homo-
sexual Saltarelli (the cause of the 1476 accusation of sodomy) pose as a
model. It would not have taken Church authorities to condemn the view,
either stated or implied, that Christ's love for mankind was made to be
identifiable with that of a homosexual. About 1505 Leonardo was prob-
ably asked to make a representation of the Saviour. Such was the subject
of a statue that Andrea Sansovino was to produce for the Council Hall
at the time of the *Battle of Anghiari*. And one of the sketches in the
Anghiari sheet at Windsor, which contains the pupil's drawing after the
91 angel of the Annunciation, shows a standing man poised in an attitude
that would easily apply to a statue of the Saviour. (That Leonardo had a
statue in mind is clearly shown by the detail of the left foot resting on a
stone.) If Salai was to have posed for it, Leonardo would again have been
choosing a homosexual to represent Christ. This was the time when
Leonardo was formulating his theory that body surface should not be
represented with musculature over-emphasized and that the Michel-
angelesque effect of a 'sack of nuts' should be avoided. It seems that
Michelangelo had planned a Herculean figure of the Saviour for the
Piccolomini altar in 1501, but eventually he was to respond to Leonardo's
lesson with the Christ at the Minerva, which has much of what Leonardo
would have been blamed (or even put in prison) for by his fellow citizens.

Among the Leonardo paintings recorded at Fontainebleau in 1642
was 'un Christ à demi corps' which is lost and which is known in a num-
ber of copies and in an engraving by Hollar of 1650, as well as in two
drapery studies at Windsor. The drawings are in the same style and
161, 162 technique (red chalk on red prepared paper) as the studies for the Louvre
St Anne, showing therefore that Leonardo might have worked on the
subject any time between 1510 and 1515. And since it was in 1514 and
1515 that Isabella d'Este was a guest of Leonardo's patron Giuliano de'
Medici in Rome, one may wonder whether she had finally succeeded in
having him get down to work on a subject she had commissioned from
him ten years before, that is, the picture of a young Christ disputing in
the Temple. This would explain the two late profile studies of doctors at
23 Windsor, one of which is sometimes considered an ideal self-portrait. A
well-known version by Luini, probably derived from a Leonardo cartoon,
shows that the central figure of Christ could well be singled out and
163 changed into a globe-bearing *Salvator Mundi*. As a deliberately traditional

subject, the image of Christ was to be given the frontality of an icon, with an almost sinister intensity in His countenence, which approaches the frenzied stare of the so-called Trivulzio portrait in another drawing at Windsor. This came about as a sudden departure from the Classical model of a profile view, but was to be toned down by placing the hieratic image within a luxuriant, sensuous frame of hair which falls in ringlets on the shoulders like gushing water. There is something irreverent, almost iconoclastic, about this image emerging from the dark background with the sharp look of a magician about to perform a trick. A pupil drawing at Windsor, next to the Trivulzio portrait, shows how this frontal image *164* could be distorted as an unintentional satire into an expression of grotesque melancholy – as if to suggest what would have happened to Christ's face had He lived longer.

I am coming slowly to the subject of this chapter, which is a magnificent drawing in red chalk on red prepared paper, the style of which *165* points to a date after 1510, possibly about 1513. This is preserved in the small museum of a sanctuary placed at the top of a high mountain over Varese, and I must confess that I have seldom seen an original Leonardo of more revealing character. It represents St John the Baptist as a young man seated on a rocky ledge, the left leg crossed over the right knee, the left arm hanging down and holding a long reed made into a cross, to which he is pointing with his right hand. The head is turned to full face, lightly inclined to the left. The expression is intense, the eyes deeply set in shadow, and there is no smile. Behind the figure are rocks and vegetation; the foliage of the trees is shown in the middle distance with a vibrating touch of the chalk. The foreground curves around in stratification lines, as if affected by water erosion. Curly grass by the ledge frames the dark area of a slit in the rock, out of which water falls. The light comes straight down from the top, and the legs cast a small shadow on the ledge. The composition has a sense of Classical measure, as in a medal or a plaquette, and the inessential is obliterated as in the Adda landscapes of 1513.

In the last four months of 1513 Leonardo could have been in Milan, in Florence or Rome, and it is therefore impossible to relate this drawing to any iconographic programme or to explain it by reference to any specific source. Florence, whose patron saint is St John the Baptist, would provide a suitable motivation for the origin of the subject, but Leonardo's inter-

pretation of it would probably have been considered at variance with a traditional one that in 1508 was still followed by Rustici in his bronze group for the Baptistery, a work in which Leonardo himself participated. In the seated St John, Leonardo has disposed of the ascetic, lean body of the prophet in favour of the fleshy and delicate beauty of an antique god, of a Dionysus. This would have been more suitable for a society of humanists in Rome, perhaps for the Pope himself, Leo X, who would have wanted an image of the patron saint of his home town shaped after the fashion of the day, at the same time as he was supporting the construction of the church of the Florentine Nation, nearby the Vatican, which was to be dedicated to St John the Baptist and for which Michelangelo was to provide a definitive project about 1550. Documents recently located show that in 1514 Leonardo had applied to join the confraternity of S. Giovanni dei Fiorentini in Rome. Probably in a moment of depression at a court which had little or no consideration for him (the Pope was to deny him permission to conduct dissections at the hospital of S. Spirito, which is located between the Vatican and the Fiorentini), Leonardo had come to realize that his only hope was a religious institution which could provide him with quiet shelter and affectionate assistance, and to which he could leave all his possessions, just as he was leaving drawings and other belongings to another religious institution in Florence, the hospital of S. Maria Nuova, which was also his bank, and probably at the convent of S. Maria Novella, in which he was accommodated at the time he was working on the *Battle of Anghiari*. There is some evidence of the first symptoms of his failing health during his Roman period. Yet he was still travelling in Tuscany and north Italy, and eventually was to accept the invitation from the king of France and leave Italy for ever. A painting of St John the Baptist would therefore be well justified in Rome, at the court of a Medici pope, and it might be in fact the painting of unspecified subject commissioned from him by the pope himself. This is recorded by Vasari, who was more interested in telling how Leonardo began immediately to distill oils and herbs to prepare the varnish, which is the last ingredient needed in a painting, and how the pope was to burst in despair saying: 'Alas! this man will never do anything, for he begins to think of the end before the beginning of the work.'

As a Roman work, the seated St John the Baptist could have been taken to be an intentional reference to the pose of one of Michelangelo's

athletes on the Sistine ceiling, to show how body musculature should be rendered according to nature and not over-emphasized for the purpose of stressing emotions – an illustration, therefore, to a note found in a manuscript of 1513–14, and usually interpreted as a reference to Michelangelo: 'O anatomical painter beware, lest in the attempt to make your nudes display all their emotions by a too strong indication of bones, sinews, and muscles, you become a wooden painter', a criticism which is remarkably echoed by Lomazzo in 1584 with a specific reference to Michelangelo: 'Let the painter beware not to do as Michelangelo did, who, wishing to show how to be a master at anatomy, gave all his figures those muscles that the anatomist alone is able to see through dissection.' Thus it is not a case of Leonardo borrowing a motif from Michelangelo – the motif was available in antique statuary and coins, and Leonardo could have gone direct to the sources, one of which is even mentioned in the *Antiquarie prospettiche Romane*, the poem dedicated to him, as a seated female figure in the Caffarelli collection, the one included in the Holkham Hall sketchbook by a sixteenth-century anonymous artist with the specific reference to that collection.

The origin of the so-called *Bacchus* in the Louvre is now easy to explain. It is a painting by a pupil using Leonardo's drawing (or perhaps a cartoon), and it is even possible that Leonardo himself had something to do with it. It is certain, however, that the painting originally represented a St John the Baptist and that it was changed into a Bacchus only in the seventeenth century. It was still a St John when it was seen by Cassiano dal Pozzo in 1625. He described it as a most delicate work, specifying that it 'does not please because it does not arouse feelings of devotion'. The unsatisfactory image could be turned into a Bacchus by simply adding a crown of vine leaves and the leopard's skin, and by changing the cross into a thyrsis – a change officially recorded in the 1695 inventory, where the entry 'St Jean dans le désert' is crossed out and replaced by the designation of 'Baccus dans un paysage'. Leonardo or his immediate assistants had nothing to do with the change, and probably had no intention of playing some esoteric game. Even the stereotyped landscape has no reference to a setting for a Bacchus, and iconographers may detect all sorts of Christian symbols in the vegetation and the animals. The result, paradoxically, is that the painting now has more religious character than the Varese drawing, in which the human figure dominates a view of natural forms,

166

evocative of the spirit of fertility with which Dionysus was associated. And one is reminded that the ancient god possessed a prophetic gift which was to make him accepted at Delphi by the priesthood of Apollo on almost equal terms. The young prophet was to be shown in the glare of a meridian light, and the painting would have had a clarity even greater than that of the Louvre *St Anne*, which it resembles in the treatment of the stratified rocks in the foreground. The *Bacchus* painting remains a melancholic ghost of Leonardo's intentions. There is no evidence that he brought it to France but it might be the one seen in his studio in Amboise in 1517, and he might have left its execution entirely to Melzi or Salai.

The three pictures seen in Leonardo's studio in 1517 included a 'St John the Baptist as a young man'; this is always taken to be a reference to another painting in the Louvre which is unquestionably by Leonardo and which shows the image of the young Saint emerging from the darkness of the background. But why should this be the painting? Cassiano dal Pozzo in 1625 and Pere Dan in 1642 described the St John-Bacchus as belonging to the Royal Collection, together with the *Mona Lisa* and the *St Anne*. The first record of the nocturnal *St John the Baptist* in the French royal collection dates from sometime before 1641 when Louis XIII offered the painting to Charles I of England in exchange for Holbein's *Portrait of Erasmus* and a *Holy Family* by Titian. At the sale of the king's possessions in 1646 it was purchased by a French banker and given to Cardinal Mazarin, and eventually entered the Louvre. There is no evidence, therefore, that Francis I had acquired the painting from Leonardo or Melzi. Even the *St Anne* entered the Royal Collection after having returned to Italy and been acquired there by Cardinal Richeliu about 1630.

167 It has become customary to consider the nocturnal *St John* as Leonardo's last painting, dating from the last years of his life, but it can be shown that in 1509 it was already done, which explains the numerous copies that originated in north Italy. There is a light black chalk sketch of *168* the pointing hand, on a folio of the Codex Atlanticus, which is partly covered by pen-and-ink notes of geometry. With the identification of the missing part of the sheet I was able to date Leonardo's notes shortly before 3 May 1509. It has always been taken for granted that the drawing is by Leonardo and that it is a preparatory study for a detail of the Louvre painting. But it is clearly a clumsy and hesitant copy by a pupil who misunderstood the anatomical relation of thumb to index, and placed the

tip of the middle finger clear under the tip of the thumb. It is precisely this detail that one finds in some of the copies. It is my conclusion, therefore, that the nocturnal *St John* was painted about 1508–09 and that it followed closely the idea of an *Angel of the Annunciation*, known in a pupil black chalk sketch (lightly touched with pen and ink by Leonardo) in a sheet of studies for the *Battle of Anghiari* of about 1503–04. *91*

In Vasari's time the *Angel* was in the collection of the Grand Duke Cosimo, but we do not know whether the school copies are accurate reproductions of the lost original. In the one at Basle the angel is wingless, and his naked body is lightly covered by a long veil that his left hand has lifted to his chest. (In the pupil's sketch the same hand seems to be holding flowers, and a scroll flutters over the head.) There are no religious attributes, and the youth has acquired the aspect of an hermaphrodite. In the copy now in the Ashmolean Museum, Oxford, the left hand no longer holds the veil but pulls a garment made of a leopard's skin, thus suggesting a metamorphosis into a St John the Baptist. Leonardo himself was to take the next step by a twist of the body, which was to bring the raised arm to a side view across the chest. As the frontality of the angel's gesture presented a most difficult problem of perspective, it was precisely the area of the foreshortened arm that Leonardo was to correct in the pupil's drawing. There is nothing of a daring innovation in showing the angel from the viewpoint of the Virgin Mary, for Antonello's famous *Annunziata* of about 1475, whose foreshortened hand anticipates that of the *Virgin of the Rocks*, is seen from the viewpoint of the angel and might have been the source of Leonardo's idea. Perhaps the true innovation of Leonardo's *Angel* is its iconography, for this cannot be the traditional Gabriel addressing the Virgin Mary nor can it be the creature of theological debates (how could Leonardo write at the same time his long refutation of the existence of spirits?), but it is a presence fashioned after the pagan symbol of Love addressing the mortals with the language of the Neoplatonists. It is *Amor* as praised in Bembo's *Asolani* of 1505 and made the subject of Bembo's own peroration to Castiglione's *Courtier*: 'You are the sweet bond of the universe, the mediator between things heavenly and things earthly. Through you the highest beings descend with gracious effect and take over the direction of lower things. And by guiding the senses of mortals towards their own origins, you cause them to be connected with the higher beings.'

169

170

It is quite possible that the nocturnal *St John* originated in Florence at the time when Leonardo was assisting his friend Rustici with the group of the Baptist between a Pharisee and a Levite for the Baptistery. If one were to attempt an interpretation of Leonardo's intentions, I believe one could fancy almost anything, including the suggestion that the Saint really looks like a Bacchus and that Leonardo may have wanted to provide his own response to a fashionable philosophy which was aiming at a pagan-Christian syncretism in art. This seems a good possibility when one considers that a contemporary anonymous poet wrote a distich on a Leonardo *Bacchus* which would be otherwise unknown to us. The distich is in a codex of poems collected by the Ferrarese humanist Flavio Antonio Giraldi (thus it is not by him, as commonly believed), and reads as follows:

> *Bacchus Leonardi Vincij*
> *Ter geminum posthac mortales credite Bacchum*
> *Me peperit docta Vincius ecce manu.*

The 'learned hand' of Leonardo da Vinci has caused Bacchus to be born for the third time. (First he was born from Semele, the Earth, and then from Zeus' thigh.) It has been suggested that such a Bacchus could have been the one mentioned in a letter from the duke of Ferrara in 1505 to his ambassador in Milan about a *Bacchus* in the possession of Anton Maria Pallavicino that he wished to purchase. (Pallavicino was to become one of Leonardo's patrons when Leonardo was in Milan after 1506.) The request was declined but the correspondence does not reveal whether Leonardo was the author of the *Bacchus*, nor does it specify whether the work was a painting or a sculpture. A Windsor drawing of a seated youth, seen in profile to right, obviously derived from a gem or a relief of a Diomedes, may be the idea for a Bacchus or a Baptist dating from the time of *Anghiari*, but it would be too late as a study for the *Bacchus* in the possession of Pallavicino. On the other hand the nocturnal *St John* is dark enough to conceal his religious symbols and to appear as an ambiguous image to urge mortals to believe in the miracle performed by the painter. The painter's 'learned hand', that was capable of conjuring up such a disturbing image, might have figured out that the mast carried by the Victories in sarcophagi of the Triumph of Bacchus could be taken to look like a reed cross – an idea well in keeping with Castiglione's reference to Leonardo

in the *Courtier*: 'Another, one of the first painters of the world, scorns that art wherein he is most rare, and has set about studying philosophy; in which he comes up with such strange notions and new chimeras that, for all his art as a painter, he would never be able to paint them.'

All this may appear too far-fetched, and I must confess that I am inclined to believe that the nocturnal *St John* was painted to illustrate an artistic theory, and was therefore intended as a paradigmatic work. It was produced during a period in which Leonardo's studies on light and shade were reaching the brink of obsession. (Eventually he was to comment on these with a sentence written in microscopic script: 'One ought not to desire the impossible.') Vasari has a revealing reference to the import of Leonardo's contribution in this field in a sentence which precedes the record of Leonardo's association with Rustici: 'To the art of painting in oil he added a certain mode of deepening the shadows, by which the moderns have imparted great vigor and relief to their figures.' And after having mentioned the angel of the Annunciation, Vasari again explains the character of Leonardo's 'nocturnal' paintings: 'So marvellous was Leonardo's mind that, desiring to throw his things into greater relief, he endeavoured to obtain greater depths of shadow, and sought the deepest blacks in order to render the lights clearer by contrast. He succeeded so well that his scenes looked rather like representations of the night, there being no bright light, than of lightness of day, though all was done with the idea of throwing things into greater relief and to find the end and perfection of art.' This character of Leonardo's painting was well under-stood by Lomazzo, who wrote in his *Idea* of 1590 as follows: 'Leonardo has always been very careful in using too bright a light, so as to keep it for the proper place, seeking that the darkness of greater intensity should reach the extreme depth of shadows. Wherefore he has achieved *in his representations of faces and bodies*, which he had made truly admirable, all that nature can produce. And in this he has surpassed everybody, so that in one word we can say that Leonardo's light is divine.' And when Vasari was to generalize about contemporary painting as compared to the achievements of antiquity (II. 95), he was undoubtedly referring again to Leonardo's contributions: 'But who would say that one was to be found in antiquity who was perfect in everything, and had handled things such as invention, design and colour, in a way that equals the present-day results? And who had observed the smooth fading of the darkness of

colour in the figures, so that the highlights were to be left only on the protruding parts?'

Leonardo was certainly convinced of the importance of his artistic views in the context of Florentine art but also aware that their complexities could not be properly explained in writing. So he decided to use the language of painting to set a model, and in fact I am extremely tempted to believe that he deliberately intended to perform an act comparable to that of Brunelleschi in publishing his theory of artificial perspective. Brunelleschi painted a small square panel of about two feet on each side representing a frontal view of the Florentine Baptistery – a panel which had a burnished silver background in order to reflect the actual sky once it was observed from its back, through a hole in its centre, into a mirror held in front of it at arm's distance. One century later Leonardo was to show that painting could be freed from the bounds of a geometric convention in order to represent a figure in space which would convey the illusion of a living presence. (Physical life as expressed by the hair which coils down with an orderly motion resembling that of water, and life as emotion as expressed by the smile and the gesture; and finally life as a visible expression of grace implying a series of smooth transitions.) The idea could have come to him as he was working with Rustici on statues for the building that Brunelleschi had chosen as the model for his perspective. Leonardo took the human image which symbolizes that building and made a panel which is remarkably close to the size of Brunelleschi's lost panel. The background is neutral, as in Brunelleschi's, and has the same function of conveying the effect of relief of the figure, stressing its sense of reality. The difference is that Leonardo did not use optical tricks but only the power of his art, so that he could expect the recognition that his revolutionary performance aimed at. This would be the simple, yet subtle meaning of the nocturnal *St John* – a painting that was to symbolize a turning-point in the development of Florentine art. But I fear that we are hopelessly far from the spirit of the time to which it belongs, and that we shall continue to detect in it a projection of our own thoughts.

171

Epilogue

There is a book, published in 1564, in which one would hardly expect to
find the name of Leonardo da Vinci. This is an edition of Dante's *Divine
Comedy*, with the commentaries by Cristoforo Landino and Alessandro
Vellutello, as well as Francesco Sansovino's additions to them. It is
Sansovino who supplements the list of illustrious citizens of Florence,
writing about Leonardo as follows: 'Lionardo da Vinci was equally
illustrious and much honoured in his time. He was so highly esteemed that
Princes would summon him with the offer of great provisions. And his
works were treasured in every part of Italy.'

This brief statement conforms to the belief, which prevailed in the
sixteenth century, that the artist's reputation depended on the stature of
his patrons. A gentle legend soon originated that Leonardo had died in the
arms of a king, and a great king at that. Historians have found that Francis
I was not at Amboise when Leonardo died. And in 1590 Giovan Paolo
Lomazzo was to report that the news of Leonardo's death had been
brought to the king by Francesco Melzi. It has been said that Vasari him-
self invented the legend as a fitting conclusion to his portrait of the
'divine' Leonardo. But curiously, the legend originated in Rome in
Michelangelo's circle. In fact the Portuguese painter Francisco de Hollanda
best known for his *Dialoghi michelangioleschi*, was the first to mention it
in his *De pintura antigua*, which was published in Lisbon in 1548, two years
before the first edition of Vasari's *Lives*. This seems to have escaped the
attention of Leonardo's biographers, although it was even translated into
English by J. P. Richter as early at 1880. 'What shall I say of Leonardo da
Vinci', writes Francisco de Hollanda, 'whom the King of France treated
with such honour, that he appointed noblemen clad in silk and brocade
to wait upon him. So great was the monarch's love for him, that in his
sickness he visited him, and supported him when he lay a-dying in his

arms. Thus did this famous painter breathe his last upon the breast of the King. Honours such as these are not for Portuguese artists.'

It is impossible to ascertain the source of this information. Michelangelo and Leonardo had mutual patrons in Rome and Florence, and Michelangelo must have known more than anybody else about Leonardo's last years in Italy and France. His nephew, Michelangelo Buonarroti the Younger, in his description of the wedding of Maria de' Medici, Queen of France and Navarre, a booklet published in Florence in 1600, mentions an automaton which was presented at a banquet, a mechanical lion, which walked a few steps and then rose on its hind quarters, opening its breast to show that it was full of *fleur-de-lis*, a concept, concludes the younger Michelangelo, 'similar to that which Leonardo da Vinci realized for the Florentine Nation on the occasion of Francis I's entry into Lyons.'

This casual reference has not the charm of a legend, but the importance of a document. It tells us something new about a crucial period of Leonardo's career, when he was about to leave his last Italian patron to join the king of France. We know now the precise occasion of his mechanical lion, and we are able to understand its political symbolism. The lion is the old symbol of Florence, the Marzocco, and as its breast opens, in the place of its heart it shows *fleur-de-lis*, the symbol of the French crown. In this way the Florentine Nation, under the governorship of Lorenzo di Piero de' Medici, nephew of Leo X, was to express its devotion to the new king of France, who was entering Lyons on 12 July 1515 after his Italian campaign.

At the time of the visit of Leo X to Florence on his way to meet the French king in Bologna in December 1515, Leonardo must have been in Florence giving suggestions to the artists who were preparing the festive apparatus for the entry of the Medici pope. The pope's brother and Leonardo's patron, Giuliano, was in Florence, and so was the pope's nephew, Lorenzo di Piero, for whom Leonardo was to plan a majestic palace just across from the old palace of Cosimo de' Medici. This was part of a project of urban systematization of the whole Medici quarter, including the opening of a piazza in front of the Church of S. Lorenzo, which would have produced a spectacular setting comparable to the Urbino perspective panels and anticipating Michelangelo's ideas for the Capitol in Rome. It was Michelangelo himself who was to receive the commission for the façade of S. Lorenzo, and it was he who closed the corner loggia of

the old Medici palace, a modification which makes sense only in the context of Leonardo's project. And an obscure passage in Vasari's Life of Leonardo tells us of the rivalry between Leonardo and Michelangelo at the time of the competition for the façade of S. Lorenzo as the reason for Leonardo's leaving for France. For centuries it was believed that Leonardo had followed the pope to Bologna in December 1515, and that he had met the king on that occasion. Even a document was found in support of the belief. But the document consists of two unrelated entries: the first is a general heading, dated 1515, specifying that the whole book includes the accounts of the expenses for Leonardo's journey to Boulogne in France (not Bologna in Italy) as well as expenses met on other occasions; the second shows simply that Leonardo was receiving his monthly payments from a Roman bank, and gives no indication of his whereabouts.

Leonardo could have met Francis I well before the Bologna event, when the king entered Lyons and was greeted by Leonardo's mechanical lion sent from Florence. On 9 December 1515 Leonardo was writing from Milan to his steward in Fiesole, but unfortunately the original letter is lost and is known only in a nineteenth-century copy. At that time the king was in Milan, and before returning to France in January 1516, he financed a vast project of canalization in Lombardy on which Leonardo had worked for many years. In sheets of Leonardo's geometrical studies dating from that time, there appear sketches of the plan of the Sforza Castle. The last period of Leonardo's activity in Italy, between 1515 and 1516, shows him moving quickly from Rome to Florence and Milan (and perhaps Lyons), and back to Rome, and it is only in January 1517 that Leonardo refers to himself as working in France on the project of a royal residence at Romorantin.

There is no evidence of Leonardo's activity as a painter during the last three years of his life in France. A report of a visit paid to him by Cardinal Louis of Aragon on 10 October 1517 refers to the condition of his health as preventing him from painting 'with that sweetness that he used to', adding that he was nevertheless still capable of producing drawings and giving instructions to others, namely his pupils Francesco Melzi and Salai, who had followed him to France. On the other hand, Lomazzo mentions a work, either a painting or a drawing, that Leonardo did for Francis I, an anamorphical subject representing horses, obviously the kind of optical amenity that was to become popular in France and Italy in the

seventeenth century. It is possible that Leonardo's latest drawings of animals at Windsor, including individual horses and groups of horsemen fighting monsters (like a St George and the Dragon), are related to what might have been the composition for the king, and it is also possible that their enigmatic iconography originated from some legendary aspect of chivalry associated with the history of France. (The paper and the hand-

172, 173 writing in these drawings are the same as in a sheet with studies for the
174 Romorantin Palace.) A sixteenth-century design for the headpiece of a horse's armour for Francis I included the representation of prancing horses
177 reminiscent of the studies for the Trivulzio monument and above all of the horse in the bronze statuette at Budapest, which in turn is related to
175 the late sheet of horses at Windsor. These late horses are characterized by a stout body and a complexity of coiling movements suitable for a distor-
176 tion into an optical trick. In a fragment at Venice there appear the forelegs of the same type of prancing horse and, just below, the spirited sketch of two lightly draped nymphs shown in a running attitude, as in the mytho-logical subjects which were to become a speciality of the Fontainebleau School. This small fragment may in fact be the only record left of Leon-ardo's last painting, a *Rape of Proserpina*, which was recorded in the Royal Collection at Fontainebleau in 1642 and which might have provided a model for a painting of the same subject by Niccolò dell'Abate.

In France, Leonardo was to see again his former patron, Lorenzo di Piero de' Medici, Duke of Urbino, who was received with great festivi-ties at Amboise in 1518, on the occasion of his marriage with Madeleine de la Tour d'Auvergne, the king's niece. Giuliano de' Medici, Duke of Nemours, had died in 1516, and his widow, Philiberta of Savoy, aunt of Francis I, was also at Amboise on that occasion. The close relationship between the Medici family and the king of France might have had something to do with Leonardo's decision to leave Italy and join a king who had the ambition to become Roman Emperor with the support of the Medici pope. The last three years of Leonardo's activity in France con-cerned canalization projects and plans for a royal residence which aptly reflect the Imperial dreams of a king whose deeds and thoughts were constantly inspired by the reading of Julius Caesar's *De bello gallico*. But history was to take a different course. In 1519 Leonardo died, and the king failed to gain the Imperial crown.

Bibliography

The greater part of the enormous Leonardo litera-
ture is useless, but even a selection of the most
significant items would fill several pages. A con-
venient list of these is in Lord Clark's *Catalogue of
the Drawings of Leonardo da Vinci at Windsor Castle*,
second edition revised with my assistance, London
1968 (3 vols.), and in the same author's *Leonardo da
Vinci: an Account of His Development as an Artist*,
Cambridge 1952 (revised Penguin edition, 1967). See
also A. E. Popham's *The Drawings of Leonardo da
Vinci*, London 1946. Full bibliographies are also
given in my own publications, e.g. *Leonardo da Vinci
On Painting: A Lost book (Libro A)*, California U.P.
1964, and *Leonardo da Vinci: The Royal Palace at
Romorantin*, Harvard U.P. 1972. For bibliographies
arranged in categories see L. Goldscheider, *Leonardo
da Vinci*, London 1959, and A. P. McMahon's
edition of Leonardo's *Treatise on Painting*, Princeton,
N.J. 1956. The book by G. Calvi, *I manoscritti di
Leonardo da Vinci dal punto di vista cronologico, storico
e biografico*, Bologna 1925, is the foundation of
modern Leonardo scholarship.

My occasional references to authors are self-
explanatory, but the reader may always check the
standard Leonardo bibliography by E. Verga
(Bologna 1931, 2 vols.), and the yearbooks of the
Raccolta Vinciana (since 1905).

Excerpts from Lomazzo's unpublished manuscript
in the British Museum, *Gli Sogni* (Add. MS. 12196),
an edition of which is being prepared by Professor
Battisti, are quoted on pp. 141–42 above from K. R.
Eissler, *Leonardo da Vinci: Psychoanalytic Notes on the
Enigma*, New York 1961, p. 150n.

The *Antiquarie prospettiche Romane*, a booklet on
Roman antiquities published about 1500 and dedica-
ted to Leonardo, was reprinted with commentary
by G. Govi in 1873 and is the subject of a doctoral
dissertation by Doris D. Fienga (University of
California, Los Angeles, 1970).

As this book has no footnotes I have no way to
credit all those publications which have provided
me with valuable background information, e.g. C.
Seymour, *Michelangelo's David. A Search for Identity*,
University of Pittsburgh Press 1967, for the opening
section of Chapter Three (Seymour's views are
somewhat revised by L. D. Ettlinger, 'Hercules
Florentinus', *Mitteilungen des Kunsthistorischen In-
stituts in Florenz*, XVI, 1972, pp. 119–42), and E.
Garin, *Italian Humanism. Philosophy and Civic Life in
the Renaissance*, Oxford 1965, p. 127, for the interpre-
tation of the iconography of Leonardo's *Angel of the
Annunciation* in Chapter Five. I am indebted to Mrs
Frieda Newman for the identification of the carob
tree in the *Adoration of the Magi*, and I have based my
interpretation of the *Virgin of the Rocks* on Mirella
Levi d'Ancona, *The Iconography of the Immaculate
Conception in the Middle Ages and Early Renaissance*,
New York 1957, pp. 73–79. Edgar Wind's paper on
the *Last Supper* appeared in the *Listener*, 8 May 1952,
pp. 747–48. The study by Maria G. Agghàzy
mentioned in the Epilogue ('La statuette équestre de
Léonard de Vinci') is published in the *Bulletin du
Musée Hongrois des Beaux-Arts*, no. 36, 1971, pp.
61–78.

For newly discovered documents on Leonardo's
activity as a military architect in 1503–04 and his
involvement with the canalization of the Arno river,
see my article 'La Verruca', in *Renaissance Quarterly*
(Winter issue of 1972), which has considerable bear-
ing on the subject of the first chapter above. Leonardo
must have been acquainted with Brunelleschi's
project of a river boat (the so-called *Badalone*), with
which great loads of marble were to be brought
from Pisa to Florence. (*Cf.* F. D. Prager and G.
Scaglia, *Brunelleschi. Studies of his Technology and
Inventions*, M.I.T. Press, Cambridge, Mass., 1970,
pp. 111–23.) An unpublished copy of a lost Leonardo
drawing, which is included in my forthcoming
Commentary on the Literary Works of Leonardo da Vinci,
may well represent Brunelleschi's ship.

The Alpine landslide recorded by Leandro
Alberti in 1550, as mentioned on p. 21 above, is
described in more detail by Leonardo's contemporary
and biographer Paolo Giovio in his *Historie* (1568 ed.,
cc. 277–78 and 439–40). Giovio specifies that the
landslide occurred towards the end of 1513 and that
twenty months later, in 1515, the dammed-up waters
broke through the valley, causing more damage and
drowning a whole company of Swiss soldiers.

The best account of Leonardo's formative years in
relation to Florentine culture is in A. Chastel, *Art et
Humanisme à Florence au temps de Laurent le Magnifique*,
Paris, 1961, pp. 403–440. My suggestion (p. 34) that
the iconography of the background of the *Adoration*

of the Magi might have been inspired by Ficino's *Pimander* is based on circumstantial evidence provided by Chastel, p. 407: it was Ginevra Benci's cousin, Tommaso, who translated the *Pimander* into Italian in 1463, and Leonardo's unfinished painting was recorded by Vasari as having been in the Benci house. Furthermore, in a Leonardo note-book of about 1500 is the entry: 'ermete filosafo' (MS. M, *verso* of cover). And I must confess that I am tempted to interpret the central group in the background as including Hermes Trismegistus and a number of Sibyls. For the perspective of the *Adoration* see P. Sanpaolesi in *Leonardo Saggi e Ricerche*, Rome, 1954, diagram on p. 41, which shows how much of the empty hut of the Nativity is left out of the picture, in that the vanishing point designates the carob tree as the vertical axis of the composition, thus contradicting the effect of centrality conveyed by the foreground assembly. The background was to be sharply defined against a coastline of undulating hills and rocky mountains, which would have been treated in atmospheric terms to stress the bulk of the fighting horses, the trees and the ruins. Two figures between the trees are shown as coming up from below, as in Michelangelo's *Doni Madonna*.

The Munich Madonna reproduced in plate IX is mentioned in the text (p. 53) simply as a work dating from the 1470s and as 'still Verrocchiesque' – perhaps too abrupt a short cut to Lord Clark's conclusions about a work that has the 'unpleasant vitality of immature genius'. As a theory that requires a number of bibliographic references, I should add that the head of the Virgin may be an idealized portrait of Simonetta Vespucci (Giuliano de' Medici's infatuation), for whom a famous tournament was organized in Florence on 28 January 1475. Vasari mentions a Leonardo *Madonna of the Vase of Flowers* owned by Pope Clement VII, a bastard son of Giuliano, who could have inherited the painting after his father's violent death in 1478. An item in an inventory of Verrocchio's works for the Medici describes a pennant for the Giuliano tournament: 'Per dipintura duno stendardo ch[on] uno spiritello per la giostra' (*Archivio storico dell'Arte*, I, 1895, pp. 163–176). A drawing for this otherwise unknown work is in the Uffizi, and A. Venturi reproduces it as Leonardo's (*Comm. Vinc.* fasc. I, pl. 1). This shows a recumbent Venus with flowers on her lap and a Cupid (*spiritello*) approaching her from the back through luxuriant vegetation that has the same character as the flowers in the Munich Madonna and in the Uffizi *Annunciation*. This part of the drawing is

shaded by a left hand, thus suggesting that Leonardo had carried out a sketch outlined by his teacher. A well-known Verrocchio drawing in the British Museum shows a woman's head with an elaborate system of plaited hair (as in Leonardo's *Leda*), and on the *verso* a sketch of the same head with the revealing detail of the hand against which it leans, exactly as in the drawing for the pennant. (*Cf.* G. Passavant, *Verrocchio*, London, 1969, figs. 93–95.) The Munich Madonna shows the same type of head, and one may wonder whether the flowers in the vase are those collected by the Venus of the pennant! Piero di Cosimo's symbolic portrait of Simonetta has a similar head-dress. Compare also the Uffizi drawing no. 428 (Berenson 1015 A), a superb, 'still Verrocchiesque' drawing, perhaps the item, 'a head of a girl with knotted hair', in Leonardo's own inventory of early works (CA 24 r). The inventory includes 'many flowers, drawn from nature', as evidence of Leonardo's early plant studies. The lost cartoon of *Adam and Eve*, which Vasari describes only for its vegetation as if to stress its intended tapestry character, may date in the 1470s, when Pollaiuolo was designing the *paramento* for the Baptistery.

For Petrarch's *De remediis utriusque fortunae* as the source of a famous Leonardo *dictum* dating from the time of *Leda* (p. 101), see the Italian translation made by Giovanni Dassaminiato in the 1420s and published in Bologna in 1867 (2 vols.), which is the only one to have the sentence 'gli dii ci vendono utti li beni per prezzo di fatica' (vol. II, p.284), almost identical to Leonardo's text.

Bramante's Tempietto (Ill. 142) is now dated after 1510 on the basis of the latest studies by G. De Angelis D'Ossat, 'Preludio romano del Bramante,' *Palladio*, XVI, 1966, pp. 83–102, and A. Bruschi, *Bramante Architetto*, Bari, 1969, pp. 986–1035. The Tempietto is not mentioned in Albertini's guidebook of 1510, which includes Bramante's other Roman buildings; and the Anonimo Magliabechiano (Frey ed., p. 125), who lists Bramante's buildings in chronological order, keeps it for last. As a work of Bramante's maturer styele, it is well in keeping with the character and style of Leonardo's latest works, including the *Mona Lisa* which I also date after 1510. The conception of the Tempietto is anticipated in one of Leonardo's studies for the Trivulzio Monument (W. 12353), and in a project for a mausoleum in a Louvre drawing of about 1507. See also the tempietti in Cod. Atl. 205 v-a (after 1505), one of which is shown as the centre of an architectural setting. For new evidence of Leonardo's association

with Bramante see my forthcoming articles in the *Journal of the Society of Architectural Historians* (Spring and Fall issues of 1973).

Several bibliographical references would be necessary to qualify my views about Leonardo's attitude towards the Antique, which are in keeping with those presented by Lord Clark in his paper given at the Leonardo Congress in Los Angeles in 1966. I must at least mention a document which has apparently passed unnoticed, namely Guglielmo della Porta's *Sketchbook* at Düsseldorf (ed. by Werner Gramberg, Berlin 1964, 3 vols.), which contains (pp. 82–97) the draft of a long letter to Ammanati about the importance of studying in Rome. Della Porta, who is known to have been in contact with the Leonardo tradition in Milan (he owned the *Codex Leicester*), quotes Leonardo as having stated, while he was in Milan, that Rome was the only teacher as far as design was concerned. Bramante's opinion, quoted subsequently, can be taken to prove that he, Bramante, was the anonymous author of the *Antiquarie prospettiche Romane*, to which I refer a number of times. 'Whoever comes to Rome as an accomplished master,' states Bramante, 'ought to divest himself [*spogliersi*] of everything learnt elsewhere, like a serpent shedding its skin' – and this he proved with the example of himself: as he arrived in Rome, he had to start afresh with a direct study of the ancient ruins. Such a programme is identical to that presented by the author of the *Antiquarie* as he addresses Leonardo in a dedicatory sonnet with the statement about divesting himself (*ignudo mi ci spoglio*) in approaching Classical Antiquity. The key to the identity of Leonardo's anonymous friend is indeed in the woodcut reproduced in Ill. 46 above, as first suspected by Dr Fienga.

List of Illustrations

Sizes are given in centimetres, height before width. The paper is white unless otherwise stated

Index

References to the illustrations are not given in the index but a full list appears on page 178.